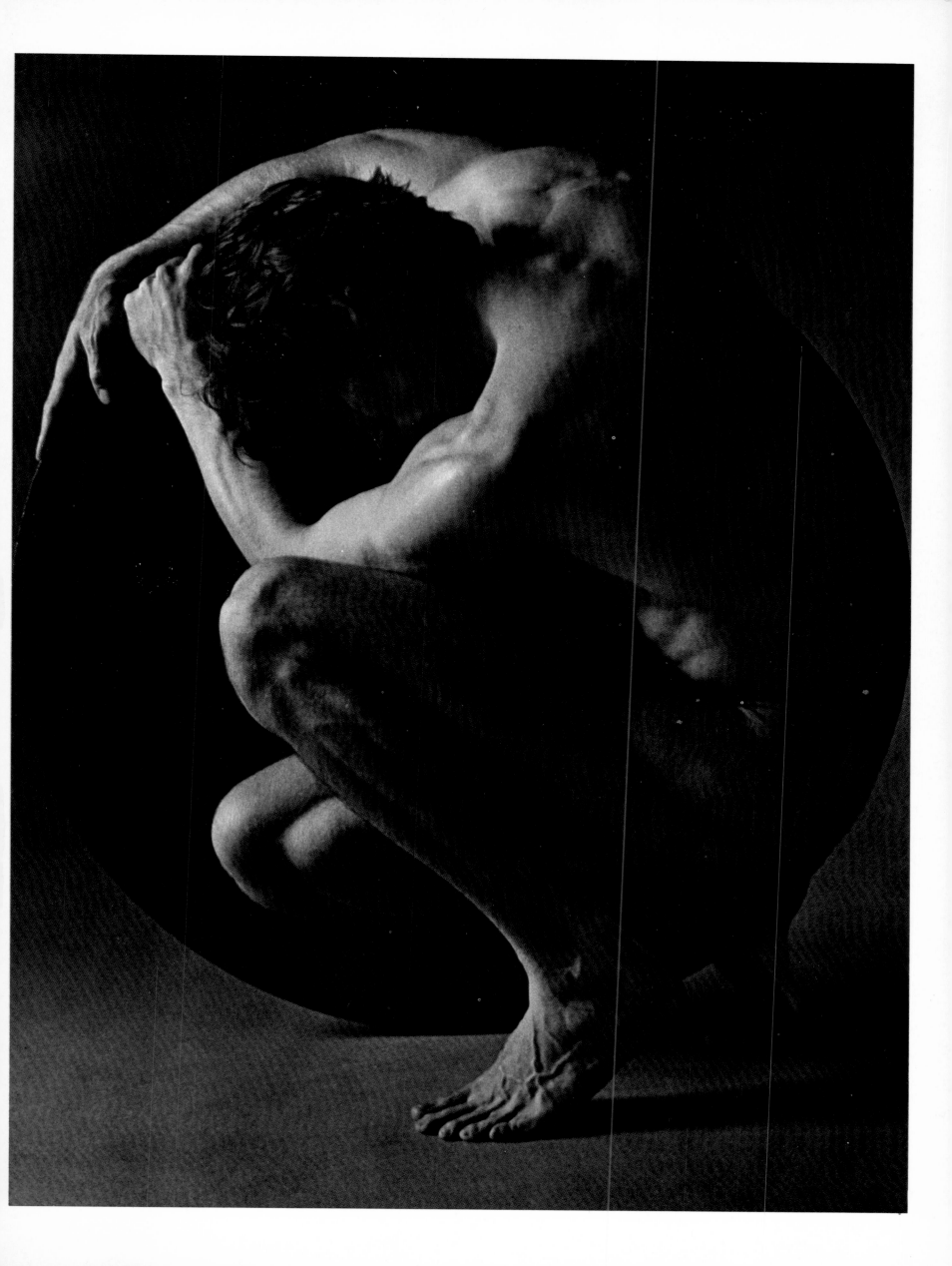

THE CLASSIC NUDE

by

GEORGE M. HESTER

✦

Design by George M. Hester

AMPHOTO

American Photographic Book Publishing Co., Inc.

Garden City, New York

Dedicated to Dick and Tina, Jack, Patsy,
Benton, Helen, Rosanne.

Second Printing, Revised, September 1973
Third Printing, March 1974

Published in Garden City, N.Y., by American Photographic
Book Publishing Co., Inc. All rights reserved. No part of
this book may be reproduced in any manner whatsoever
without the written consent of the publisher.

Library of Congress Catalog Card No. 72-93373
ISBN 0-8174-0554-2

Manufactured in the United States of America

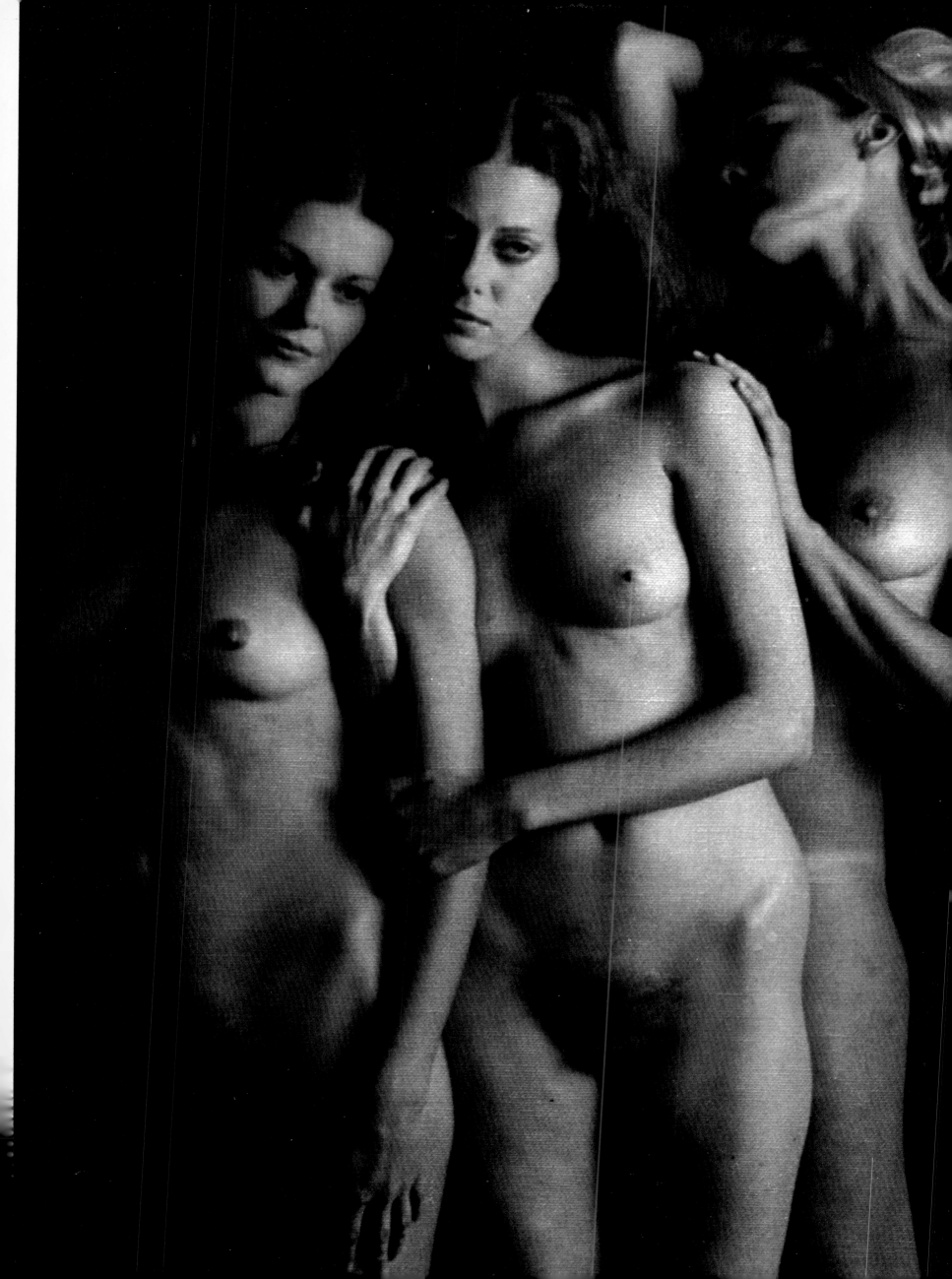

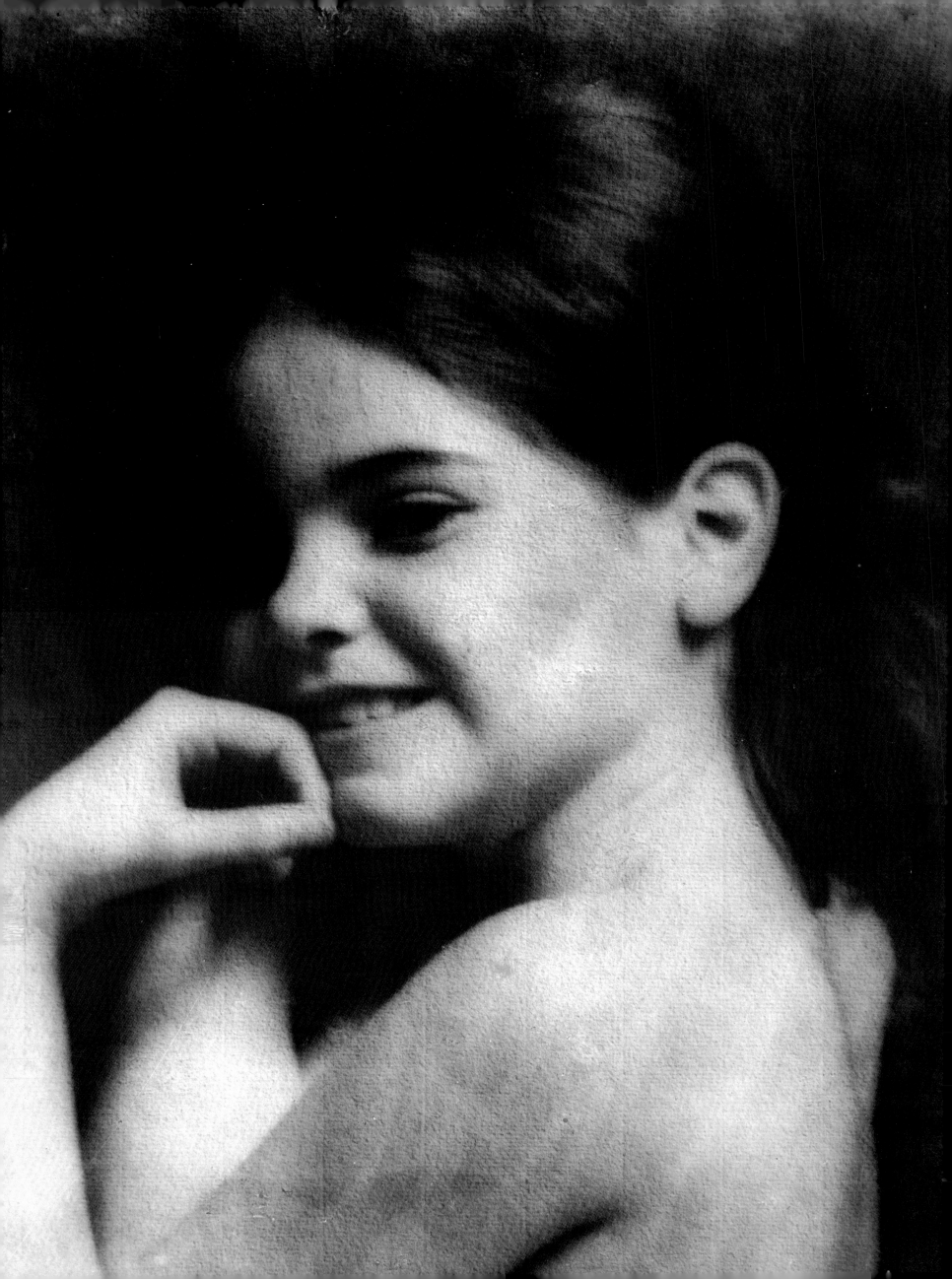

hotography entered the world during the mid-nineteenth century as the step-child of the Victorian period, with all its social and intellectual taboos. At a time when draperies were put on statues and piano legs were "limbs," photographing a nude subject was difficult and risky because of subtle but severe public pressure. It was almost axiomatic that a photographer of the naked body had mean purpose and vulgar intentions, and was to be put down firmly or ostracized. Fortunately, that period and its long hangover are past. The modern photographer, like any other artist, knows that art is a matter of aesthetics, not of morality or uplift. Yet even today, the art form of photographing the nude is still comparatively uncommon.

Why does the photographer, painter, or sculptor choose the naked body as a subject? To most of us it is the epitome of all creation and the supreme transmutation of matter into form. Man is the measure of all things, in all cultures. In the course of history we have recorded the image of ourselves in one form or another; man assuredly likes to look at himself in the mirror of time. The ancient Egyptians saw the human body and its likeness primarily as a vessel for the soul and built the Pyramids to contain it. The nude as seen by the Greeks was classic in concept; as seen by Michelangelo, monumental;

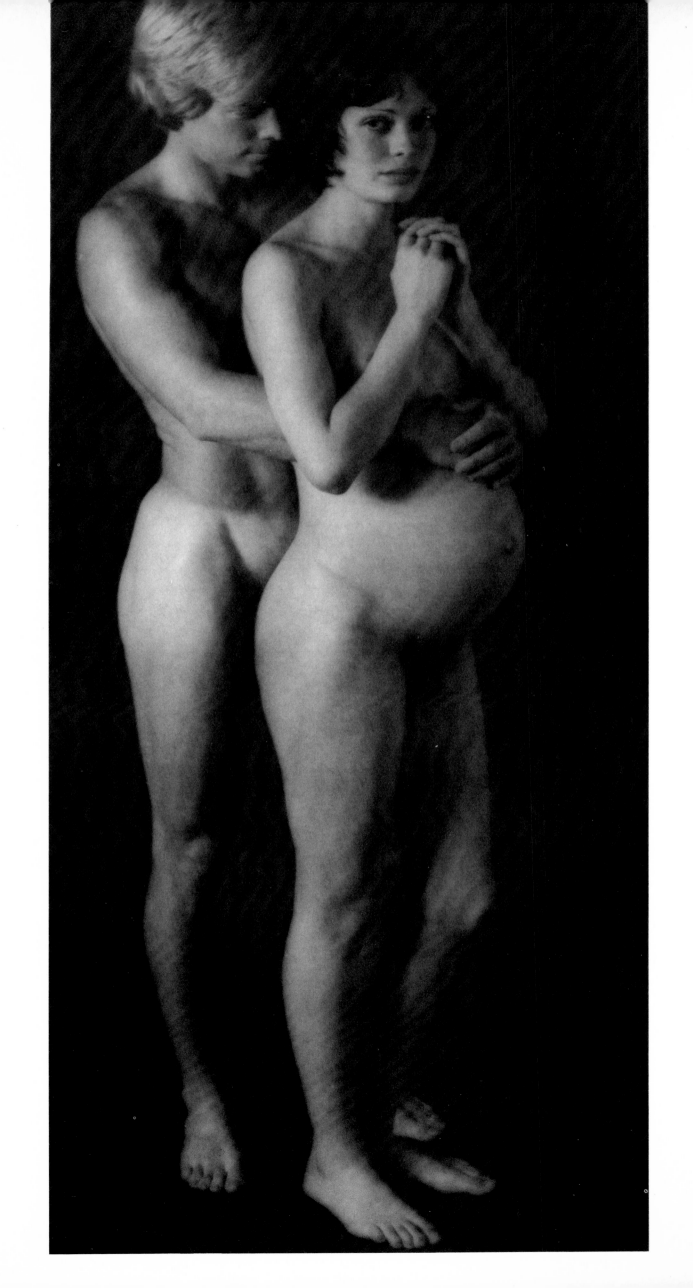

as seen by El Greco, distorted to express mystical vision; in Hindu art, erotic. It has been shown as heroic, sensuous, strong, weak, distorted in a thousand forms—but nobody has ignored it. I find that I have a particular affinity for the Greek conception relating it to the ideal of wholeness: the body as the ultimate totality, the symbol of integrity, the aggregate of good and bad, the alpha and omega of artistic structure. Greek artists of the classic period projected their lifestyle and culture across the ages to us through their work. These masters observed the model, then chiseled interpretations of their inner vision; they were the *avant garde* of their time. There are no rules set for eternity; when minds are ready for change, artists question, probe, and dare.

Possibly one reason for the reluctance of many people to accept the nude in serious photographs is that the nature of the photographic medium gives it an illusion

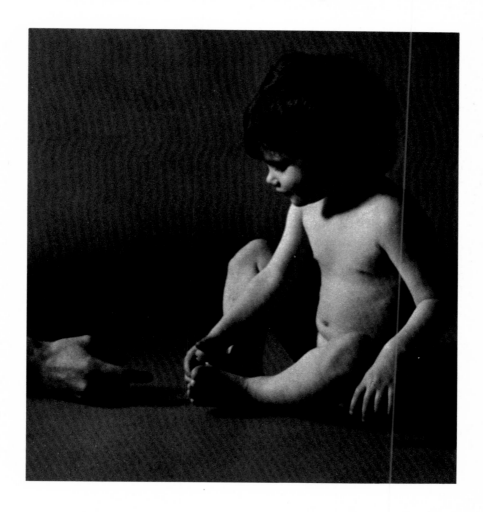

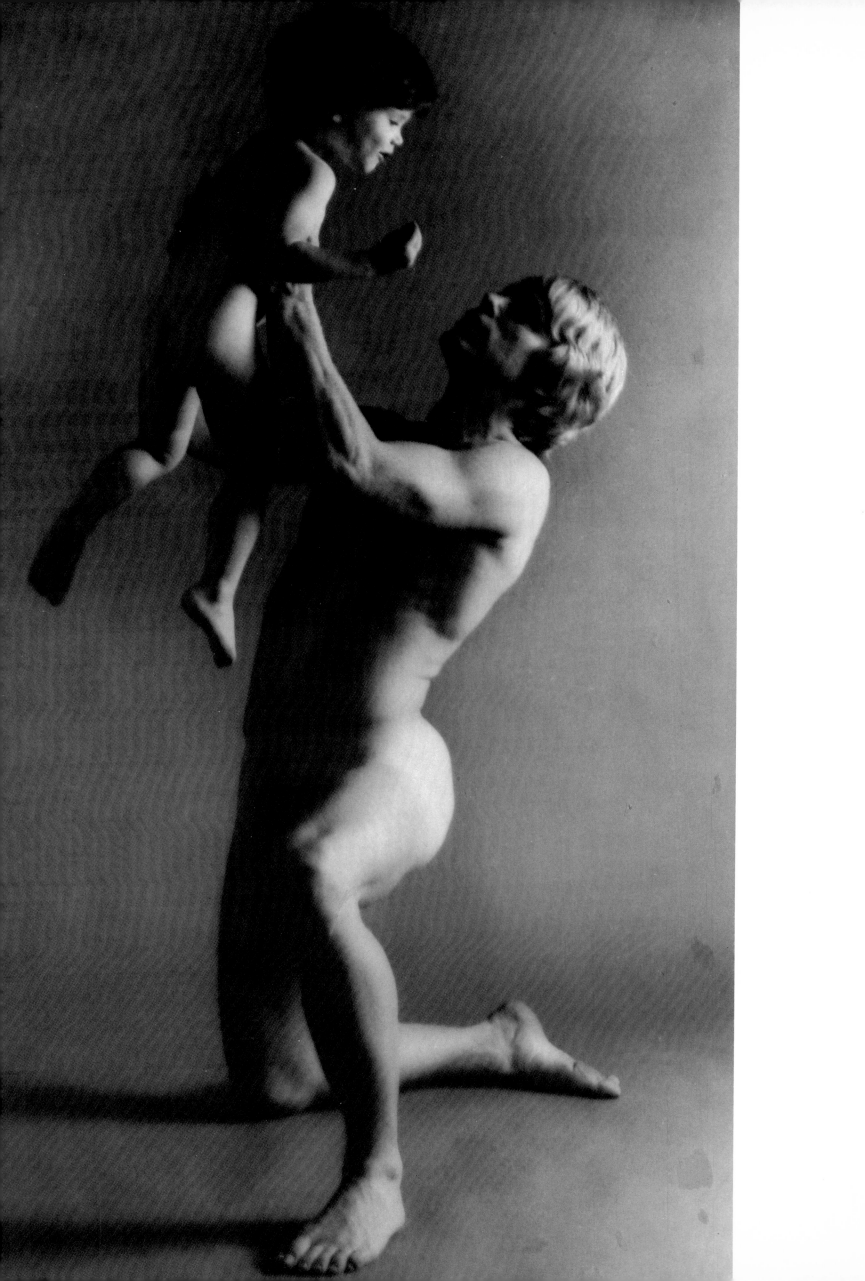

of actuality, as though there were no intermediary between the viewer and the subject. But this assumption is indeed illusory. I have not hesitated to inject myself and my interpretations in order to capture form and light in the terms of my own inner vision. The click of the shutter is merely the beginning of a process by which we create the image, using all the various techniques at hand to alter and affect the results.

Most people are indifferent to the priceless possession of two good eyes; possibly it is the awareness of his own gift of vision that makes an individual an artist. A passionate intensity is needed to register visual impressions and transfer them from his imagination to canvas, stone, or film. An artist who uses a camera tries to catch in a split second a moment of beauty. Thus the camera suits our speeding times as a medium of expression. Each

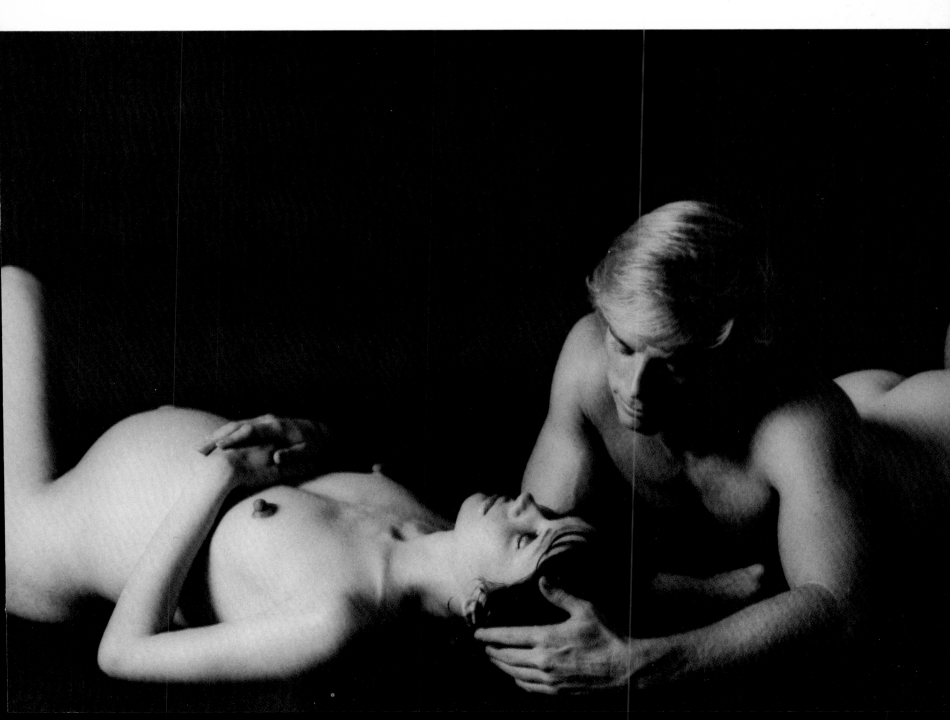

artist of the past has worked with the peculiar tools of his era; the camera is mine.

Today, swift-paced changes and new techniques in photography enable us to alter the photographic image in many ways. This experimentation is good, and from it comes the work that develops into tomorrow's forms. However, the photographs in this book are not adventures in techniques. They are attempts to show the body simply, beautifully, and expressively, coupling freedom of spirit with love of the human figure.

Most of the photographs in this book are in black-and-white, and deliberately so. I wanted the challenge of exploring the range of the monochromatic palette—the infinite gradations of black, subtleties of tone, texture, volume, line, and darks and lights. It is the same challenge that attracts artists to work in charcoal, lithograph, and other monochromatic media instead of paint. The use of black-and-white also provides a single aesthetic element, unifying photographs that in many other ways differ in mood and technique. Finally, the qualities of a monochrome palette eliminate many extraneous and distracting elements and permit one to concentrate on the essential, universal qualities of the figure.

I used the same background, lighting, and lens setting for every photograph in this book (including color). A black no-seam paper served as the background. A strobe was the one light source used throughout. (Back and sidelighting tend to flatten the figure; with one light source, the *chiaroscuro* effects and intrinsic sculptural qualities of the body become the focus of the work.)

An $f/11$ opening at 1/60 second, using 1000 watt-seconds from the strobe, was used for all photographs. By limiting myself this way, I was free to concentrate on the subject.

I could have used fast film; I chose not to. I had no need for it, having decided against all affectations of pose or lighting, and against all props and artifices that might require such film speed. Moreover, I wanted to escape its limitations: a hard-edged image and a grainy texture. Therefore I chose Panatomic-X for its qualities as a slower film. This film can be enlarged from a 35mm negative

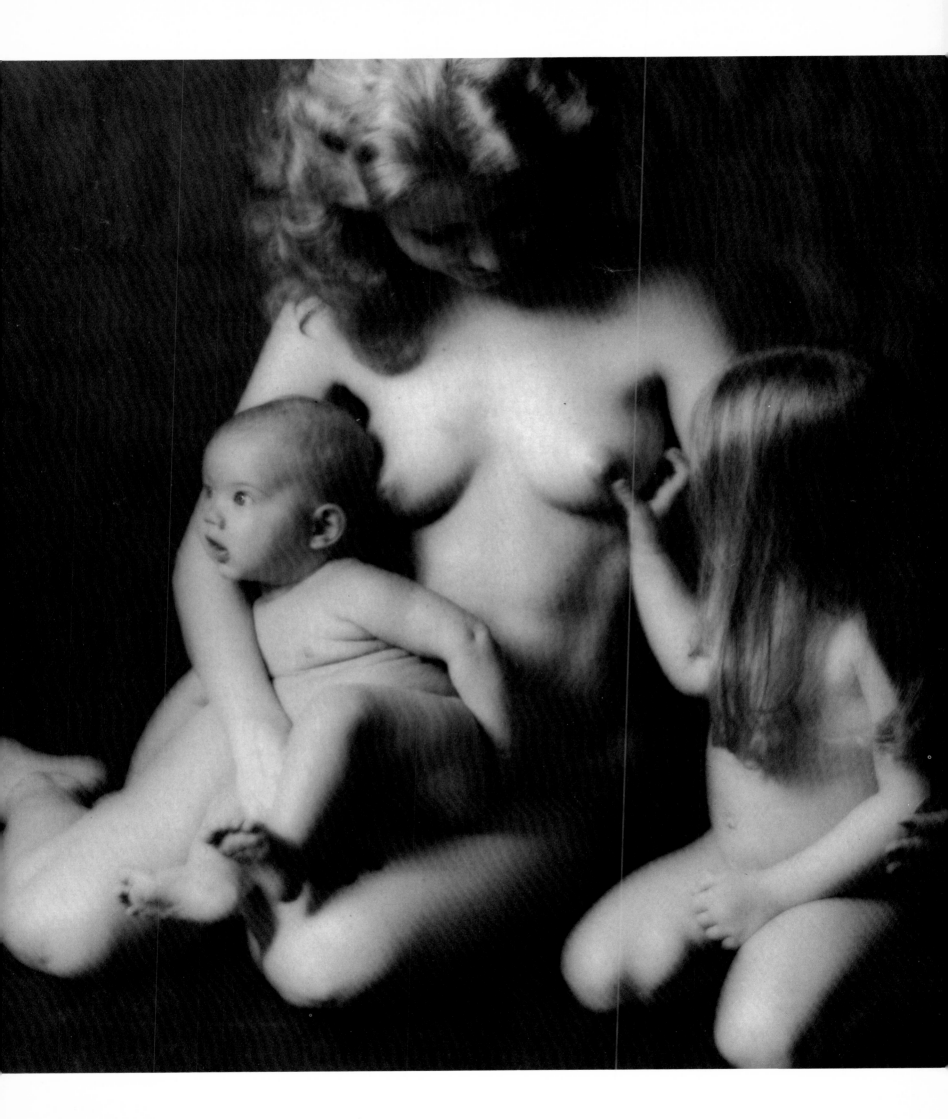

without resulting in the grainy quality inherent in the faster films. Furthermore, I could work with it in the darkroom to achieve the effects I wanted, for its chemical properties permit the photographer to manipulate the negative into an interpretation satisfying to his inner vision, his photographer's "eye."

I have already mentioned the Greek concept of the human body. I suspect that as I approached the creation of this book, I had in mind, unawares, that quality of Greek sculpture which (whatever it may have been for the Greeks) is known to us in monochrome. So perhaps, ultimately, without knowing it, I was seeking in black-and-white a means to this end.

I cannot close without a word about the enormous and invaluable contribution of my models. They were my collaborators, without whom this book could not exist in its present form. Many of them were amateurs—friends and neighbors; those who were professionals were totally unaccustomed to this type of photography and its needs. I gave them a minimum of direction, and that only to get each shooting session started. The spirit in the photographs is the spirit they then brought forth as they moved naturally and with spontaneity into the creation of these works.

Perhaps the happiest of all were the children, especially when they were photographed with their families. Many times shooting was interrupted as they raced from the set to other parts of my studio/apartment, only to come tumbling back moments later, pensive or laughing, into the range of my camera.

I cannot overstate my appreciation to them all, adults and children, amateurs and professionals alike, for the privilege of working with them. Since some of the models prefer the privacy of remaining anonymous, I shall name none of them; but I thank them all.

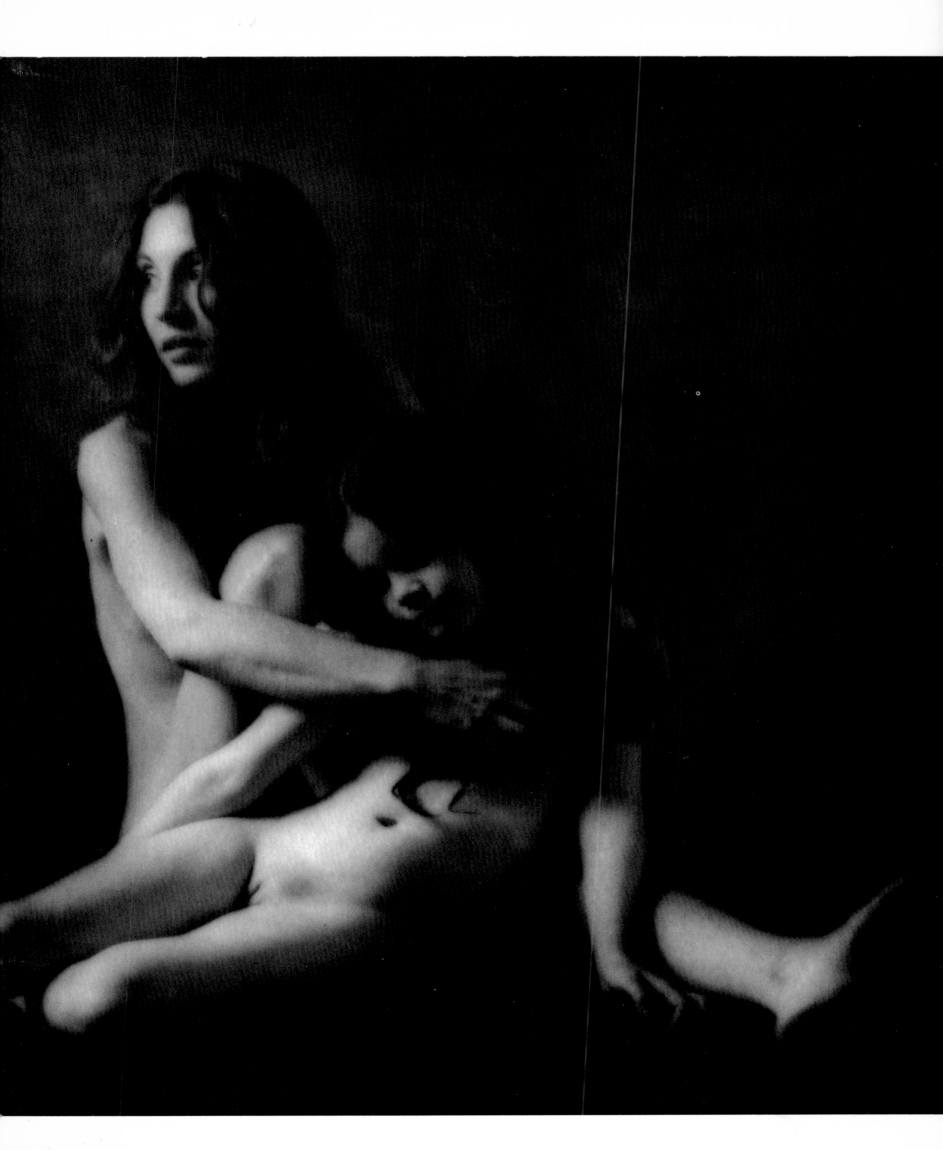

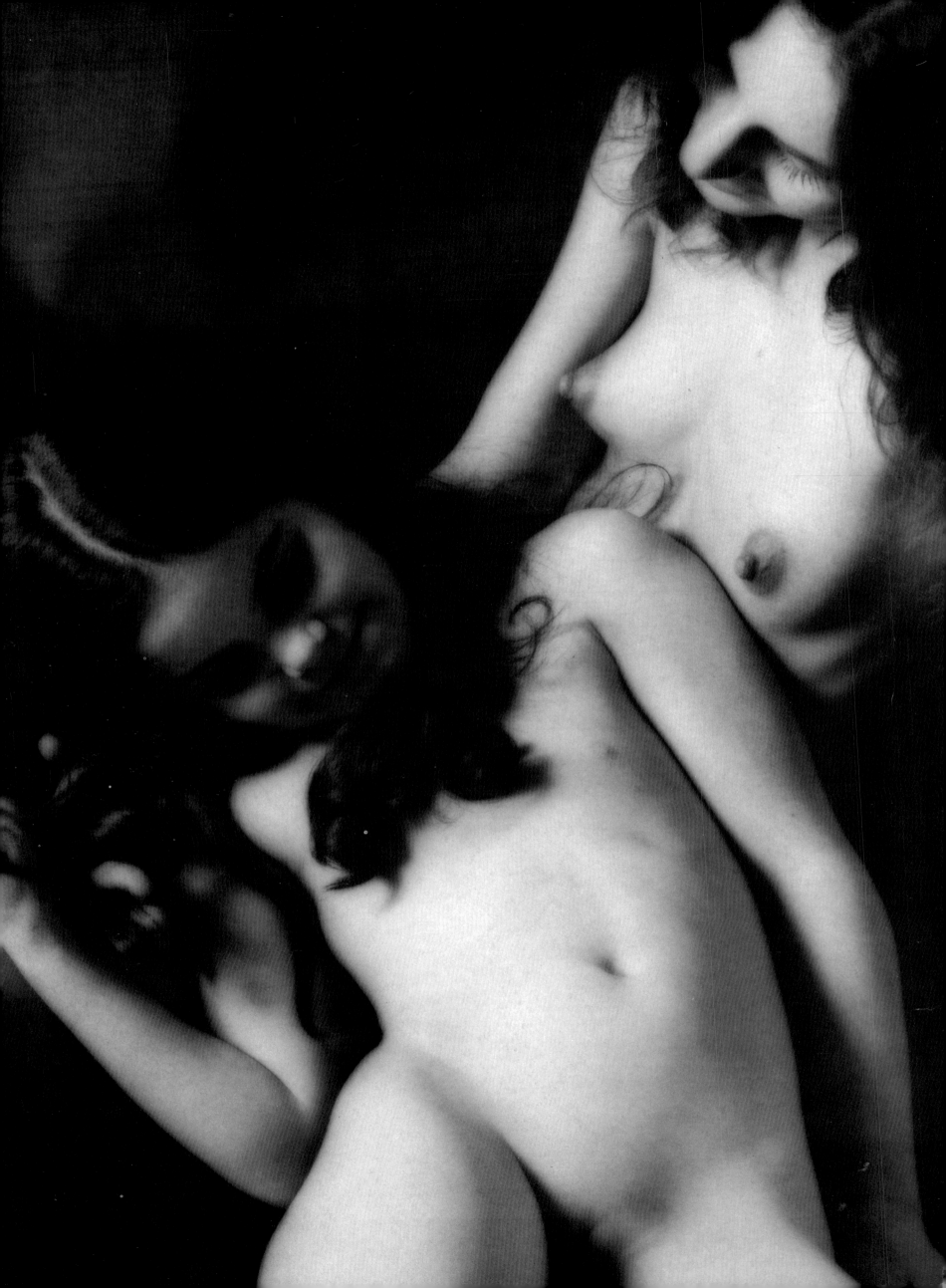

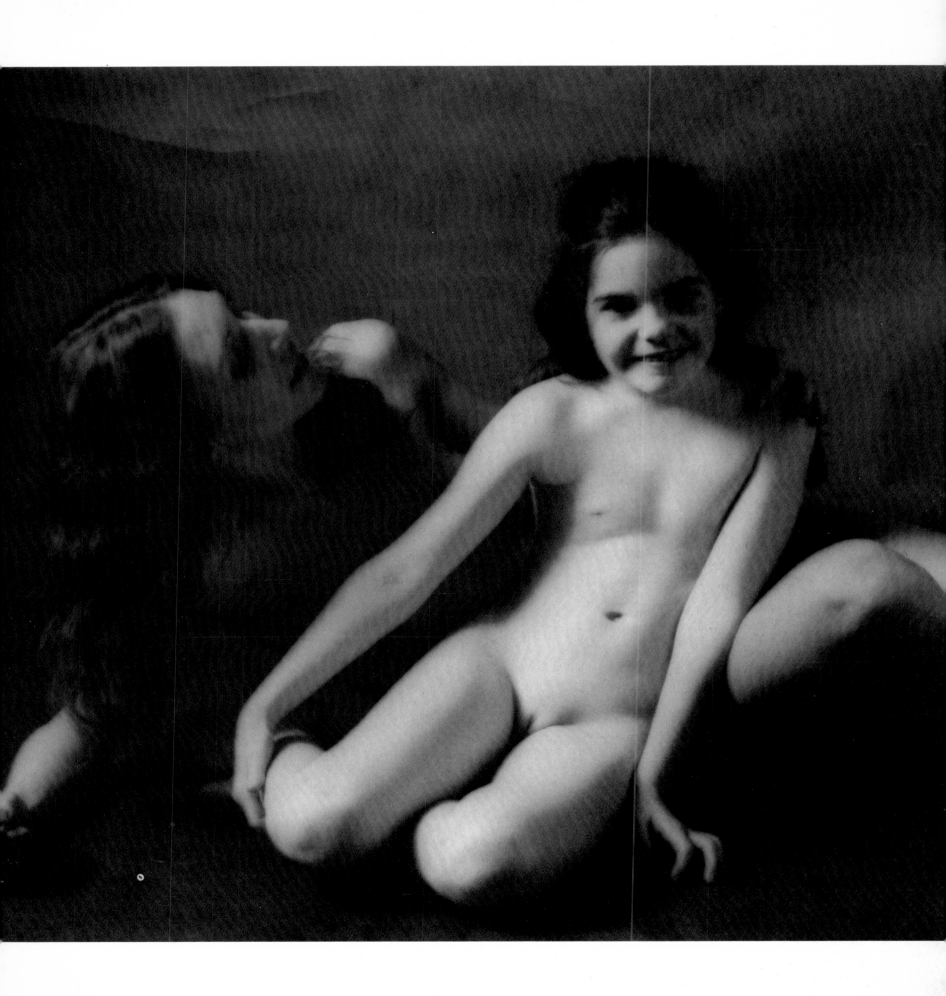

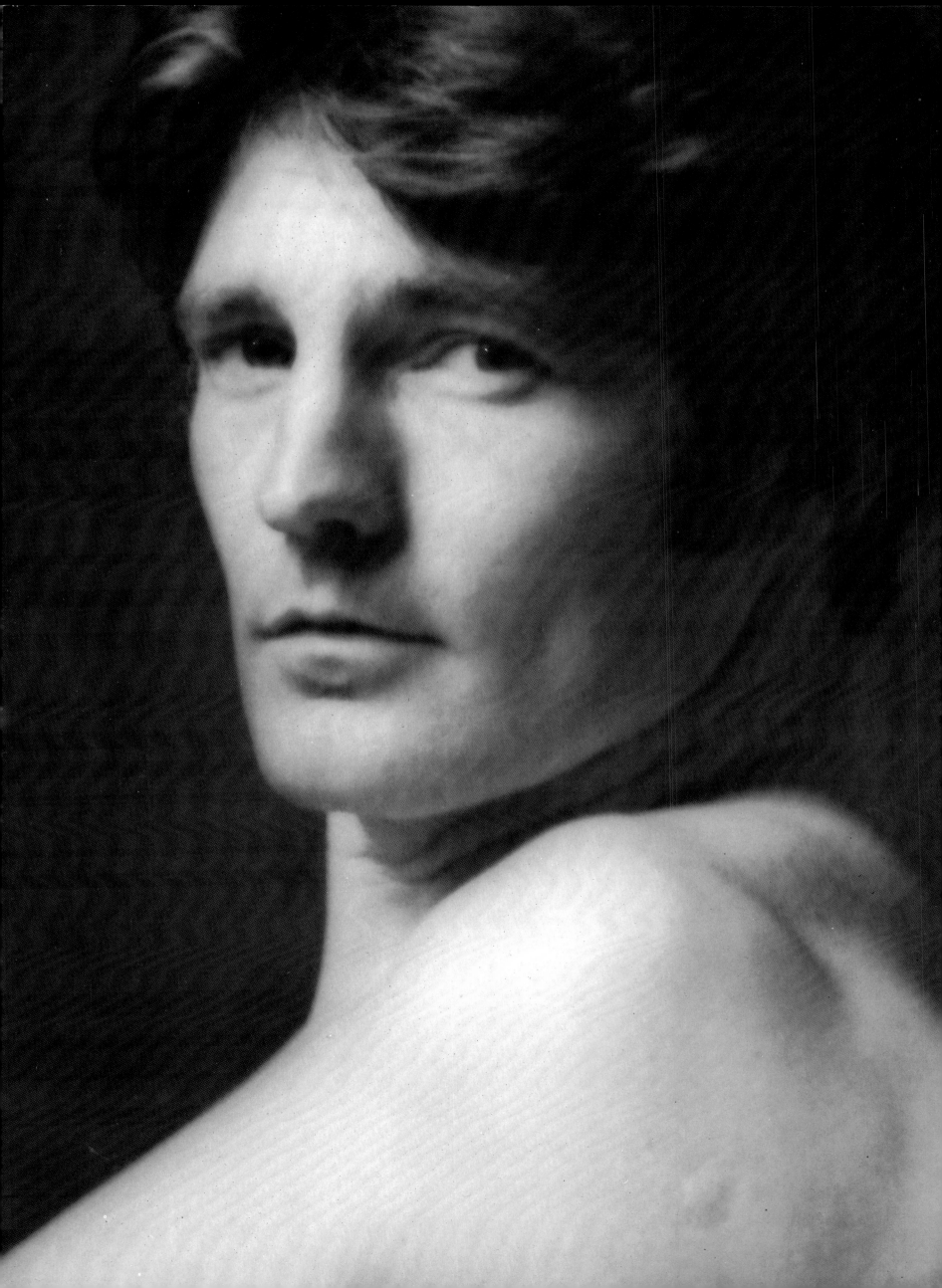

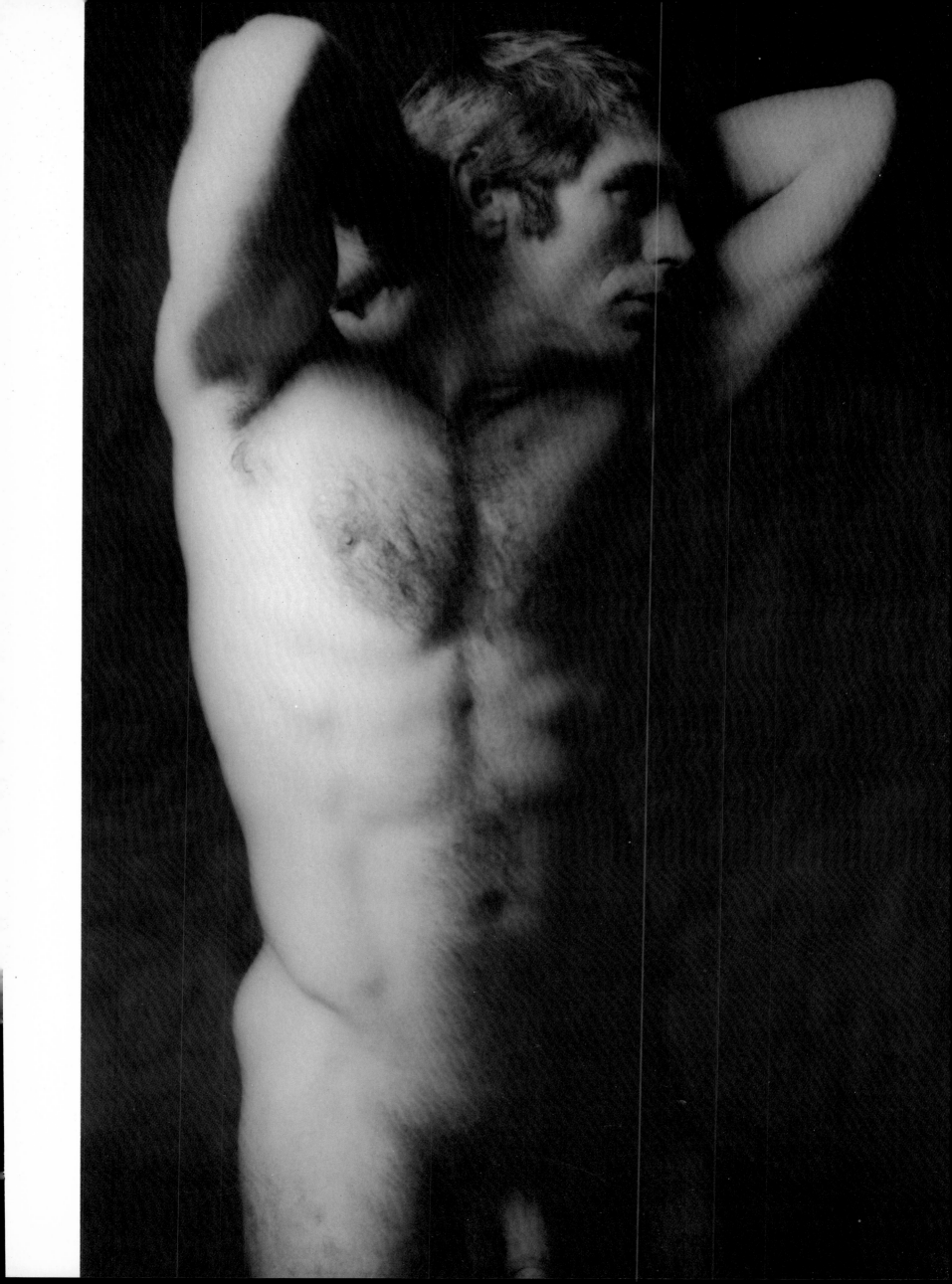

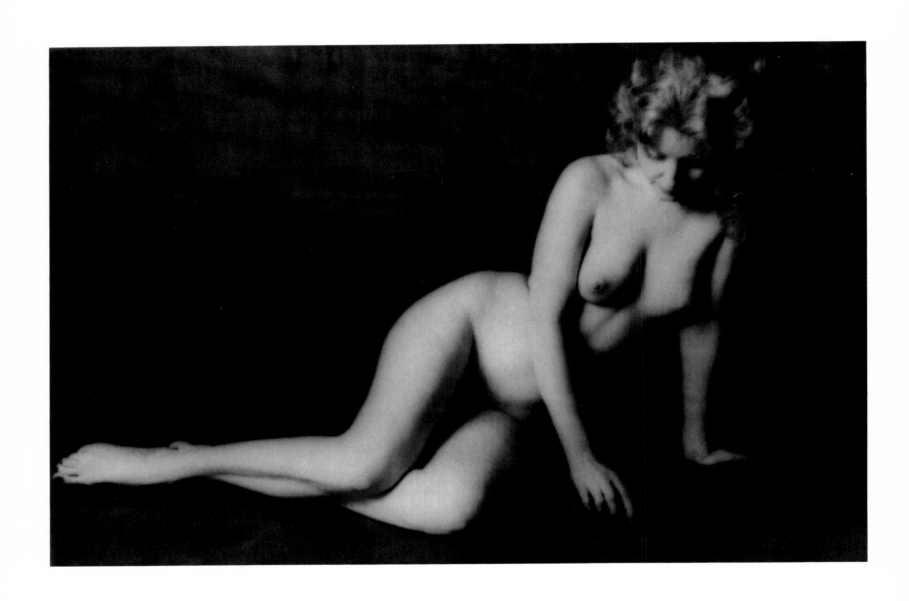

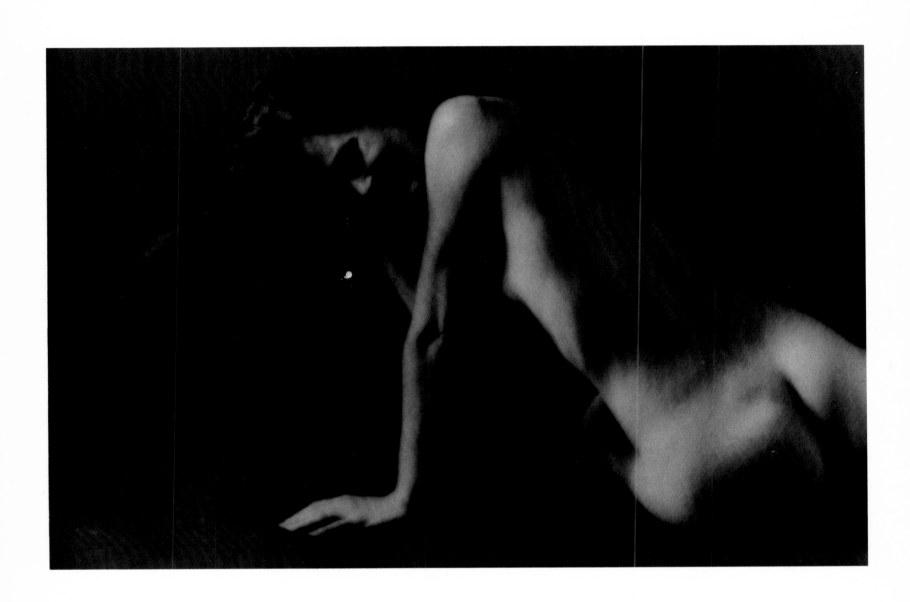

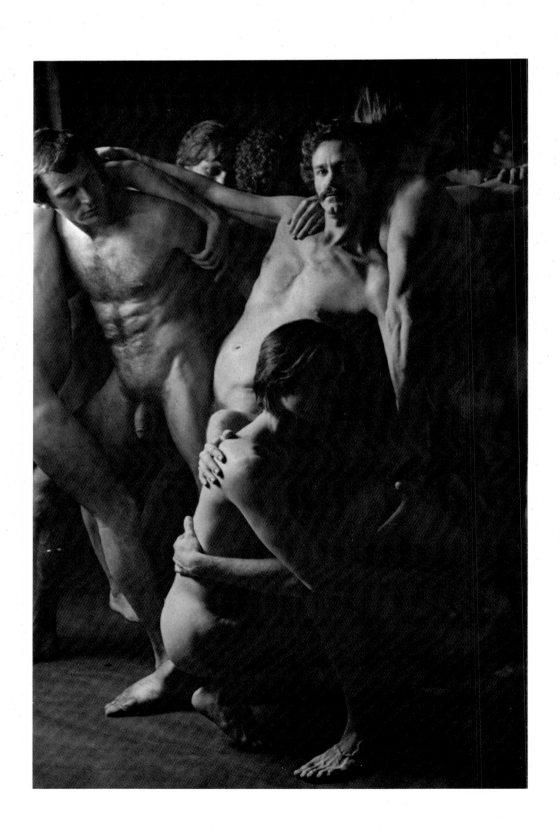

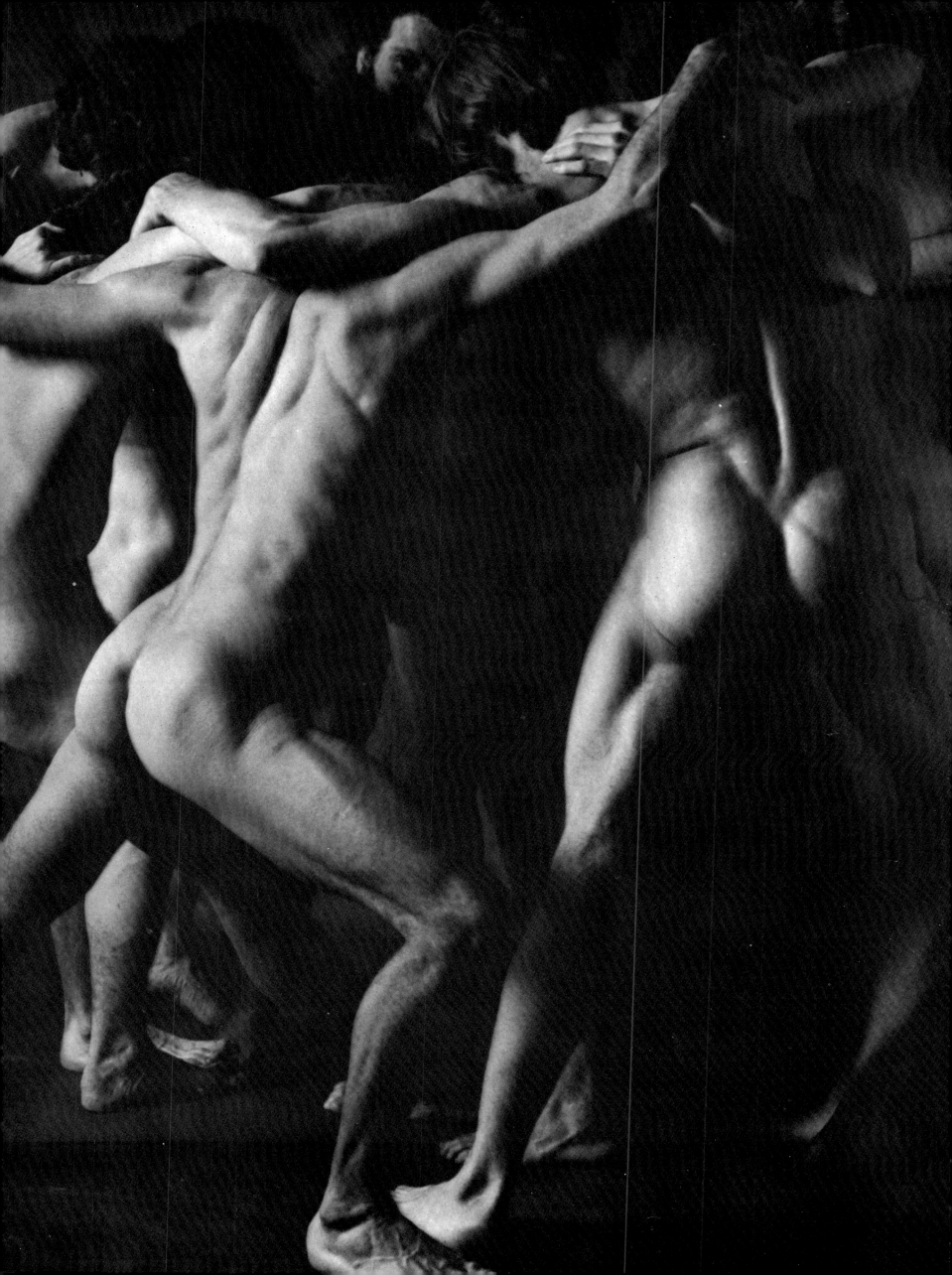

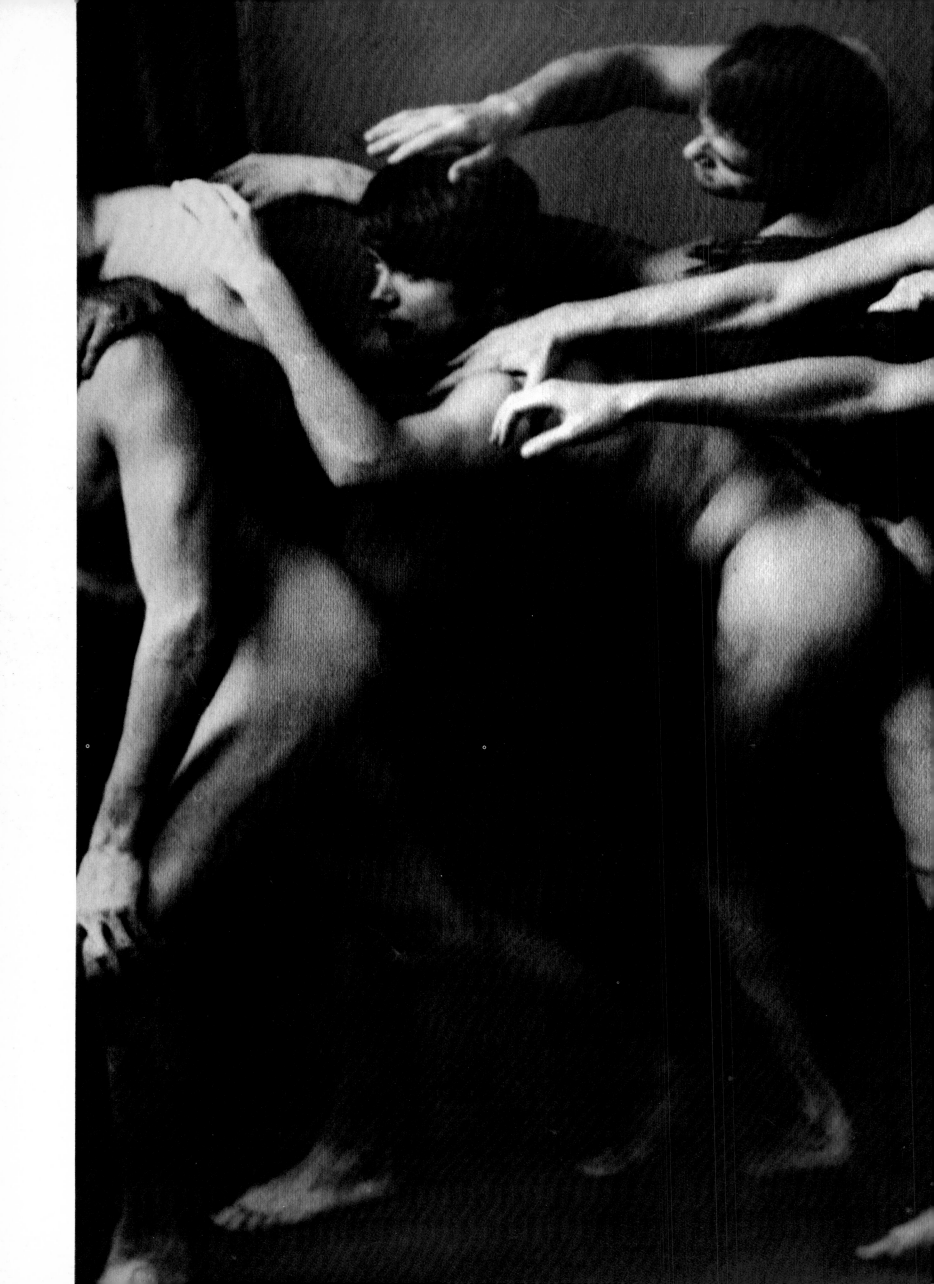

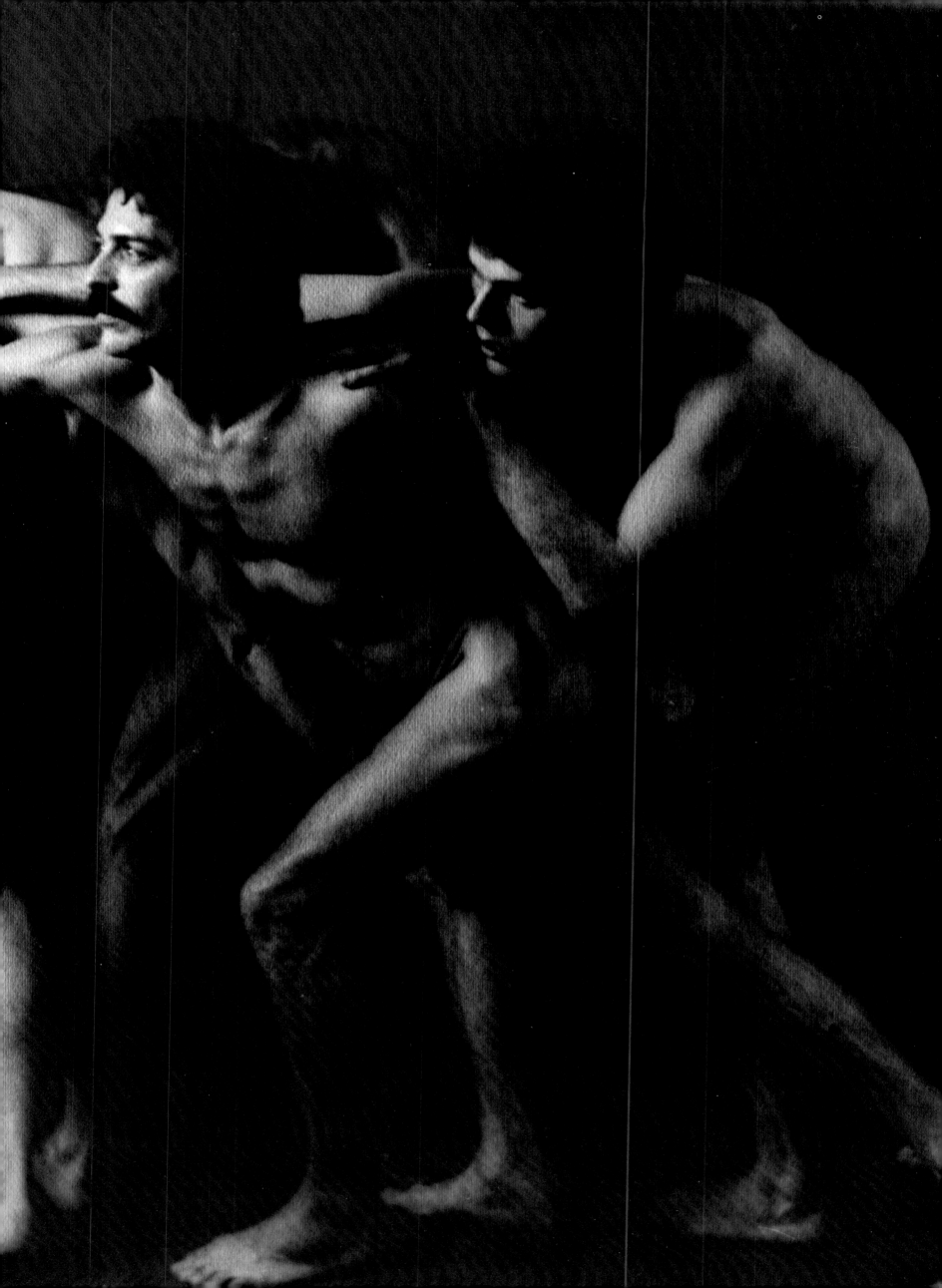

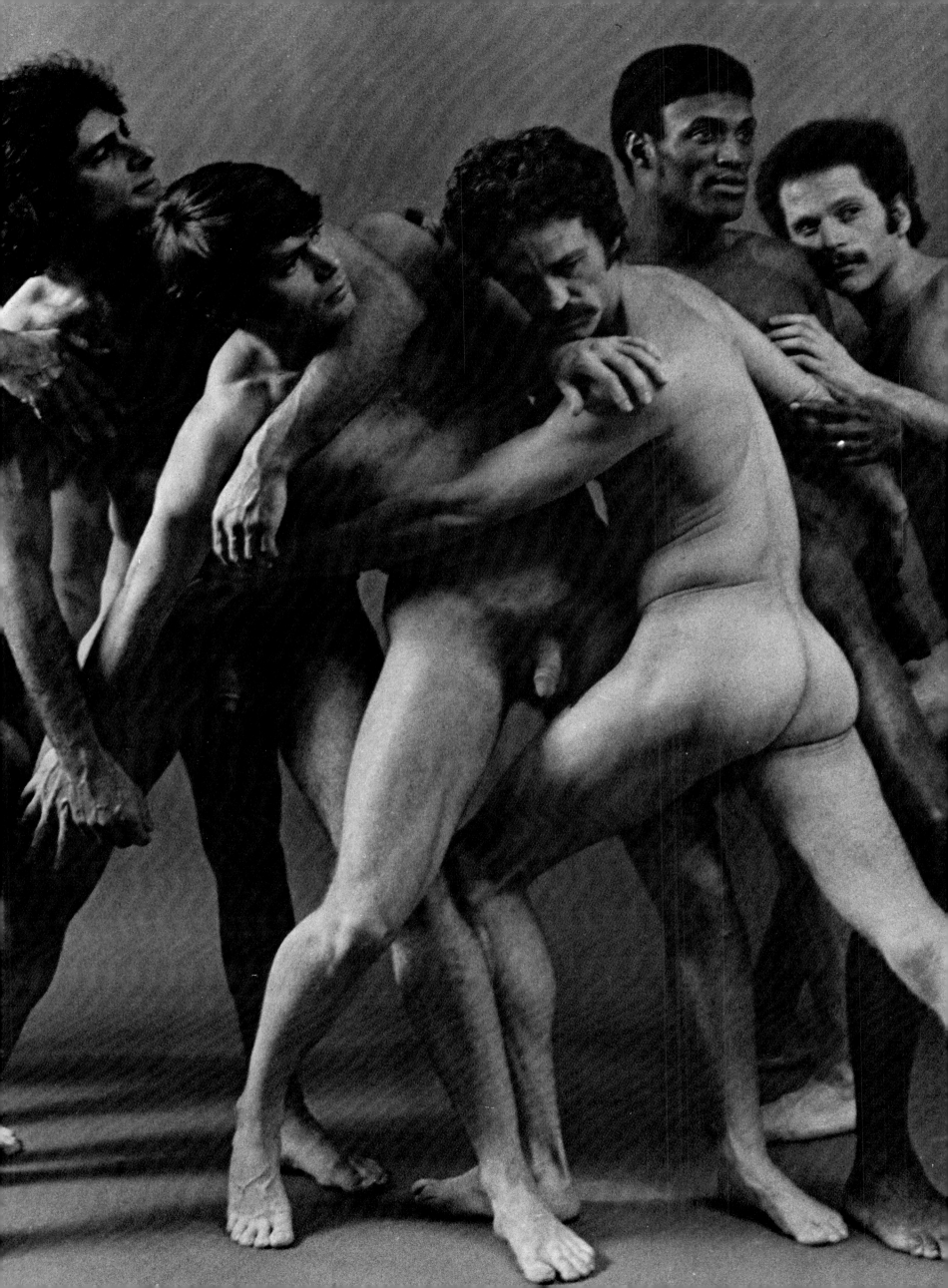

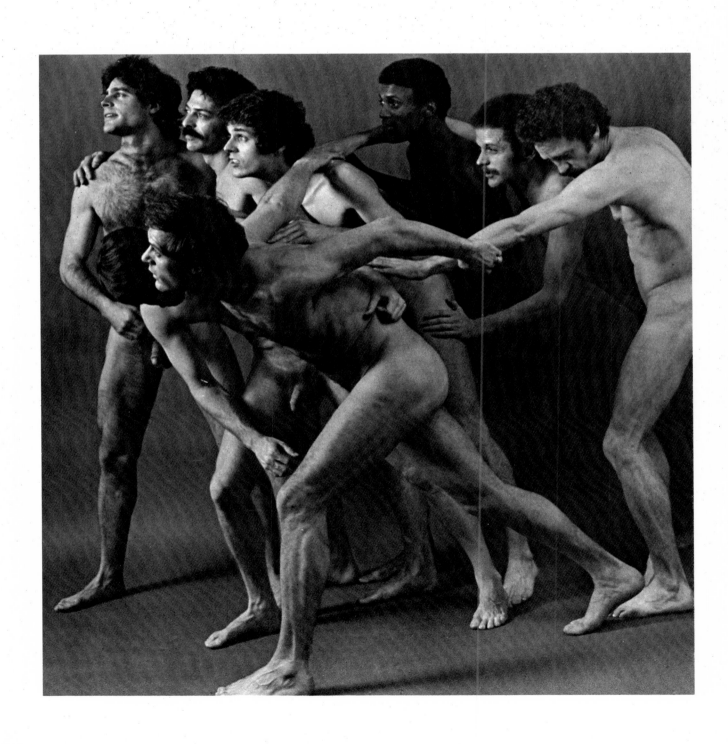

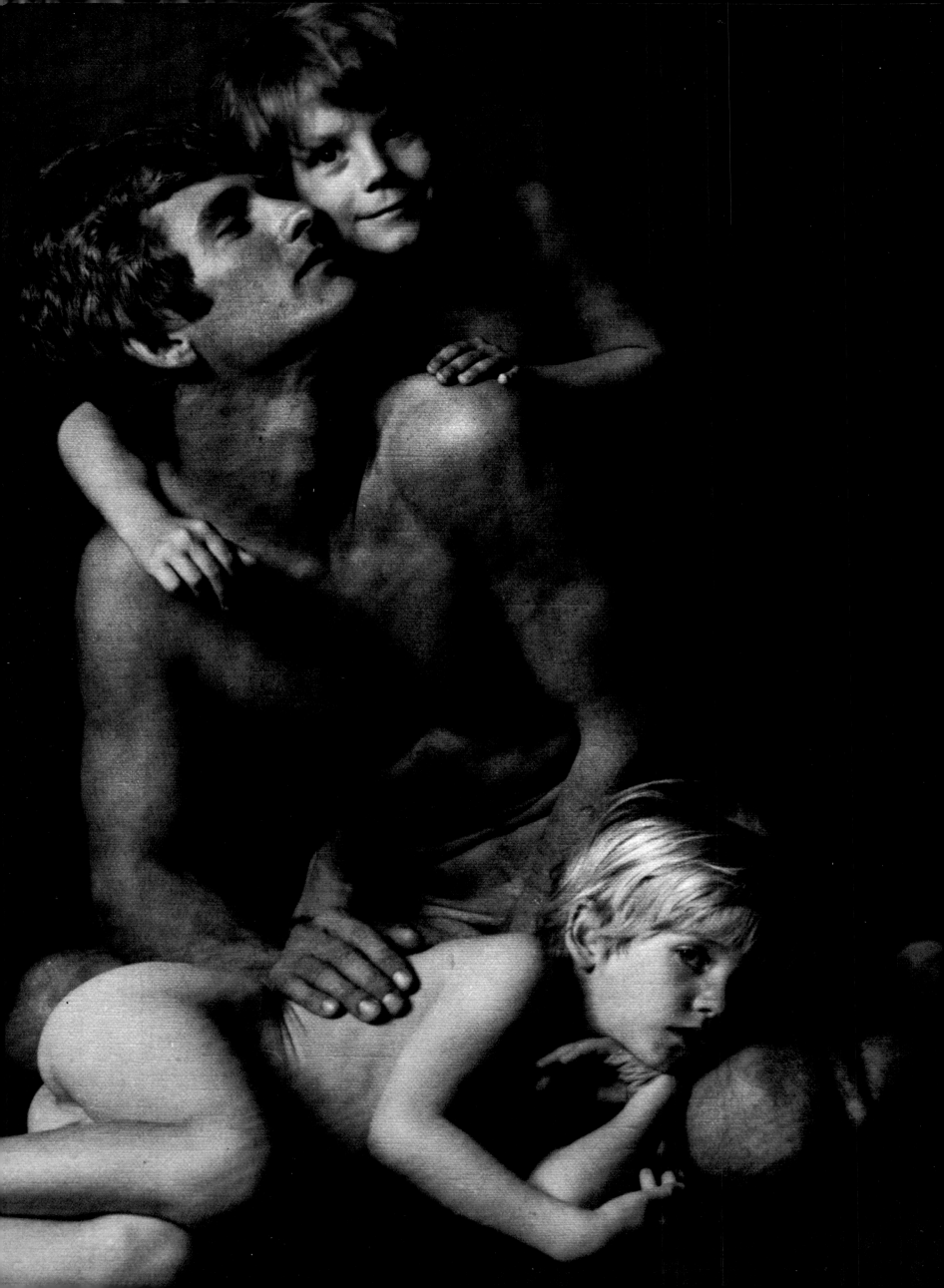

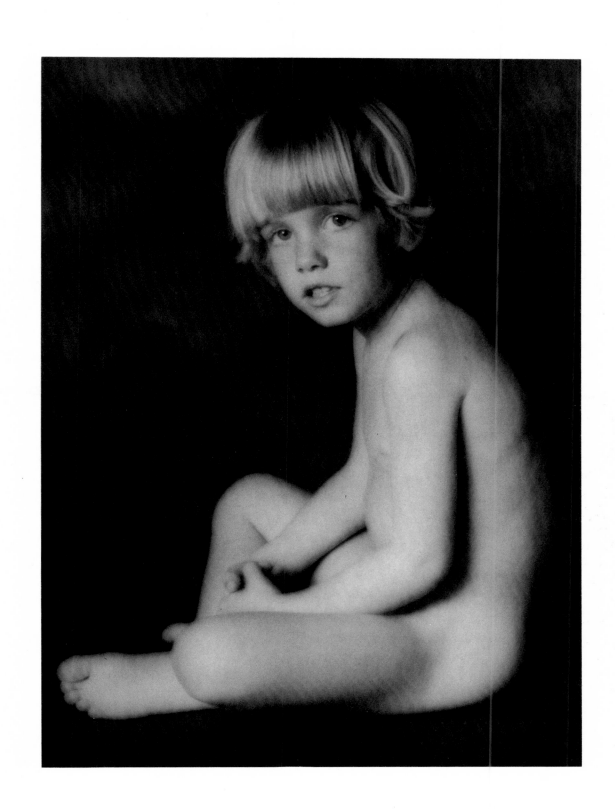

olor film first became known and available for widespread use shortly before World War II, a century after black-and-white photography had become commonplace. Millions of dollars had been spent over a period of many years to develop color; word of its wonders was already widespread well in advance of its introduction at the World's Fair of 1939. Thus the actual appearance of color film—available to Everyman and Everyphotographer—was greeted with great enthusiasm by an expectant public, with good reason: the addition of color offers a particular delight for the visual sense, and the eye is ever so grateful for this pleasure.

Because color photography is so popular, vast amounts are used by the media, not only in photojournalism but even more importantly in advertising and fashion photography. Not surprisingly, much of this enormous mass of work can without the slightest unfairness be described as undistinguished. This is unavoidable in mass photography, and to me it seems irrelevant to photography as an art. In photography as in other forms, it remains for those who are concerned with artistic potential, and are willing to master the techniques of their craft and move beyond them, to bring forth the fullest recreative and creative possibilities of the medium. Such work need not carry the label "art"; many of the famous photographers whose work is found in our magazines have been able to achieve splendid work even within the limitations of commercial and advertising requirements.

The satisfactions of color as a medium for photographing the human body differ from those of black-and-white. One can never totally exhaust the potentialities of color for revealing the texture, musculature, and tonal variations of the skin. With it, one can see the blood beneath the skin, the bluish overtones of pale flesh. Color photography offers an emotional experience different from that of black-and-white: a recognition of the eloquent subtleties of hue similar to those revealed in the

paintings of certain of the great Flemish and Dutch masters. When color is related to the psychology and mood of the work at hand, it can heighten excitement, enrich visual sensation, and transform the very nature of the subject.

As I mentioned earlier, I like to photograph Man. I like to photograph life, and the nude is part of life, infinitely varied and expressive. Color film records more than the ordinary eye sees; in its visual penetration, it uncovers what only the greatest artistic geniuses were able to see and reveal to us hitherto. Juxtaposing the two arts of painting and photography, we can see echoed in contemporary photography the tremendous "eye" some painters had for color and its aesthetic and pictorial values. Today's color photographers combine their technical repertory of chemistry, lighting, darkroom techniques, and cropping with the aesthetics of composition, form, design, mood, and the all-important "eye." That "eye" is a fusion of concepts, the photographer's own taste, his ability to transmute them into the finished photograph. Finally, perhaps most important of all, the "eye" is seen in its ability to select from among all the works he shoots the ones that are truest to the photographer's inner vision.

In the color photographs for this book, I wanted the human form itself to be the source of color, without the distraction of excessive color used outside the figure. I have therefore used one simple light source and the same background as I did in the black-and-white photographs that make up the major part of this book. At other times, with other subjects, I might choose to use rampant color in great amounts and with a freedom akin to that seen in Balinese dance costumes. But not here. Here I chose instead the controlled color representation of the human form as it has been treated in the formal and emotional traditions of Western art.

Photography is ultimately controlled by the taste of the photographer, which eventually evolves into a personal style; yet, as in every field, a mastery of technical problems is the prerequisite for such an evolution. The

solution to one problem always leads to a new range of problems, but technical mastery allows one to choose which problems to tackle. To simplify my technical problems in preparing this book, I used two cameras, matching my color film with a corresponding black-and-white film that could be shot at the same aperture settings and with the same lighting. Therefore, in shooting, I was able to switch immediately from one camera to the other, from black-and-white to color and vice versa, using the same strobe power for both. Despite recent improvements in film, there is still one major problem unsolved: the differing qualities of color emulsions in different batches of film. One can only hope that technical improvements in film manufacture will solve this in the next few years.

As many other photographers do, I usually develop my own film. When the color prints or transparencies begin to come from the darkroom, my excitement rises as I anticipate my first look at them on the light-box. Even if that first look is disastrously disappointing, the excitement heightens as each succeeding batch emerges. Here is where the photographer may discover the one significant shot he has been working for. Here is where the personal "eye" is called into action. And it is in this process of review—not once, but over and over again: selecting, rejecting, deciding repeatedly—that he must depend on that personal "eye." His work must stand or fall by it.

So far, these comments have dealt with my ideas, my craft, my goals, and my "eye." But ultimately, the value of the photographs in this or any other book depends on you, the viewer. If in looking at them you think that one nude has a Rubens-like skin quality, or another seems reminiscent of a Botticelli stance, if a child's face has some special quality or expresses a moment of life that resounds within you, it is because your inner consciousness has been moved; they were not preconceived as such. You yourself are at work, collaborating in the creation of these pictures. The quality of the film and the models have sparked a dormant memory—in you as they did in me—and have awakened your own "eye."

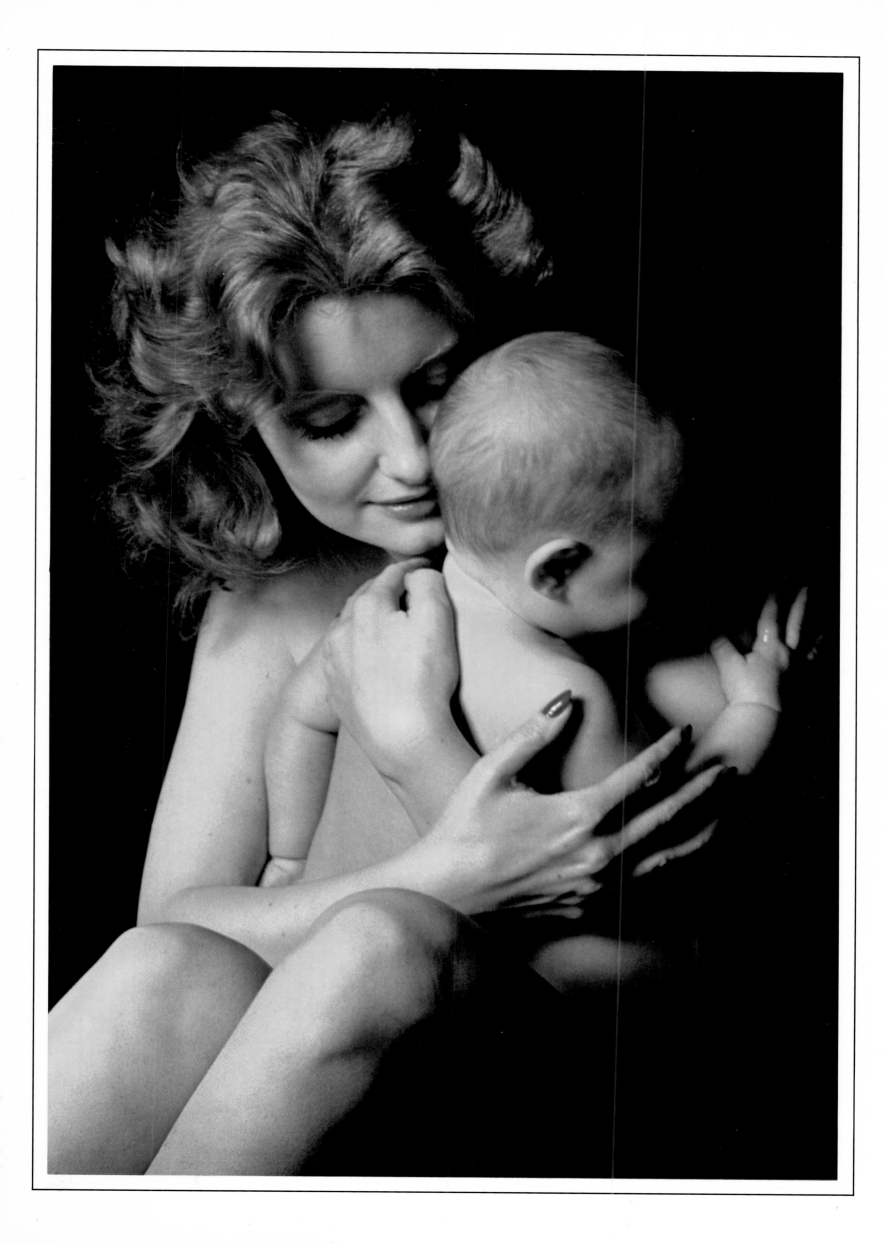

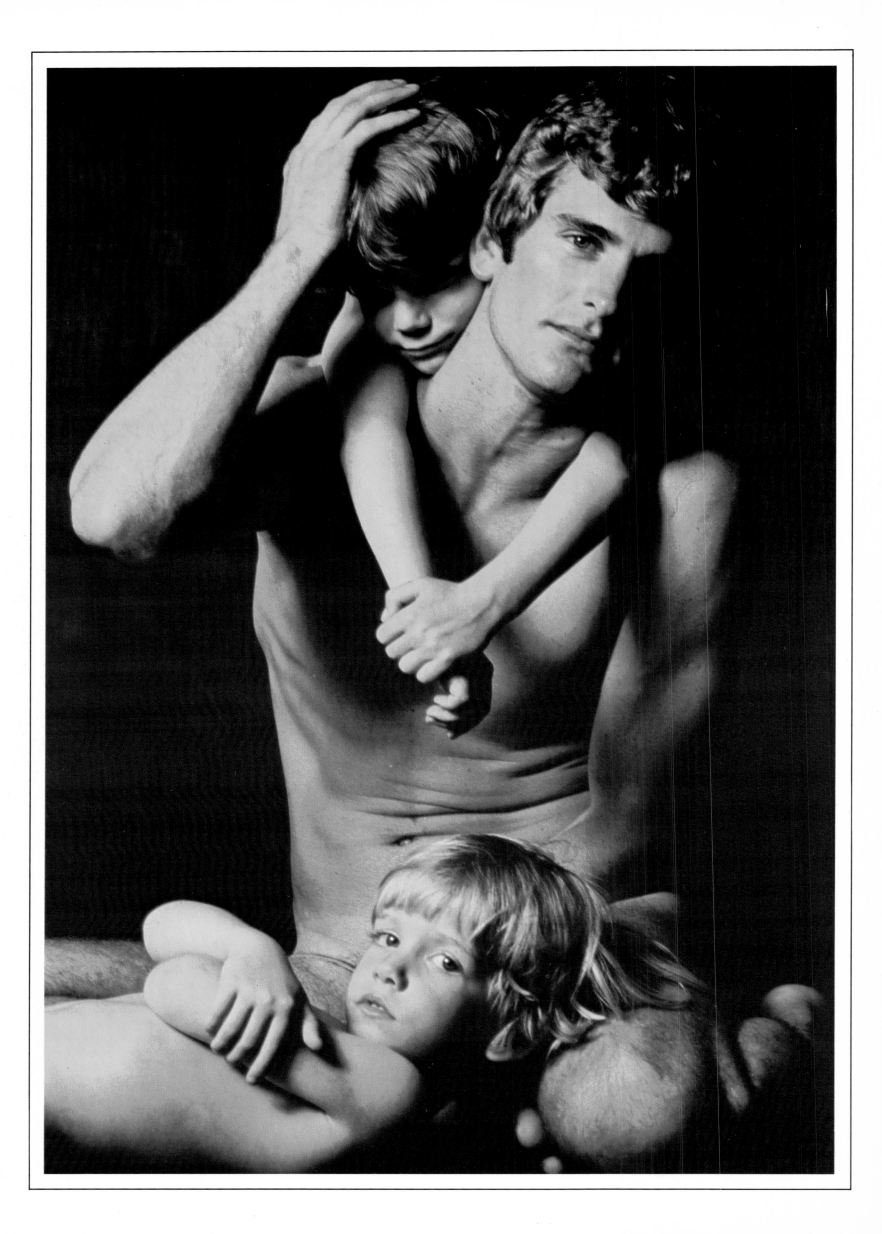

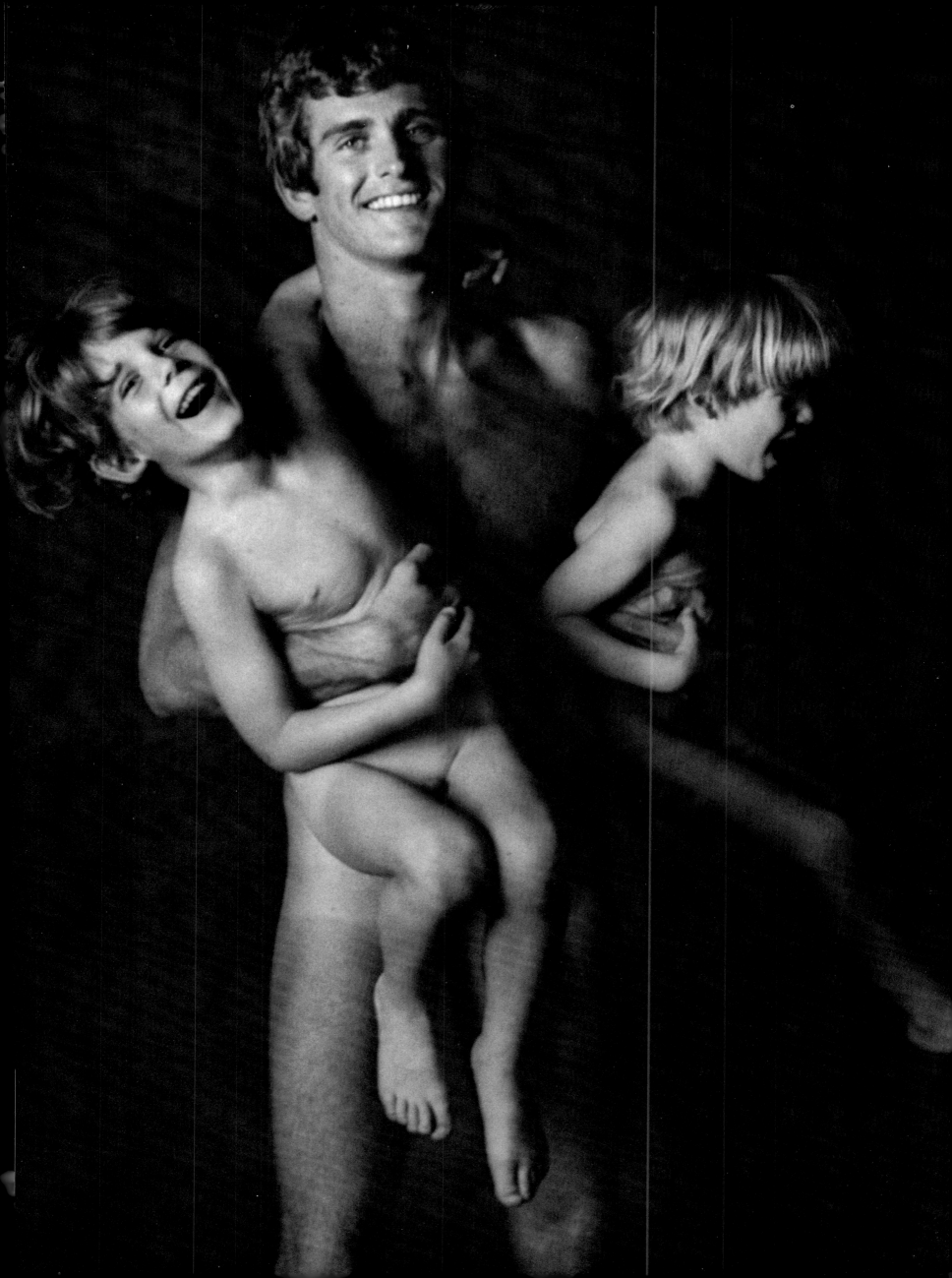

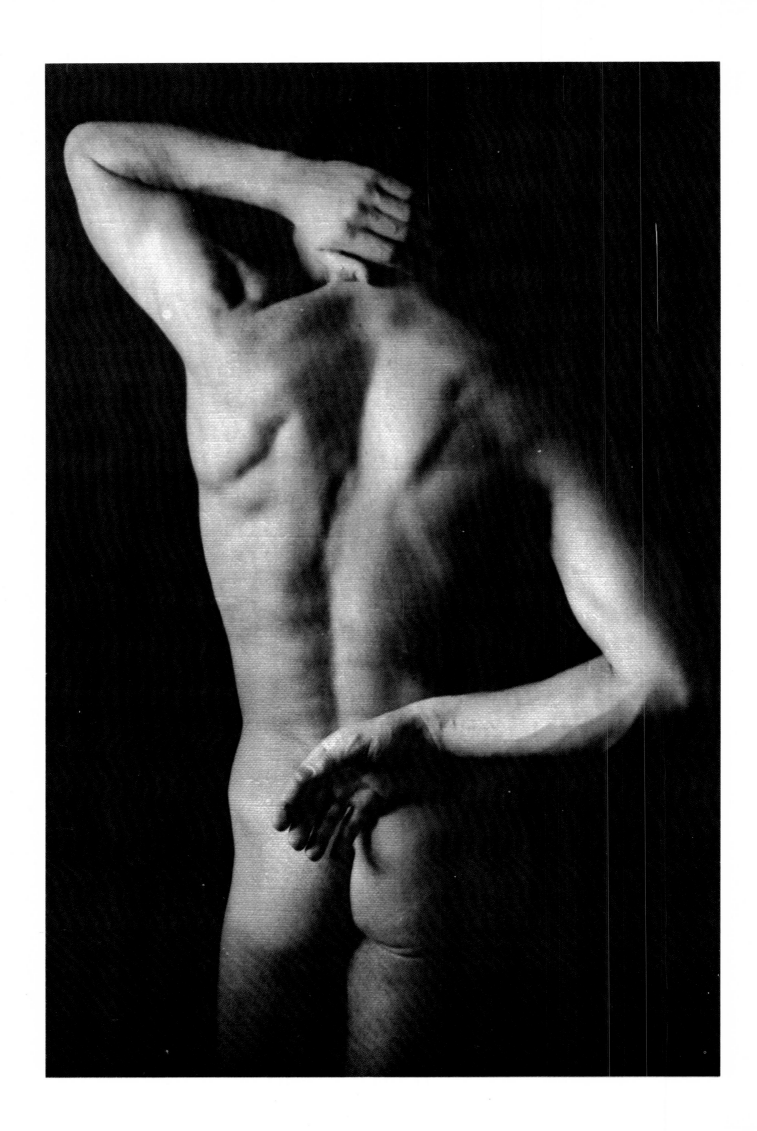

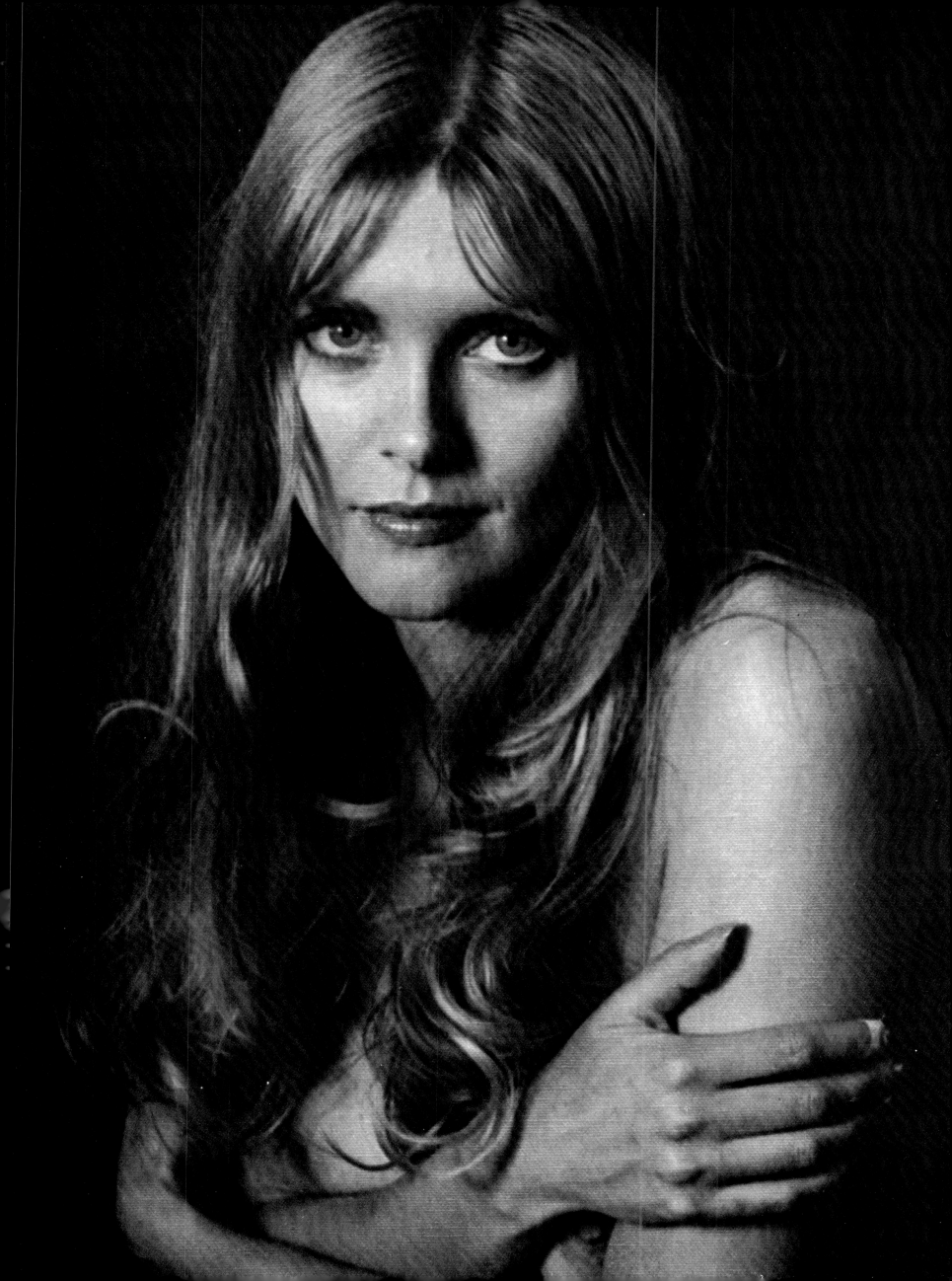

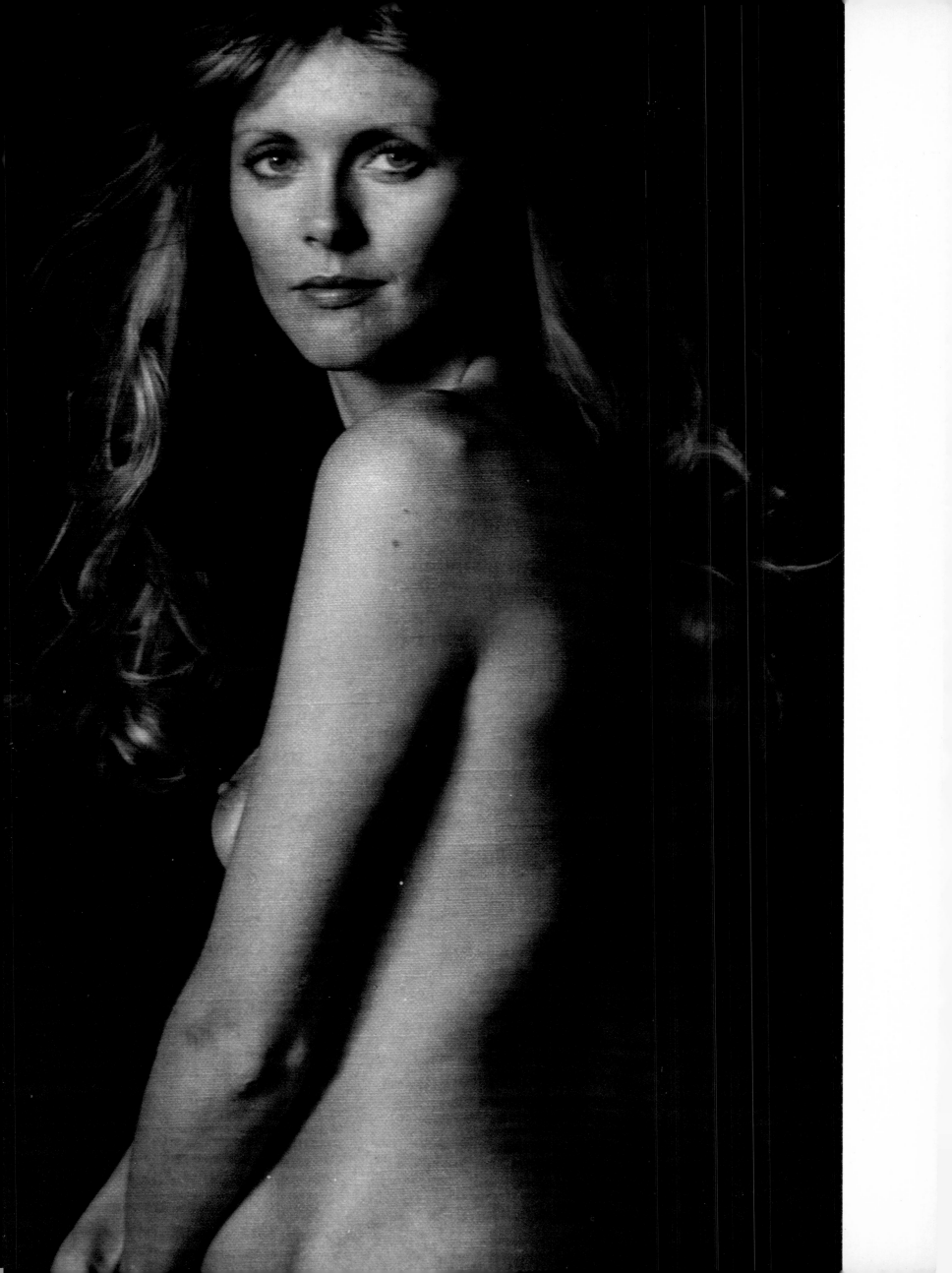

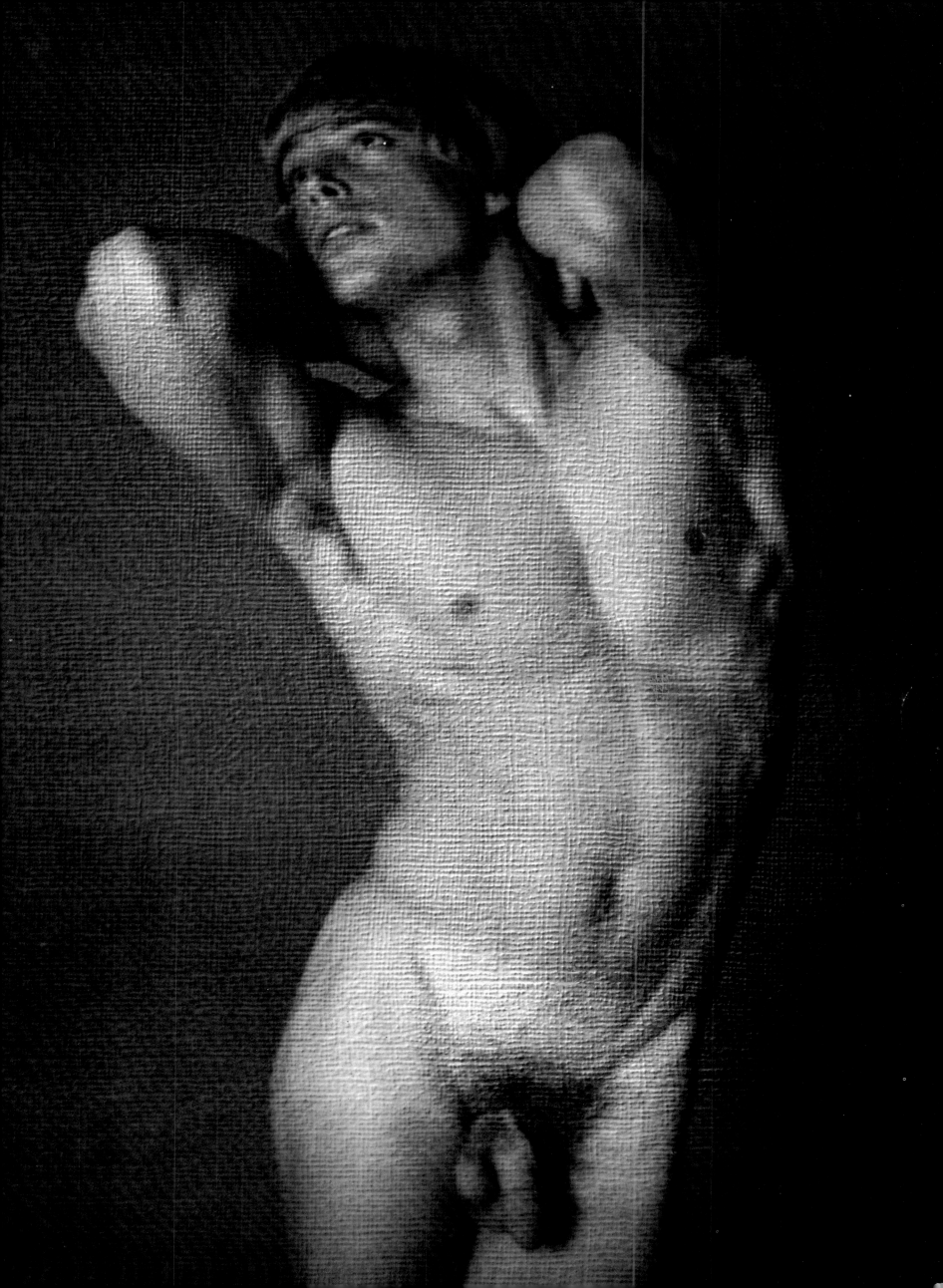

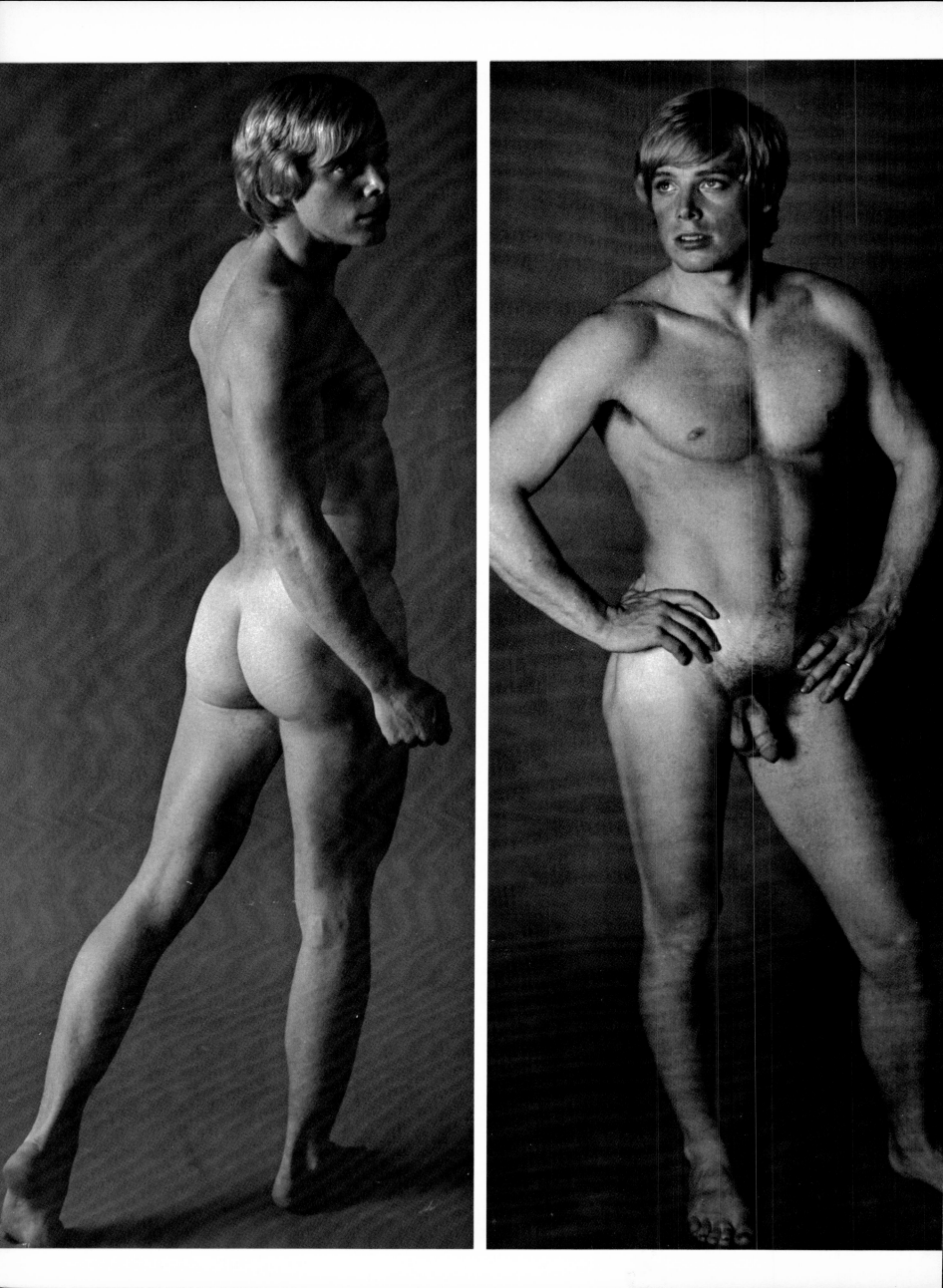

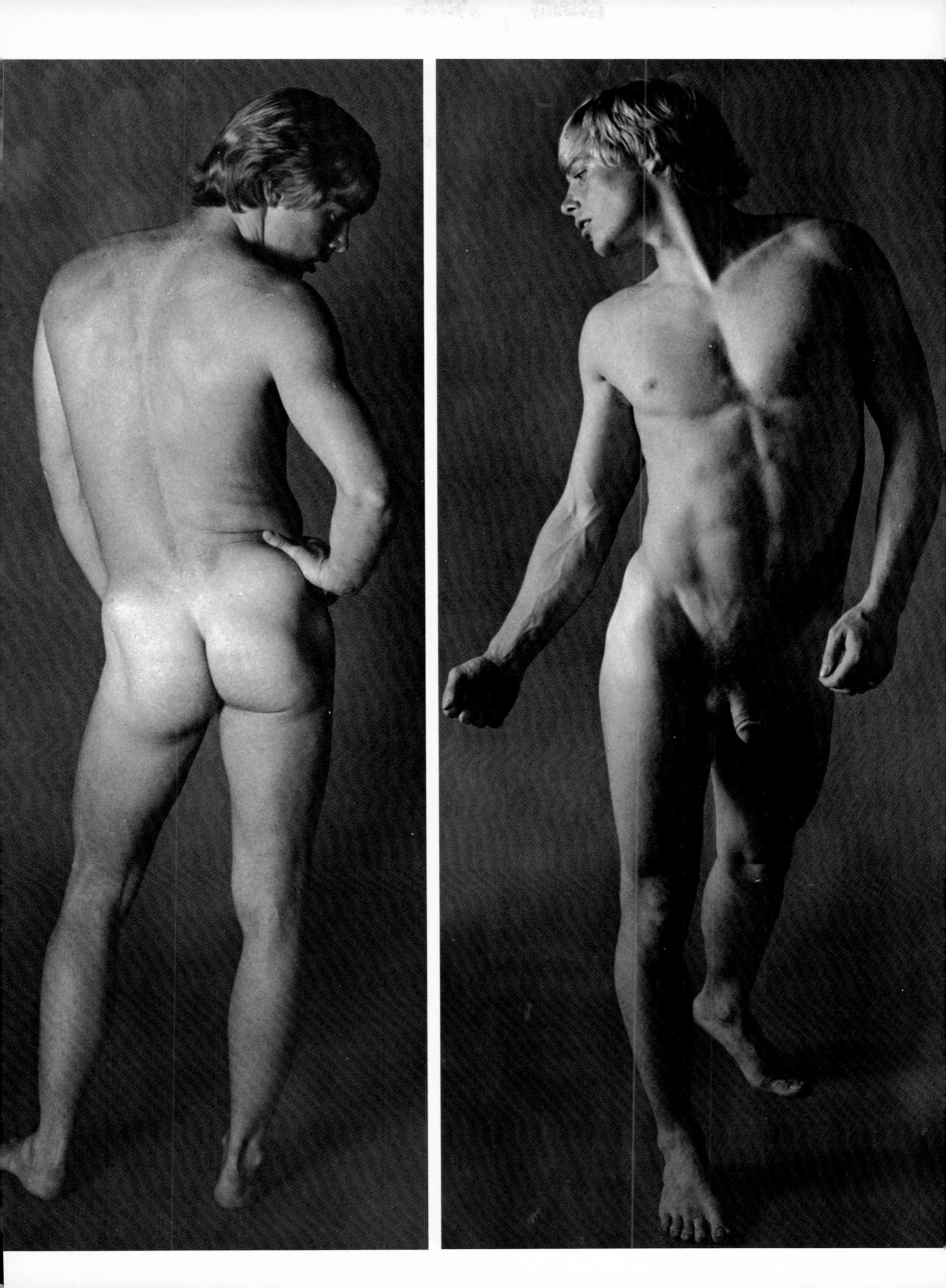

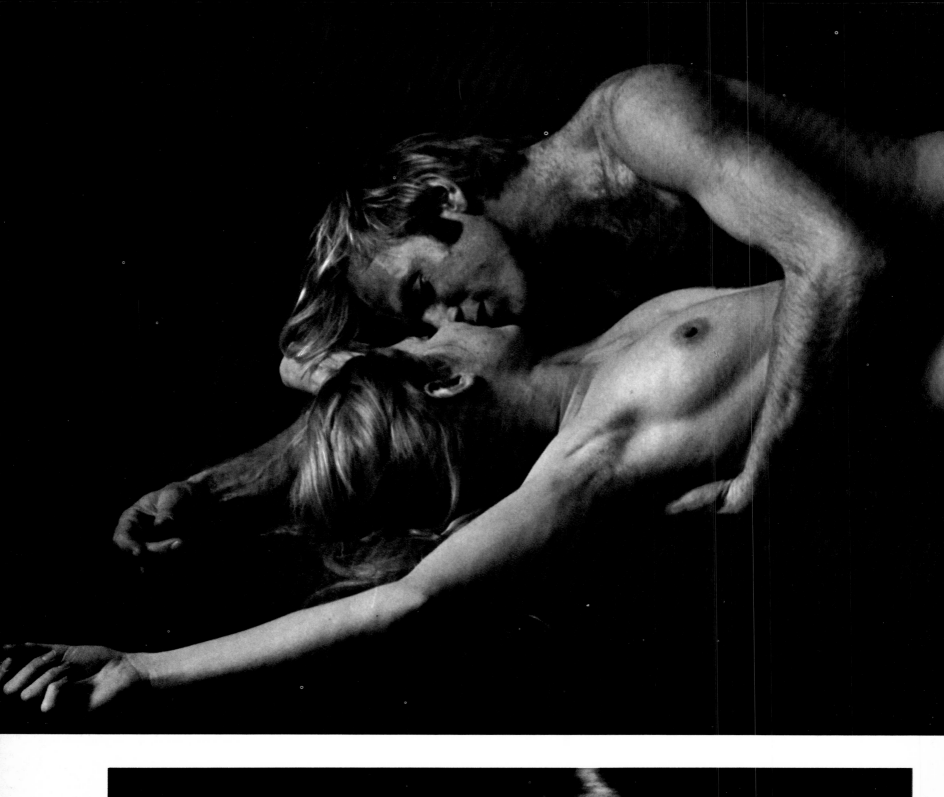
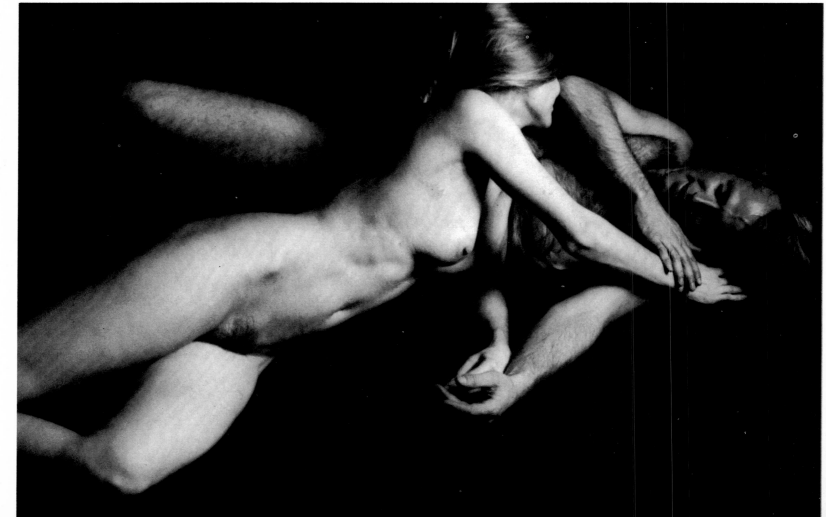

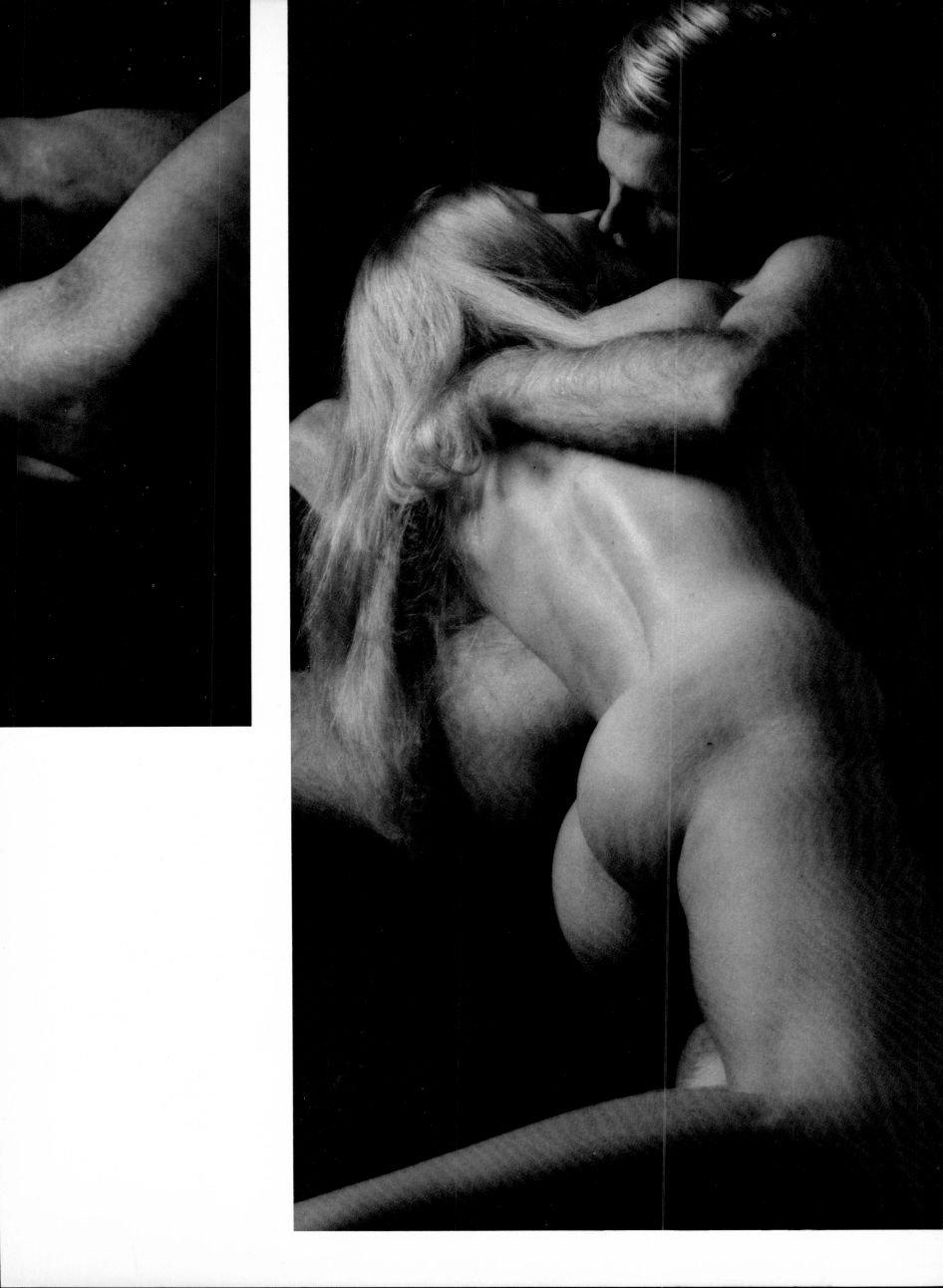

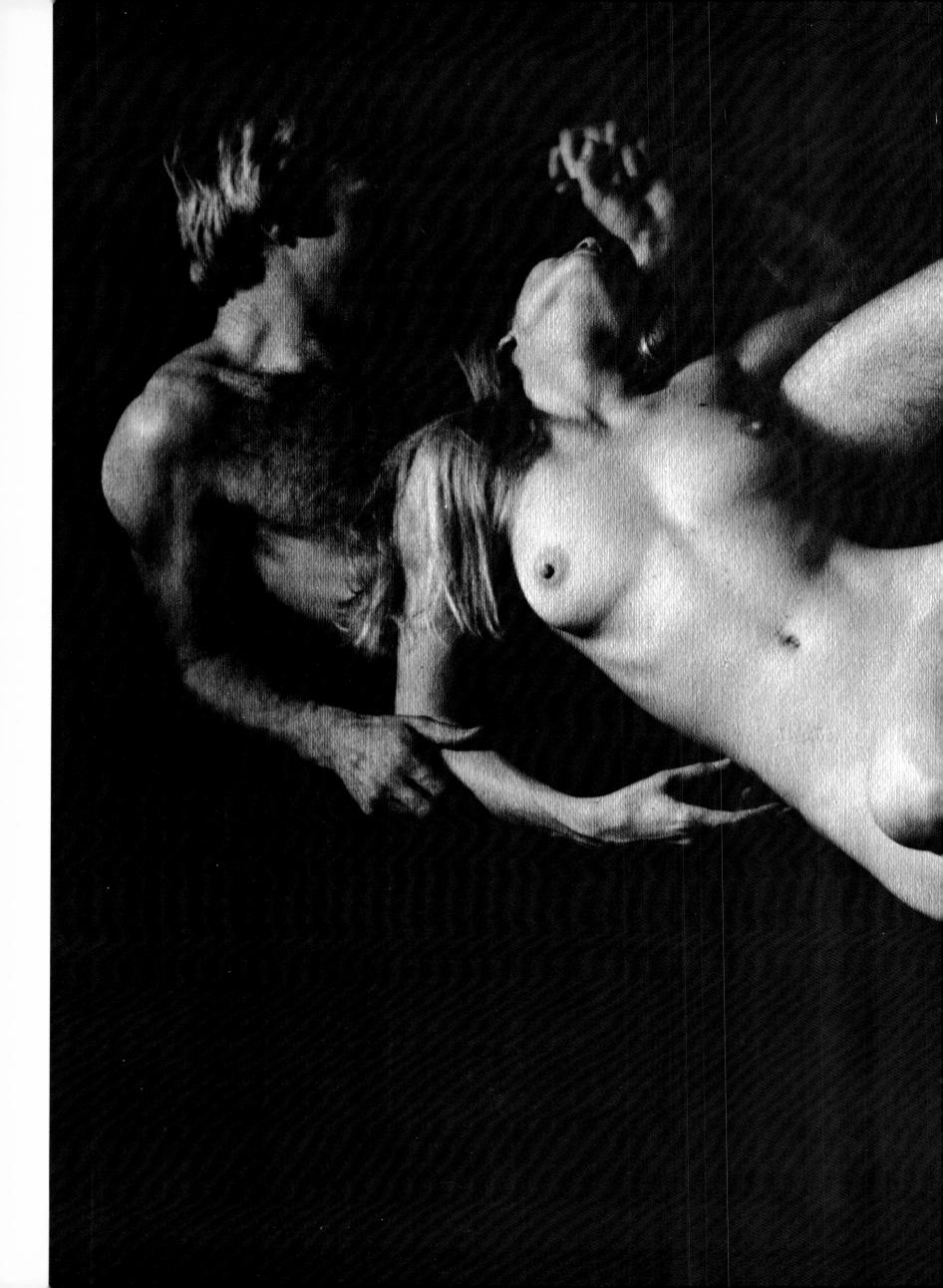

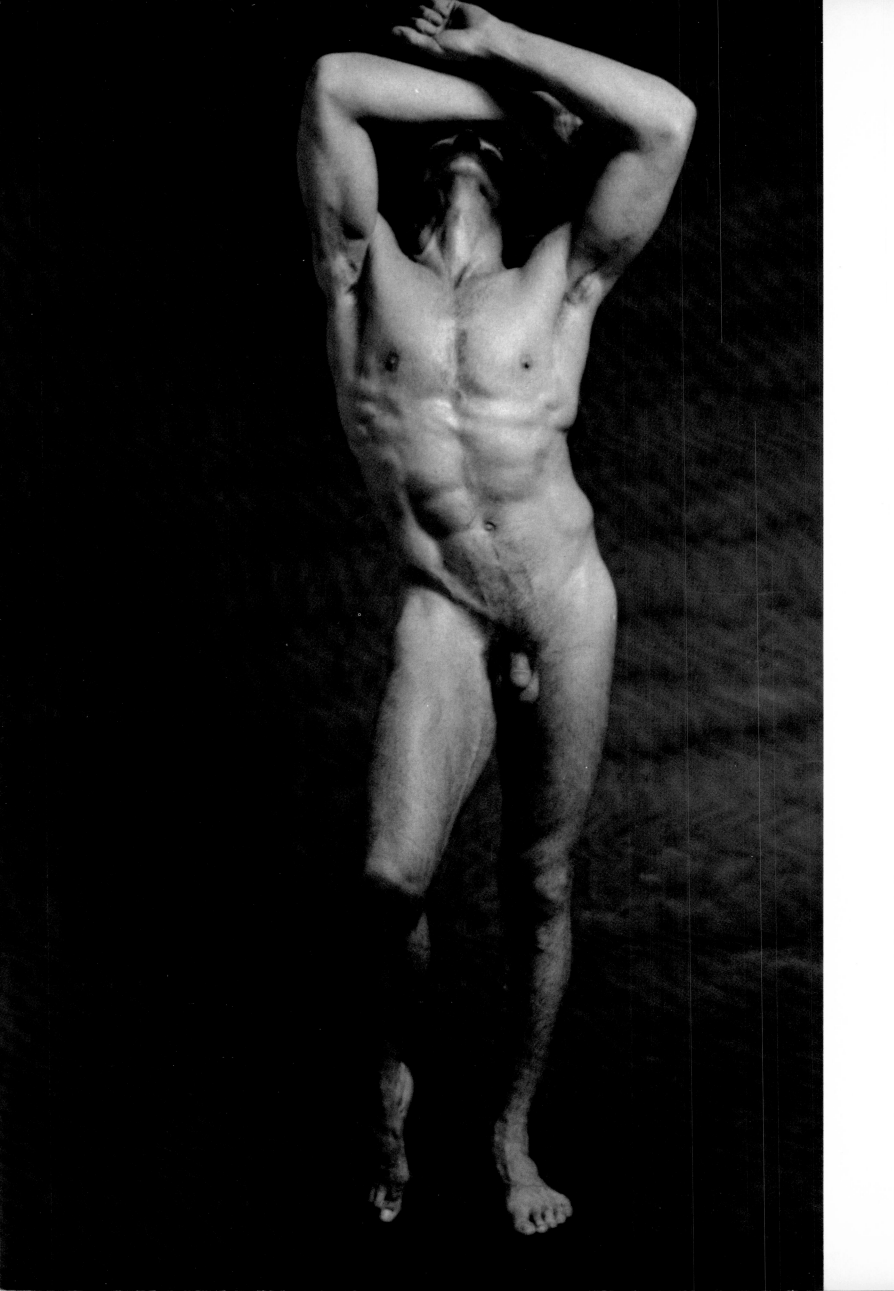

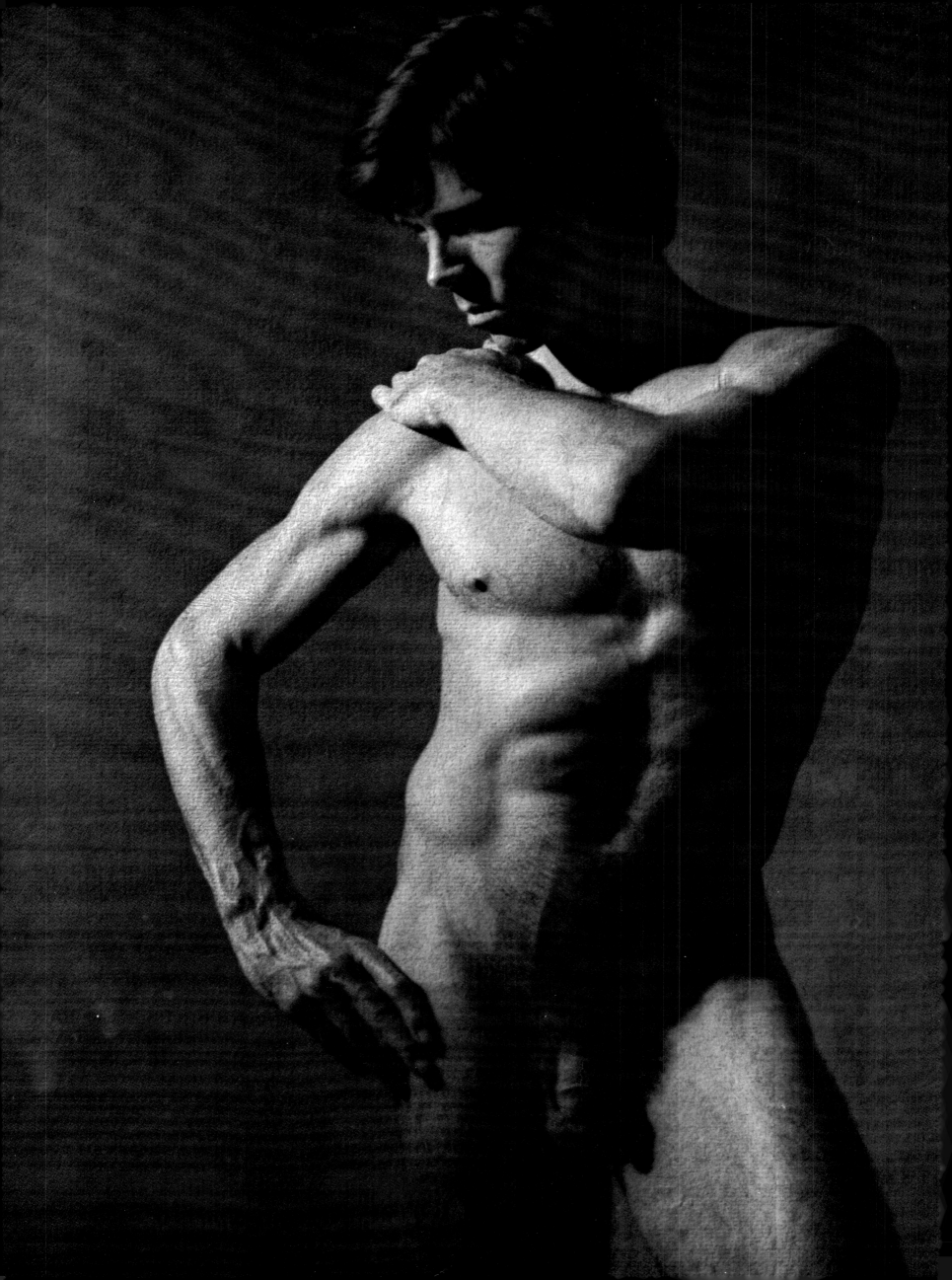

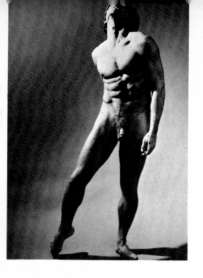
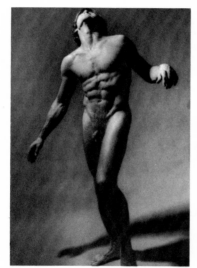
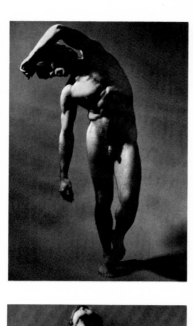
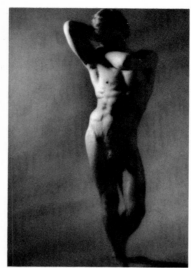
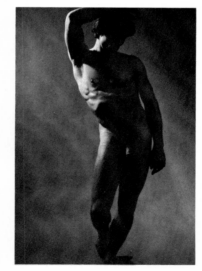
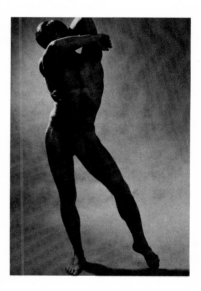
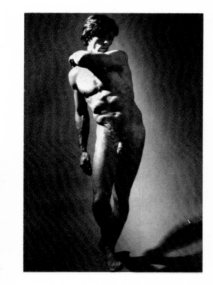
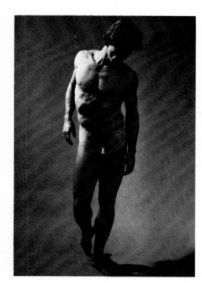
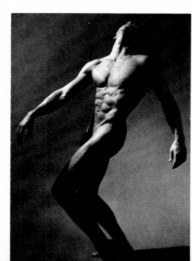

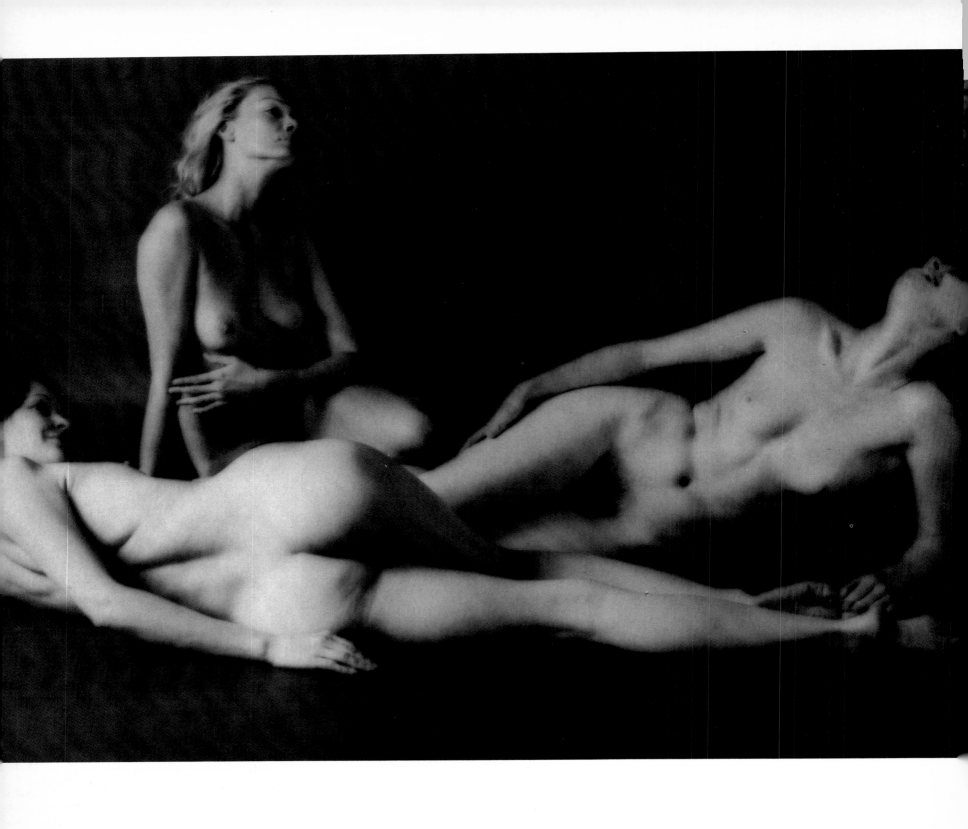

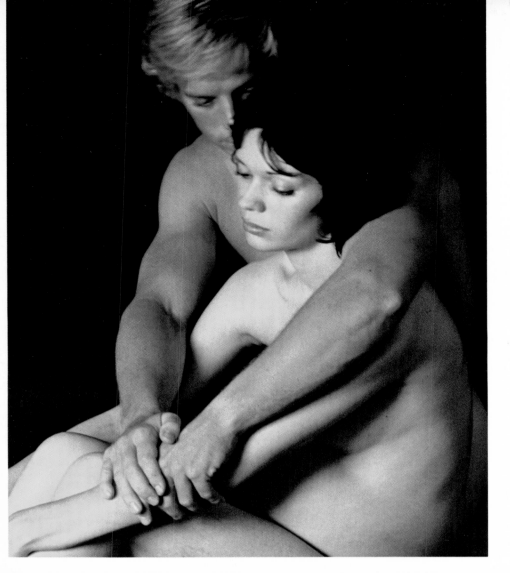
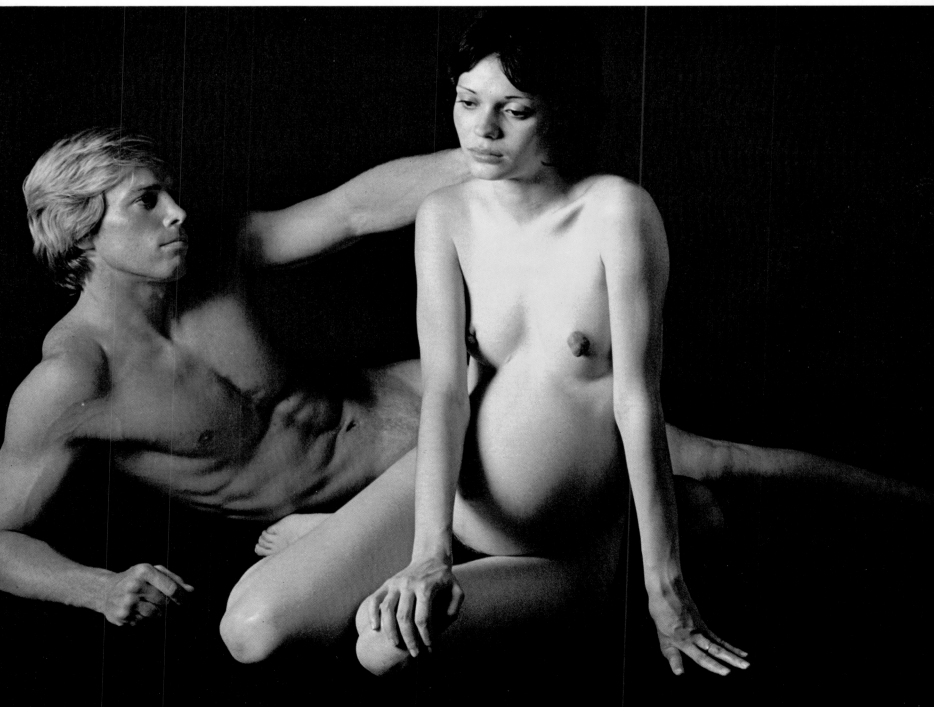

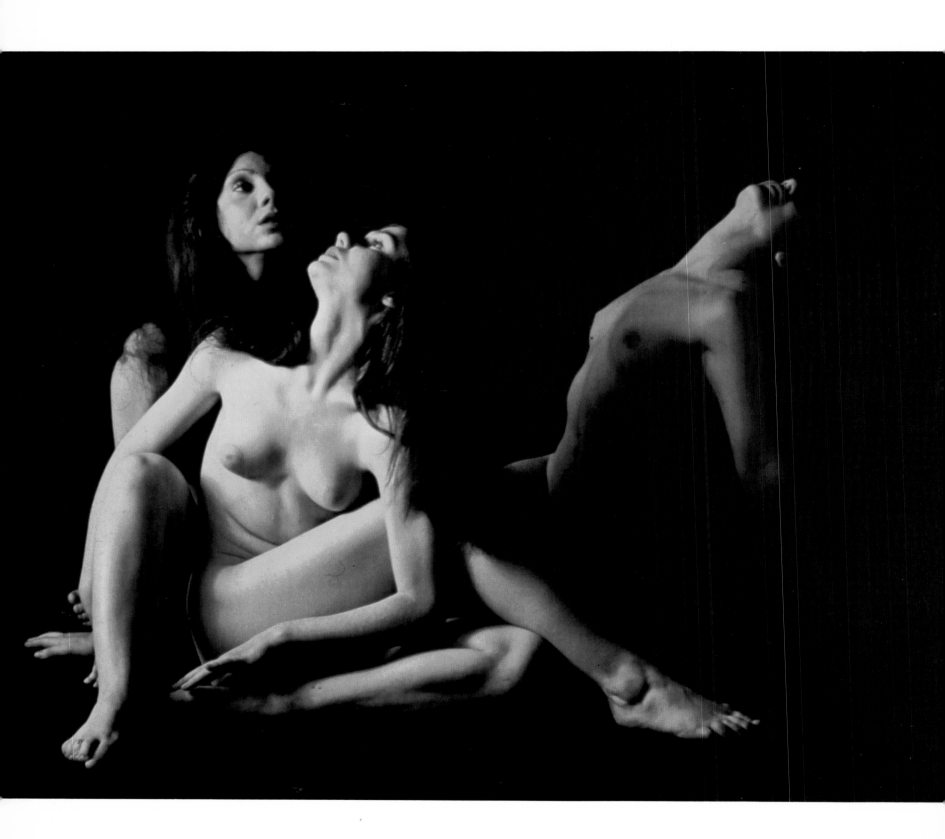

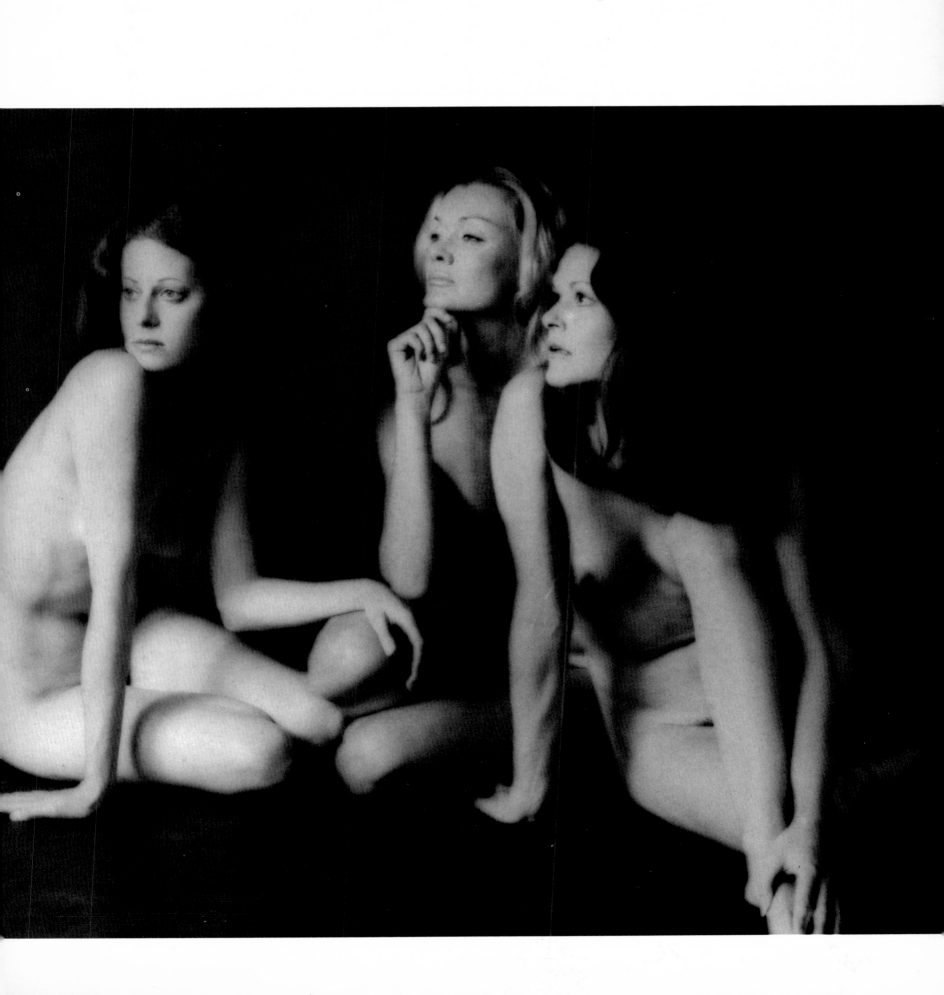

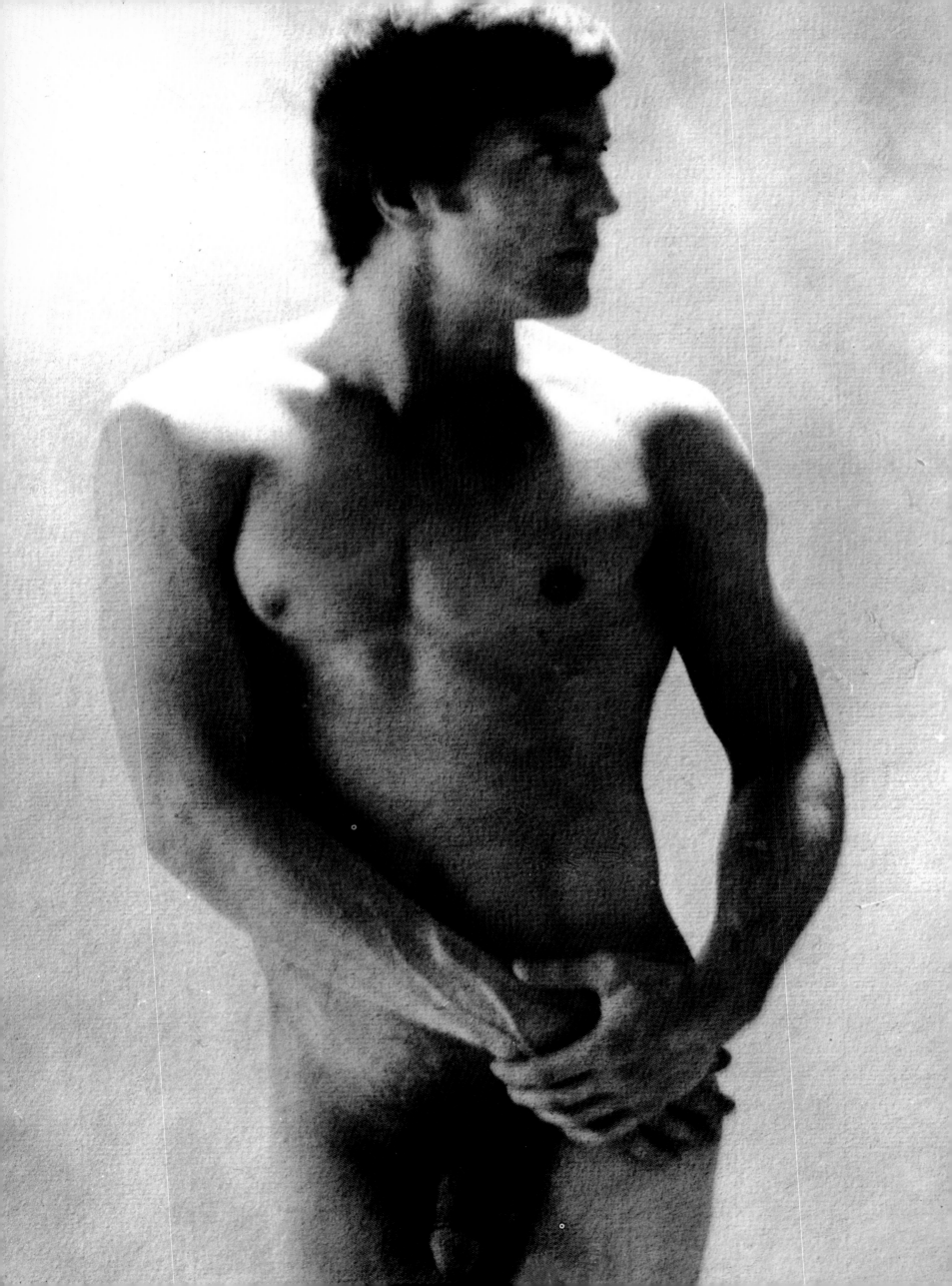

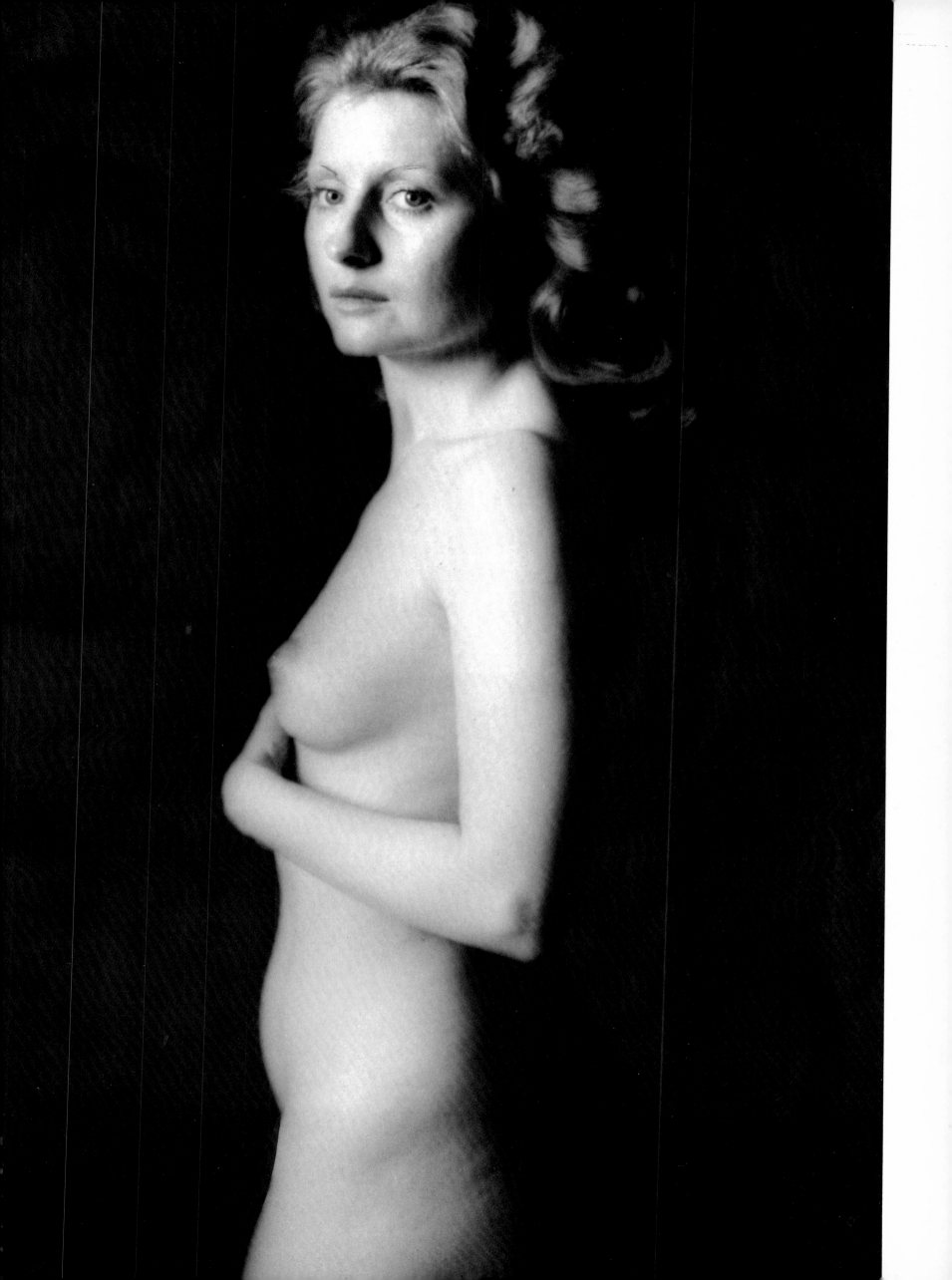

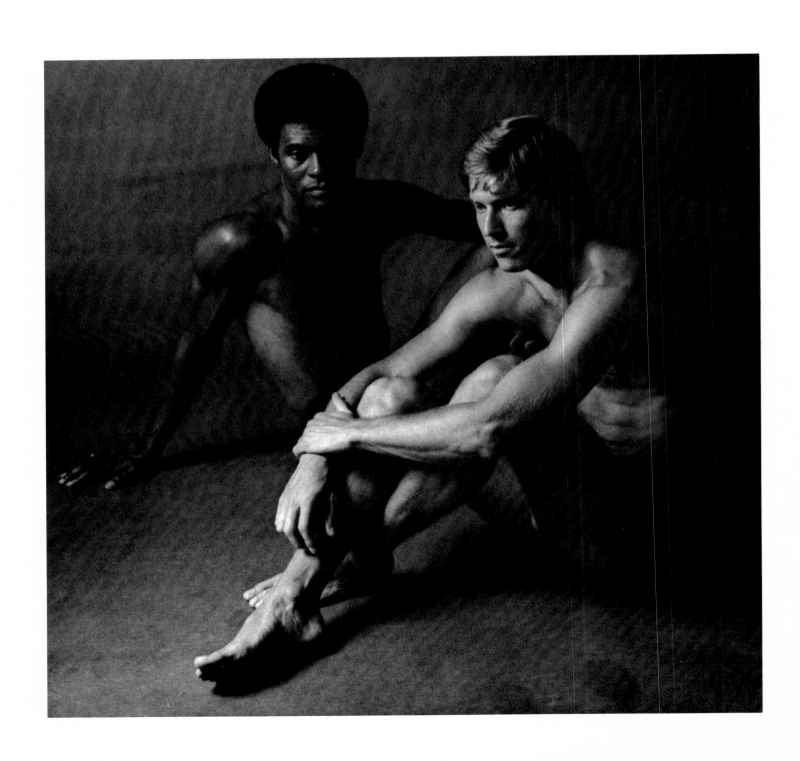

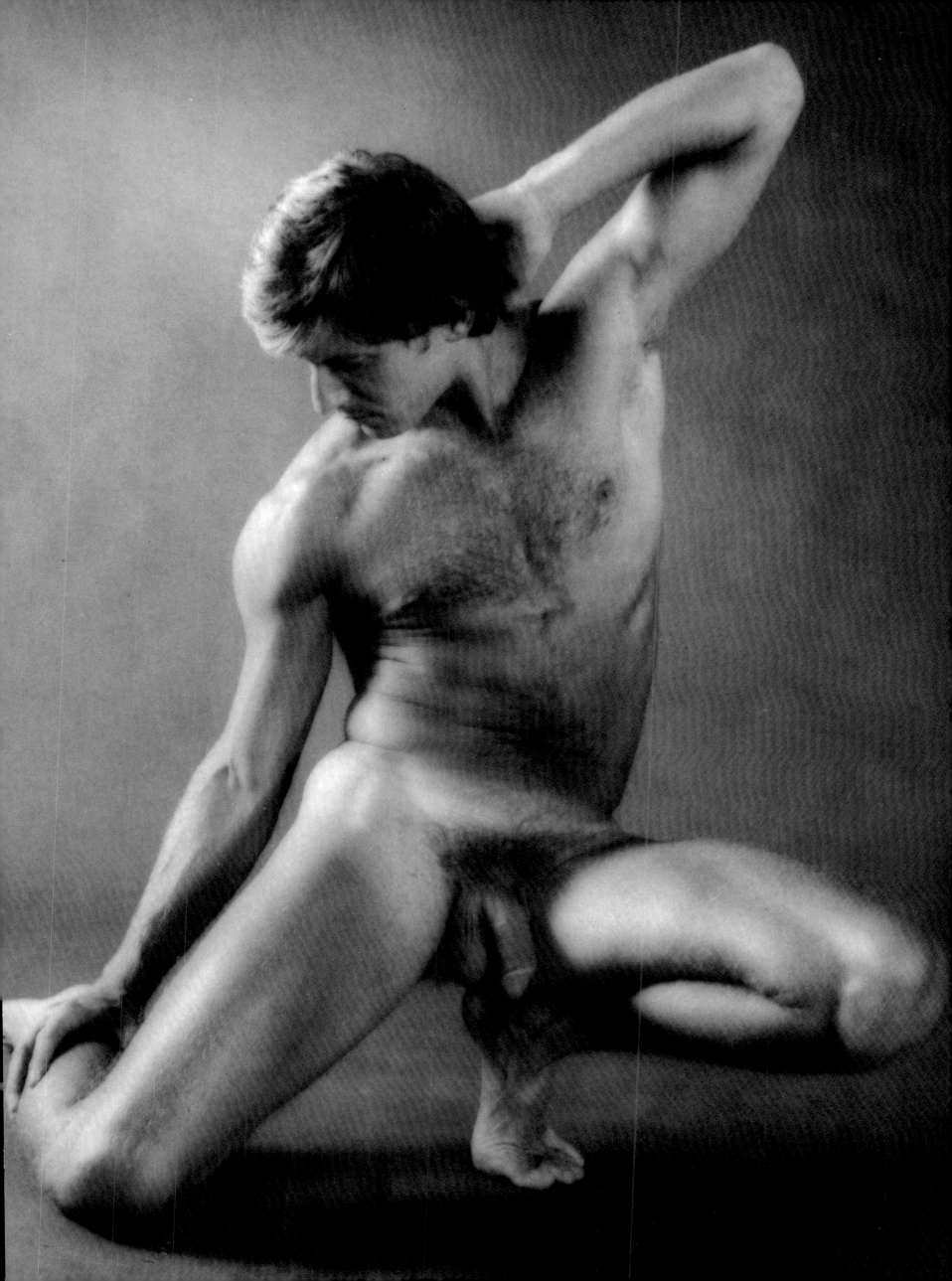

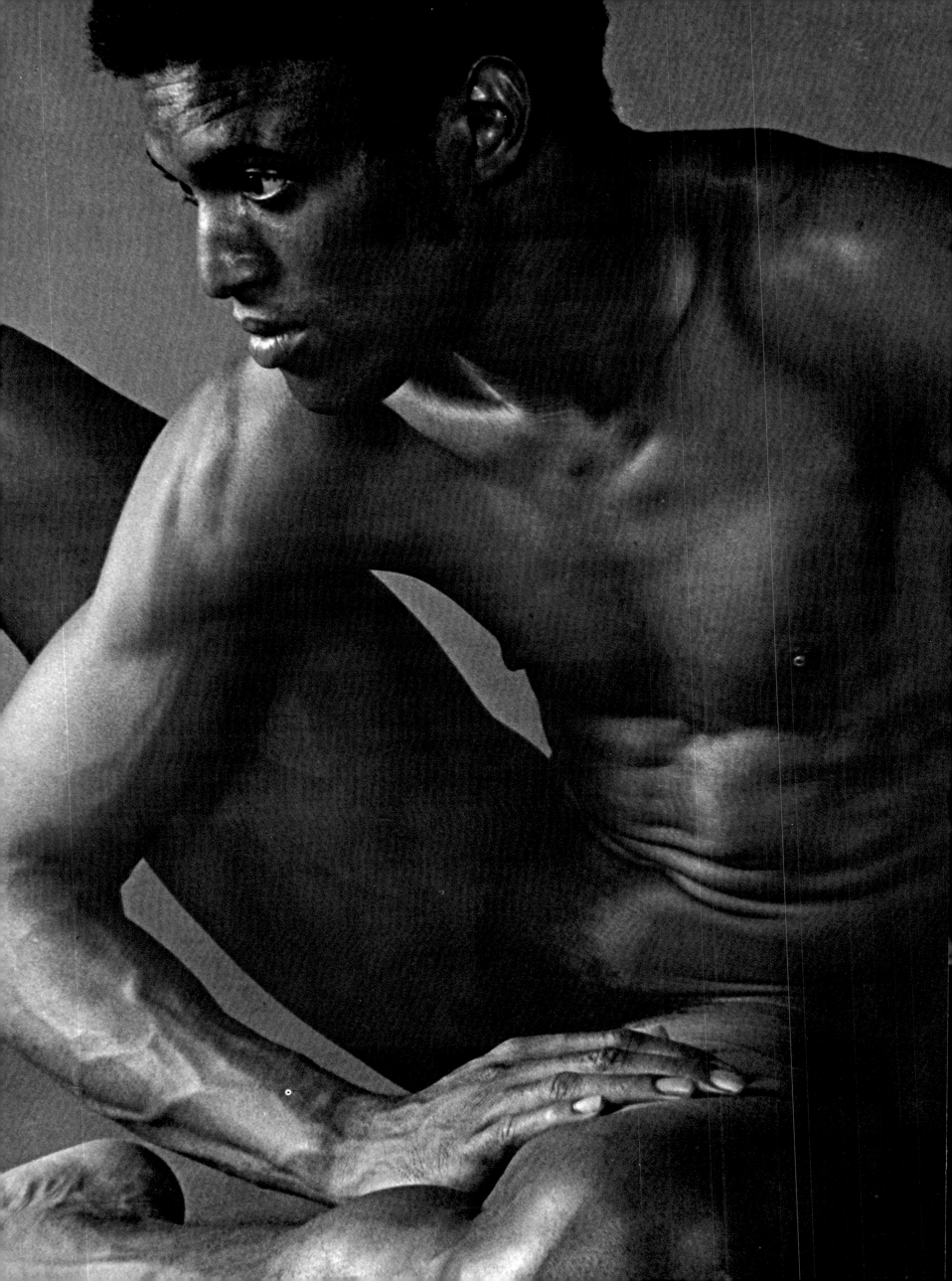

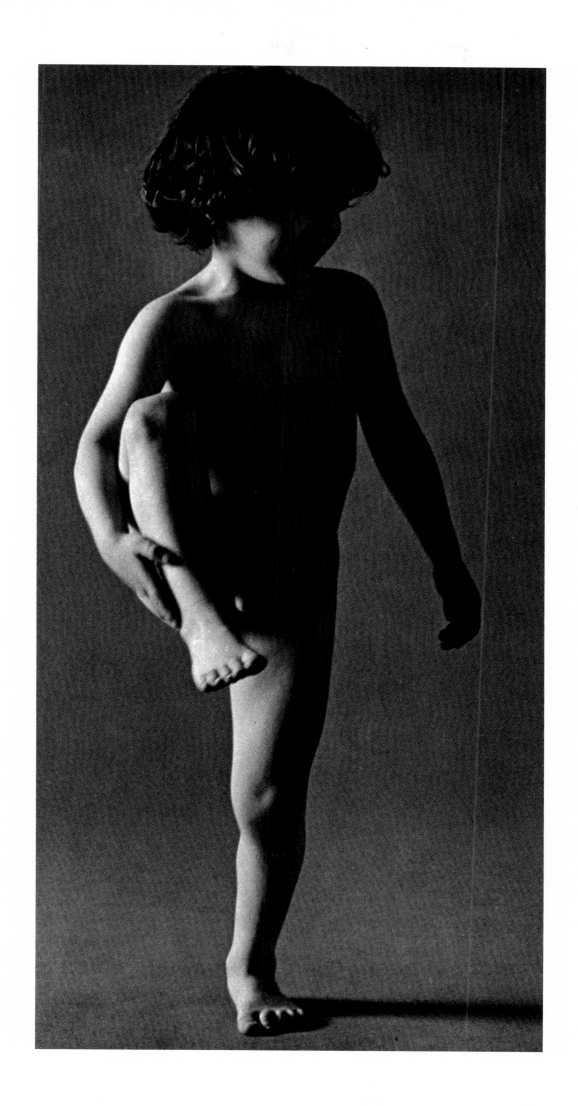

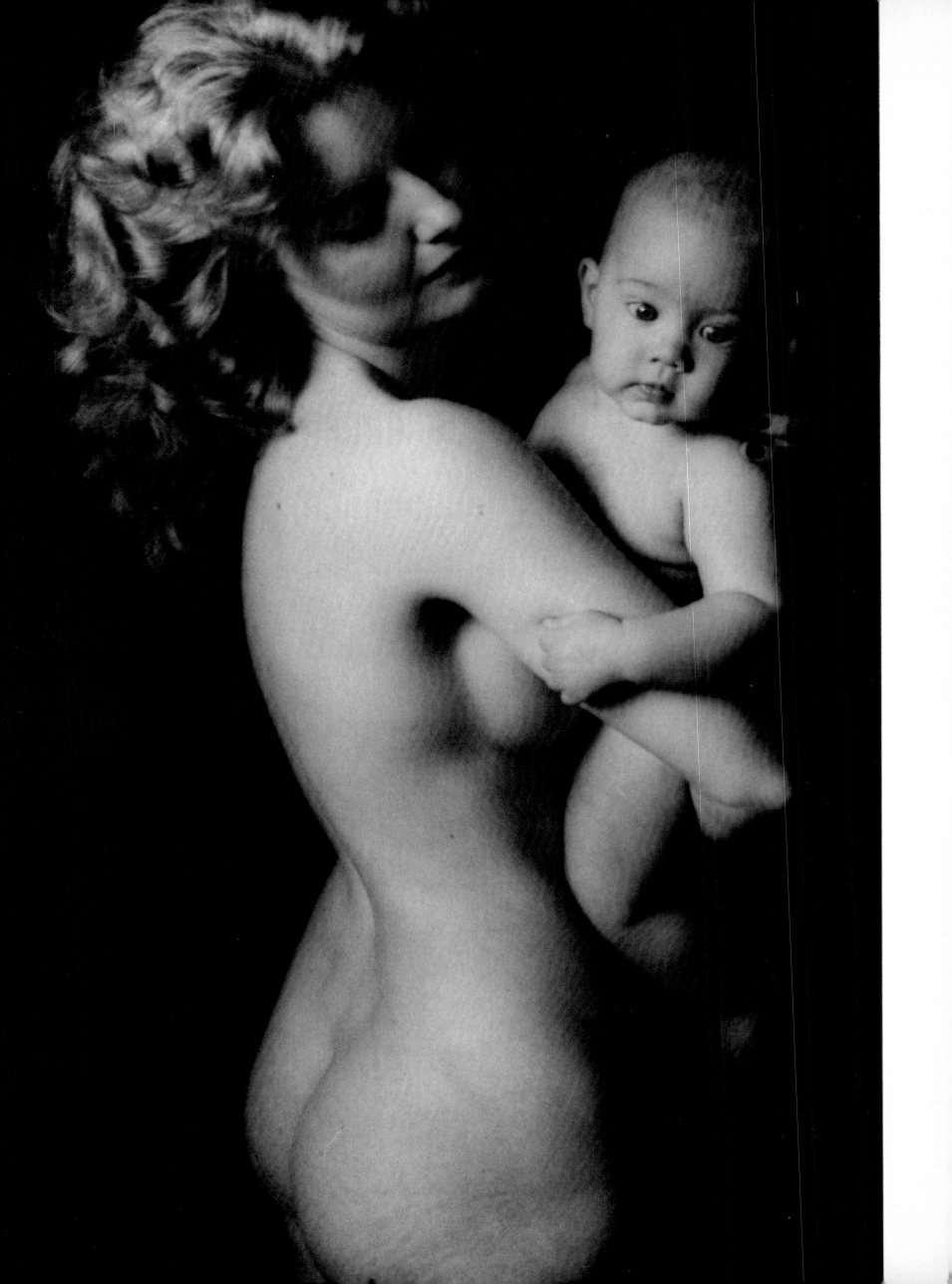

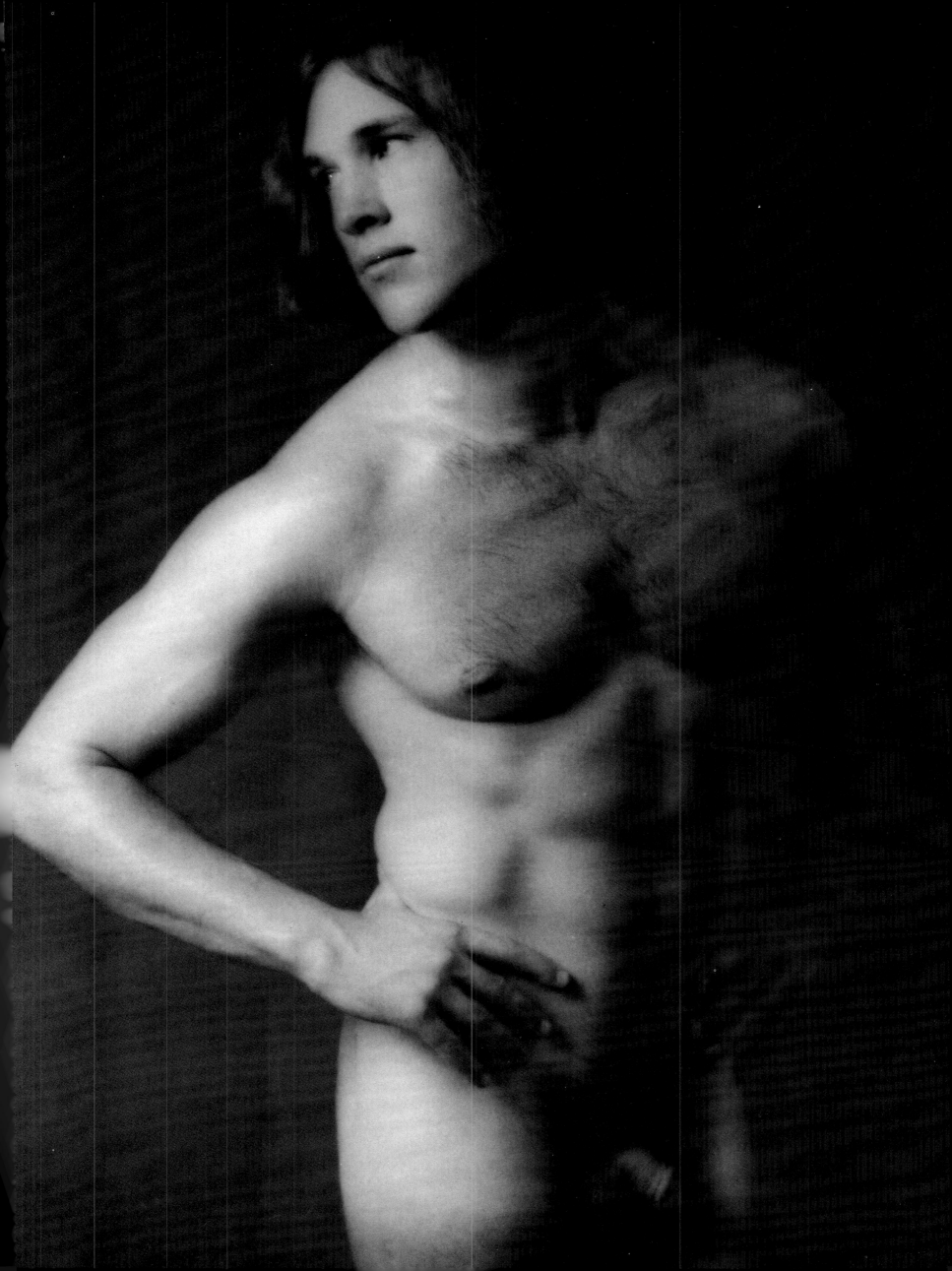

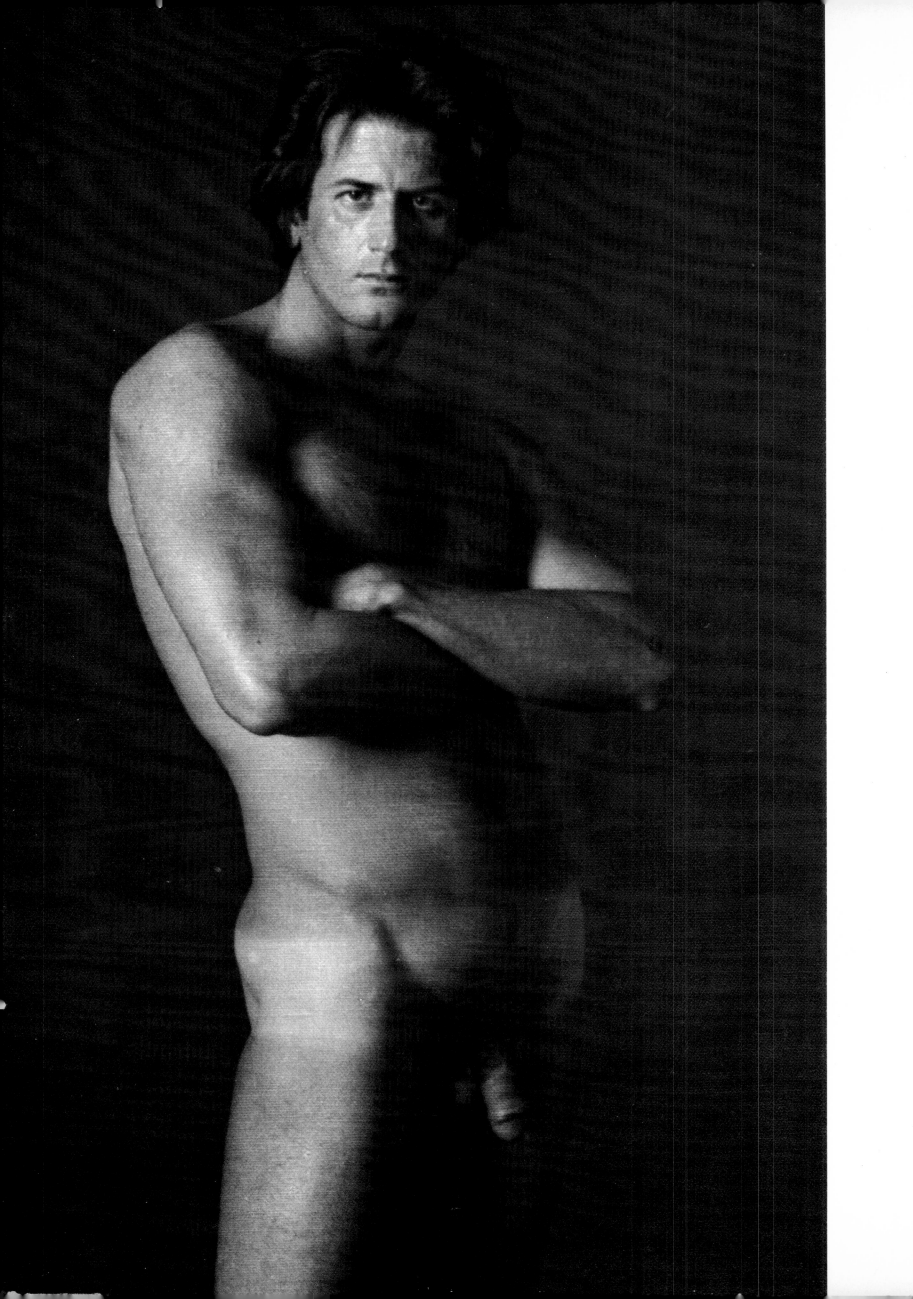

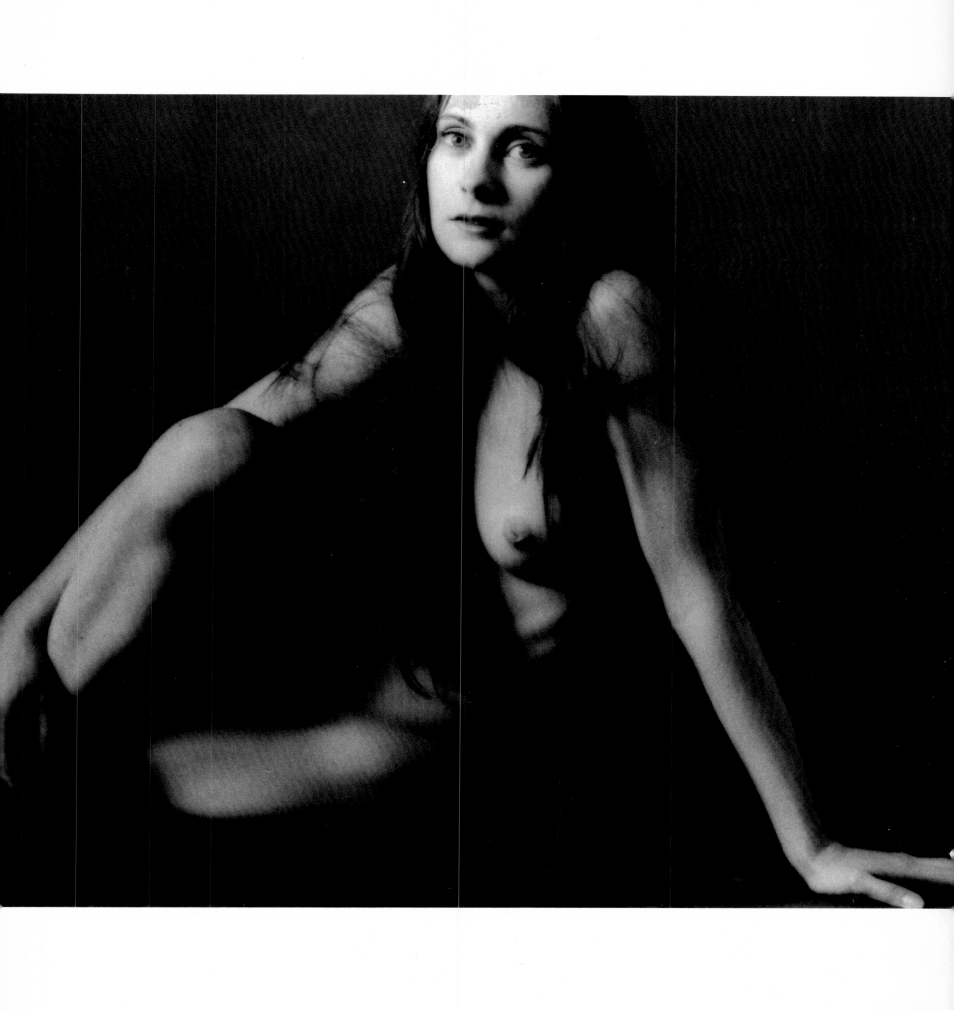

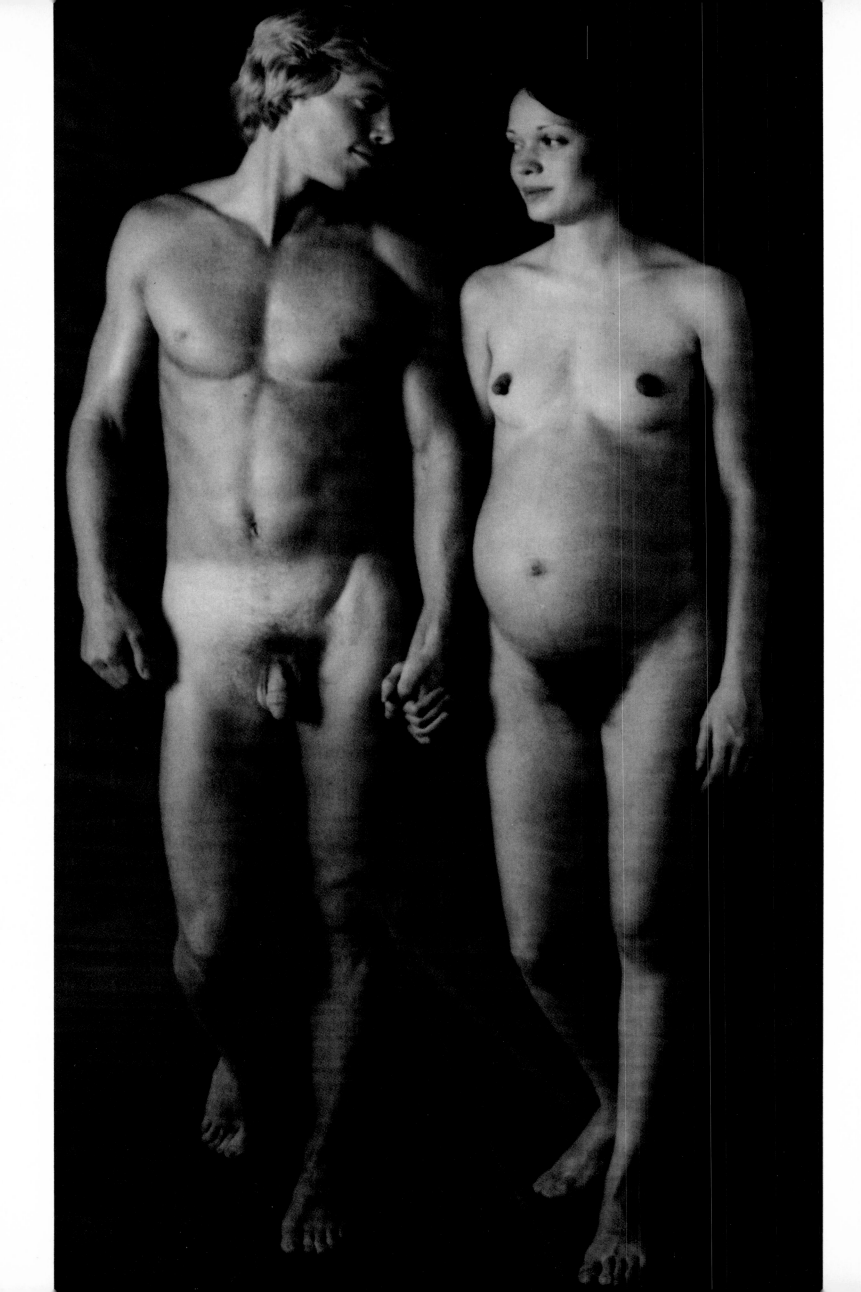

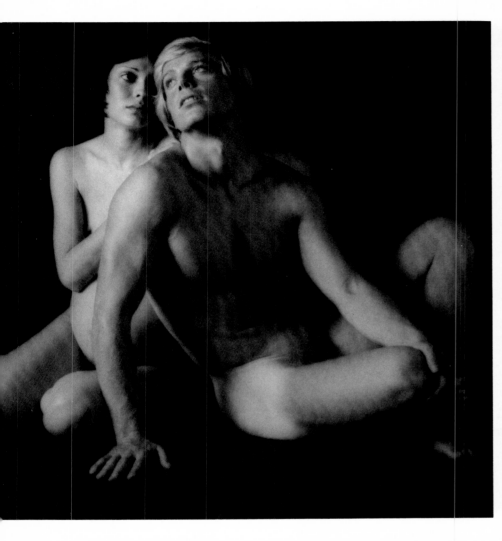
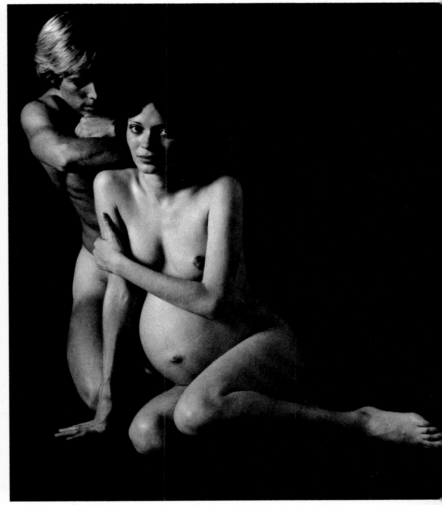
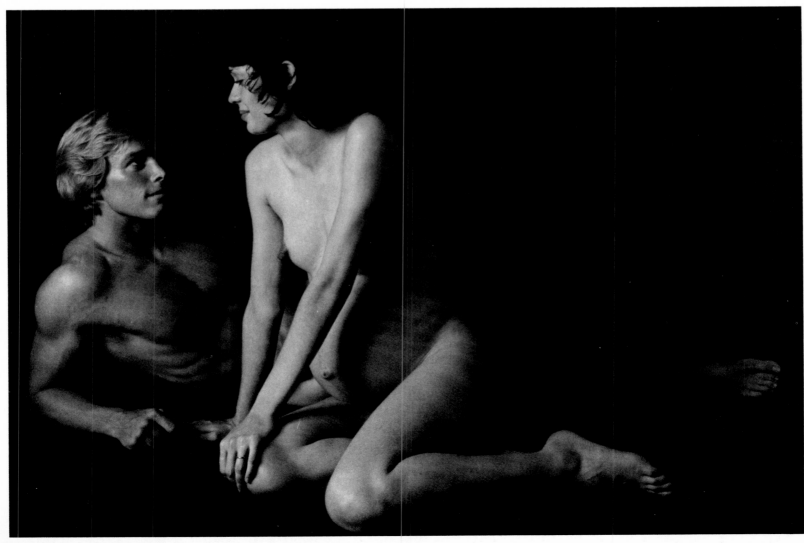

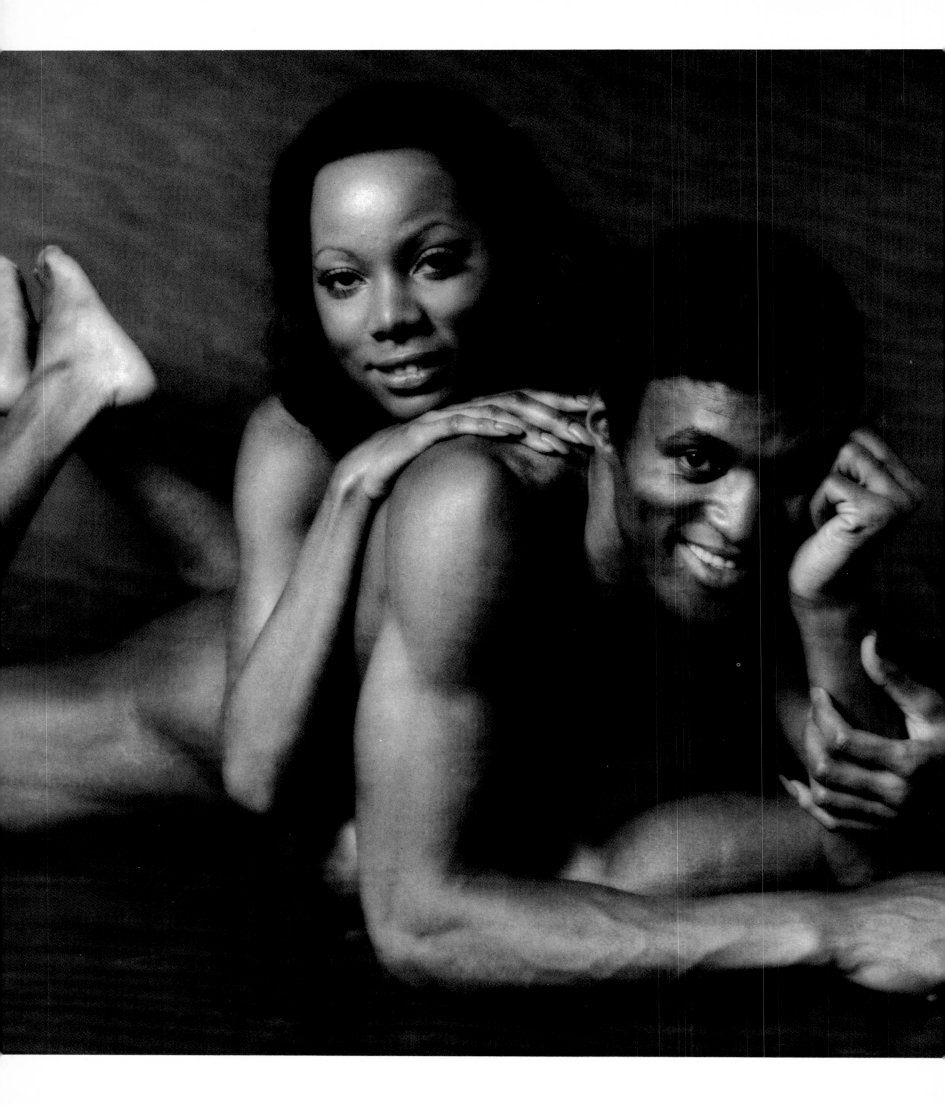

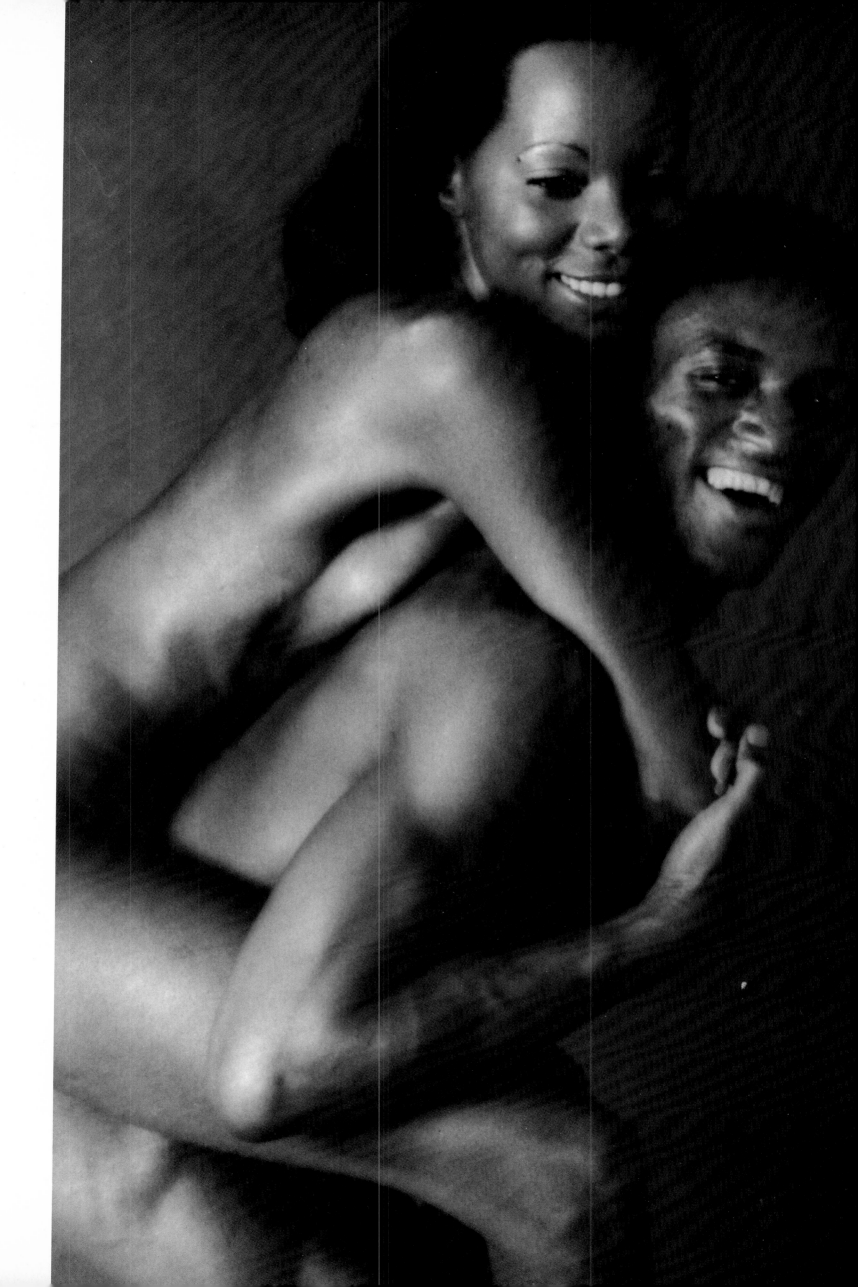

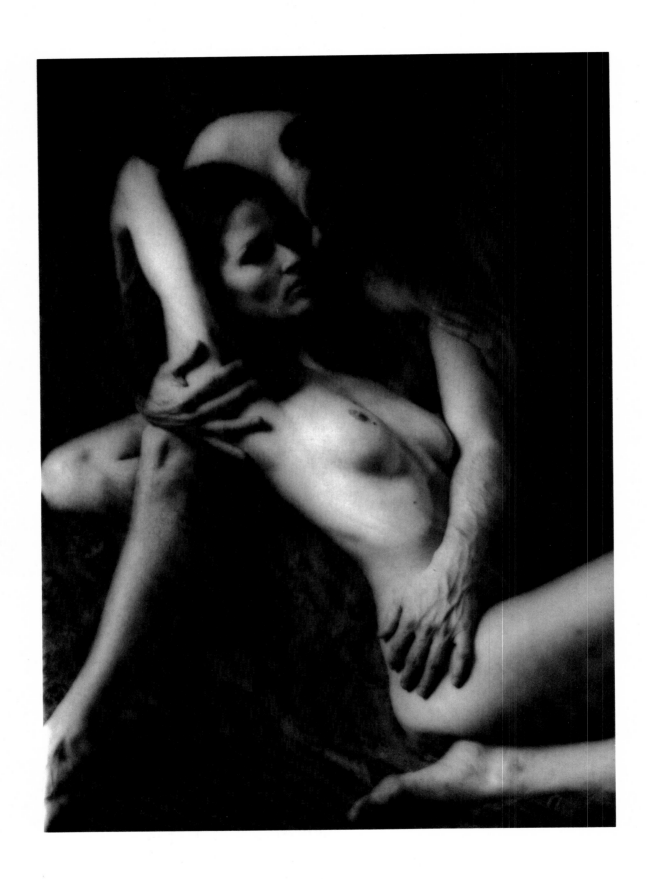

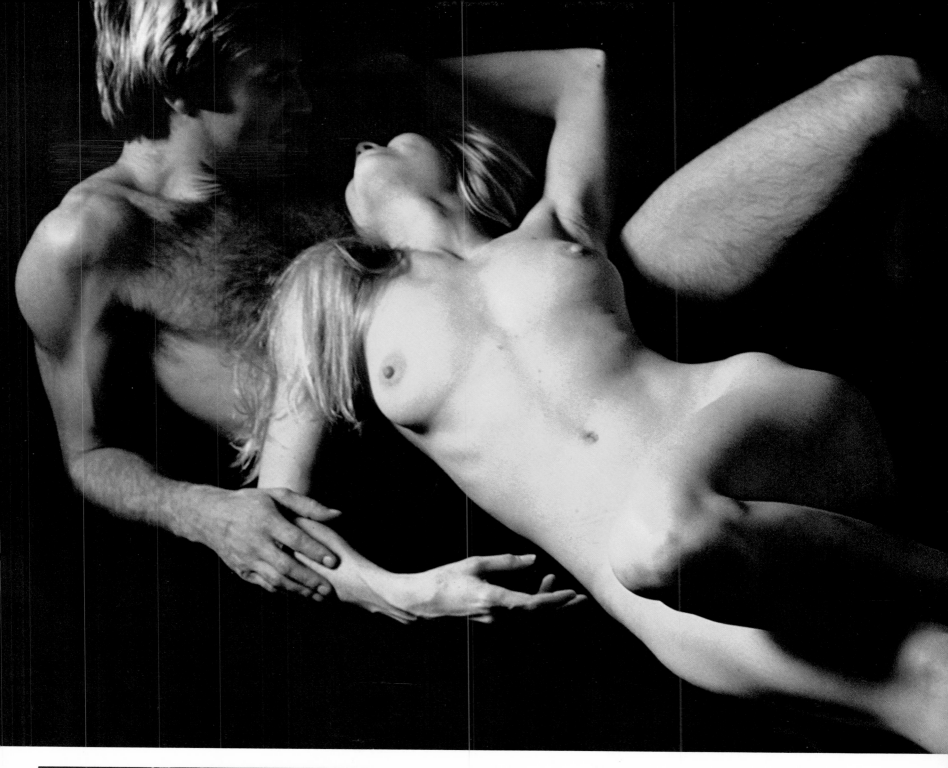
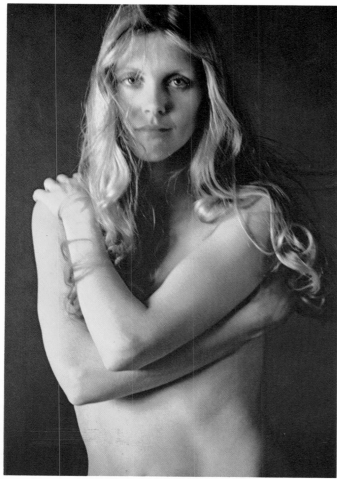

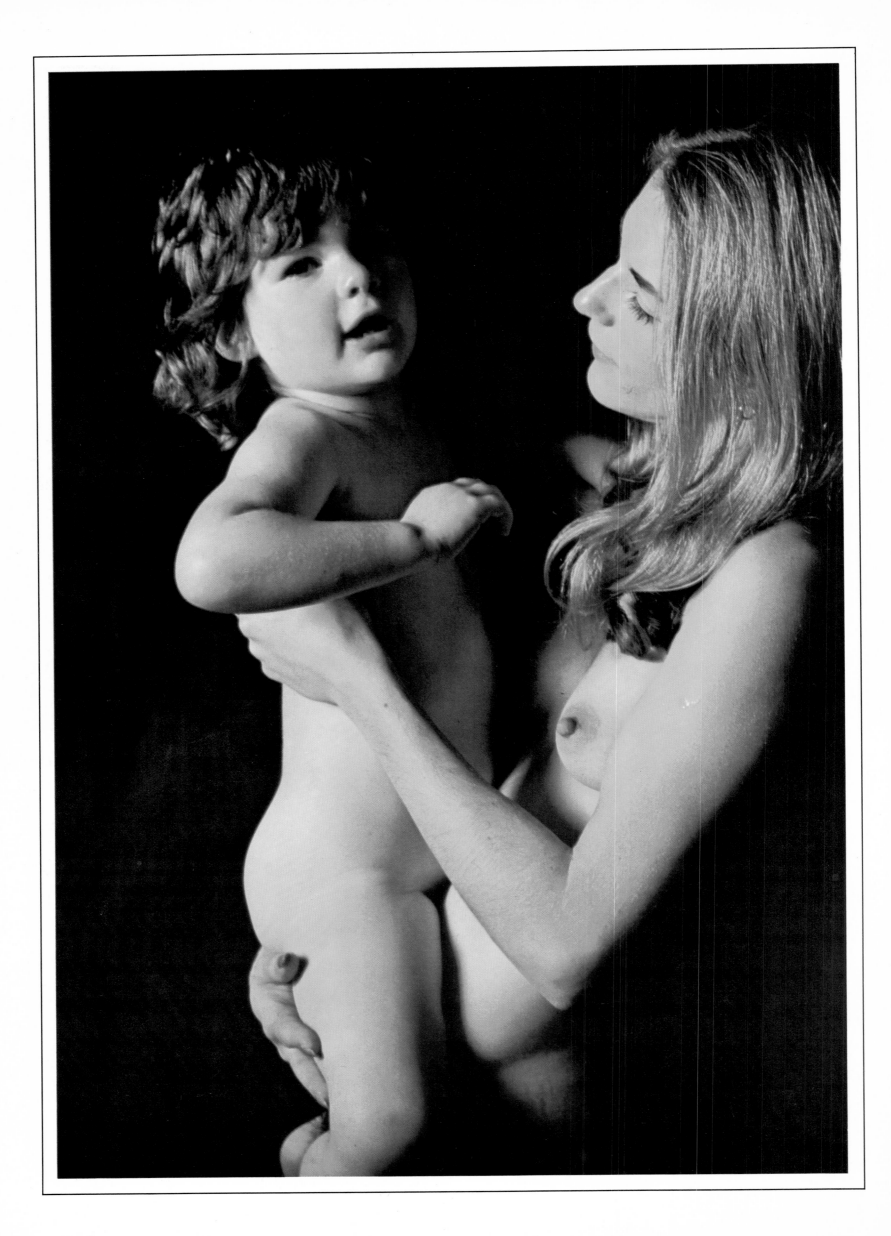

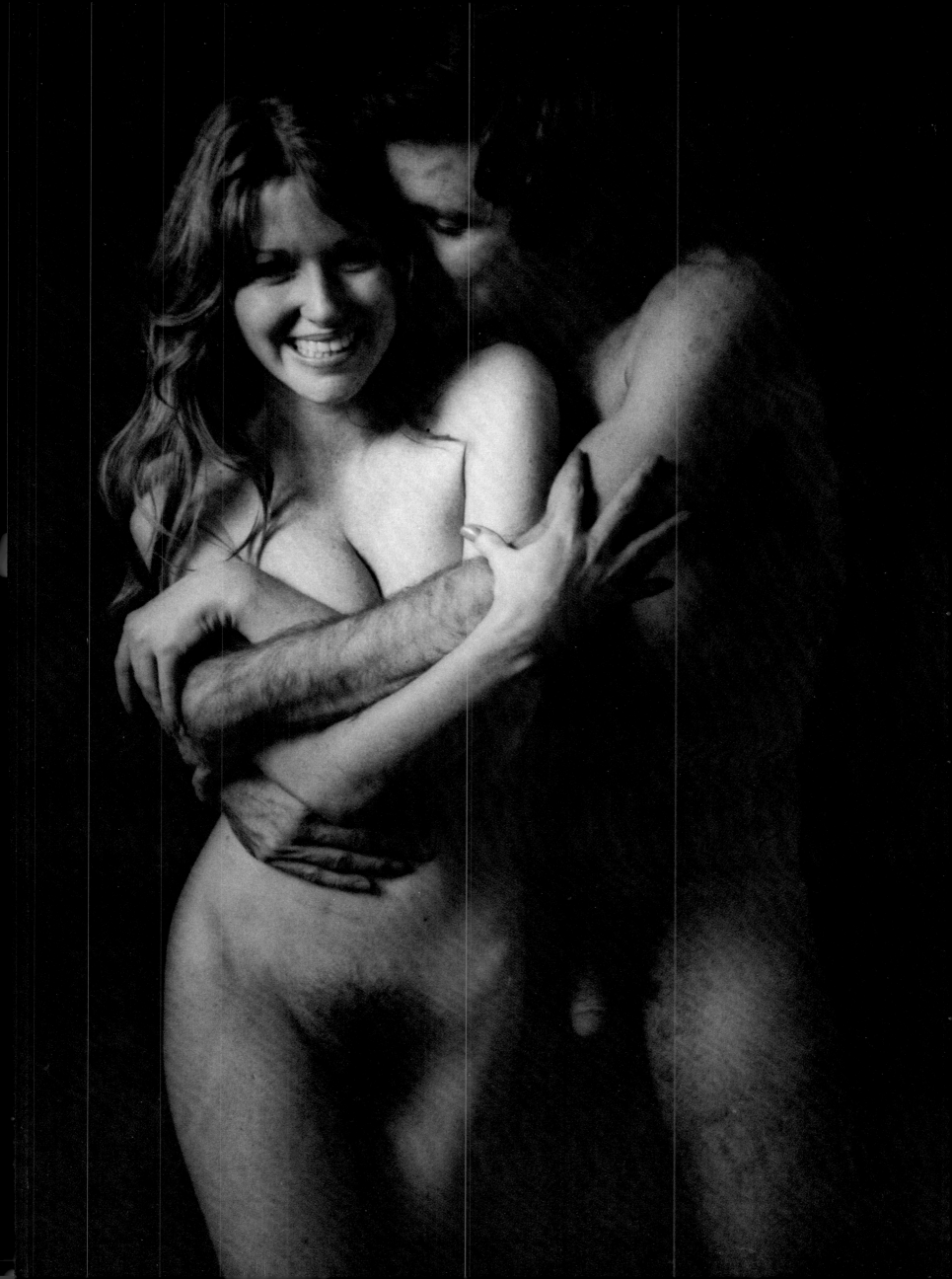

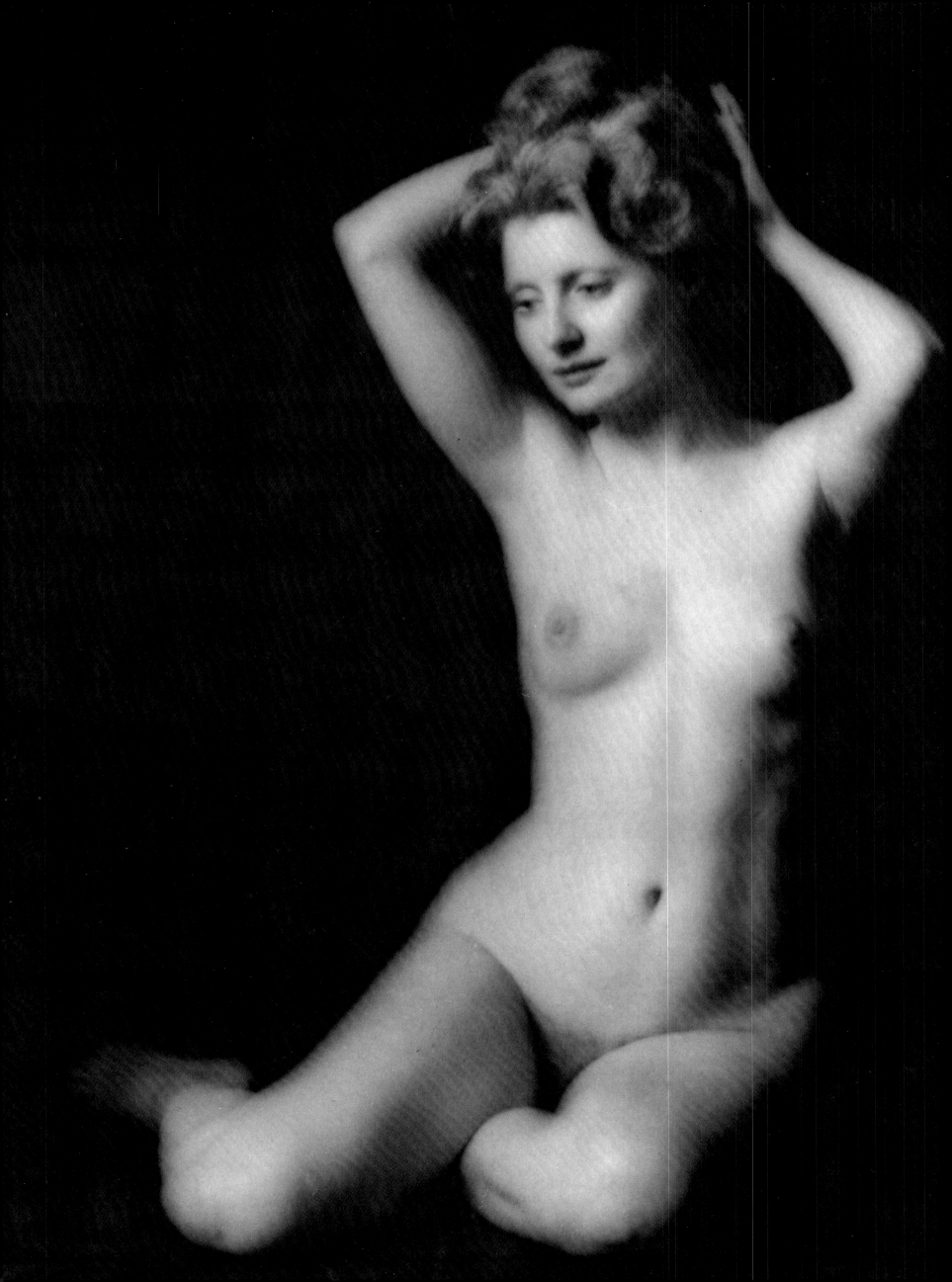

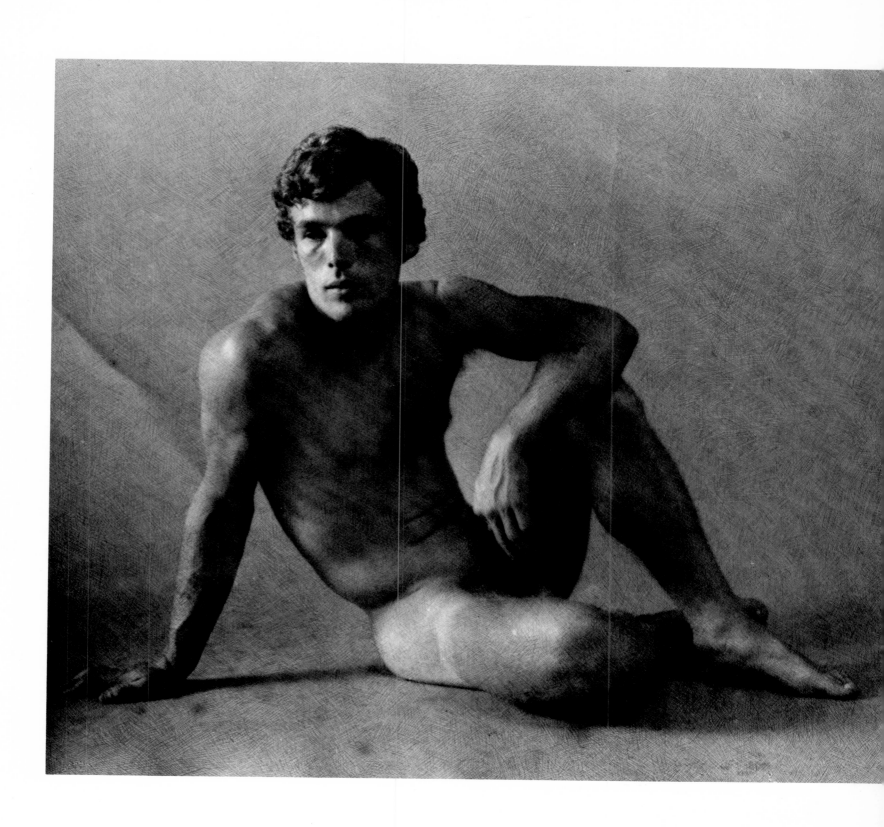

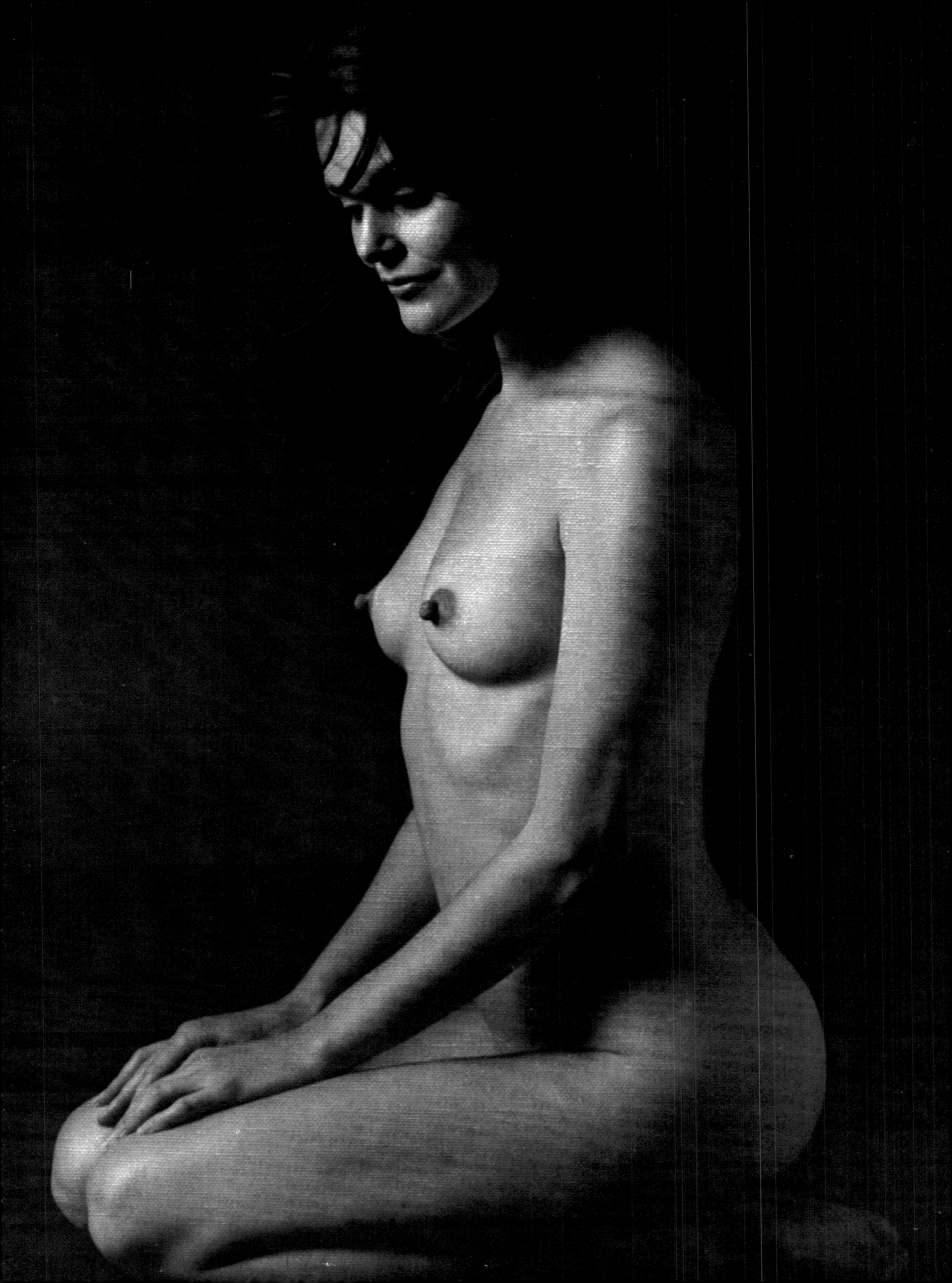

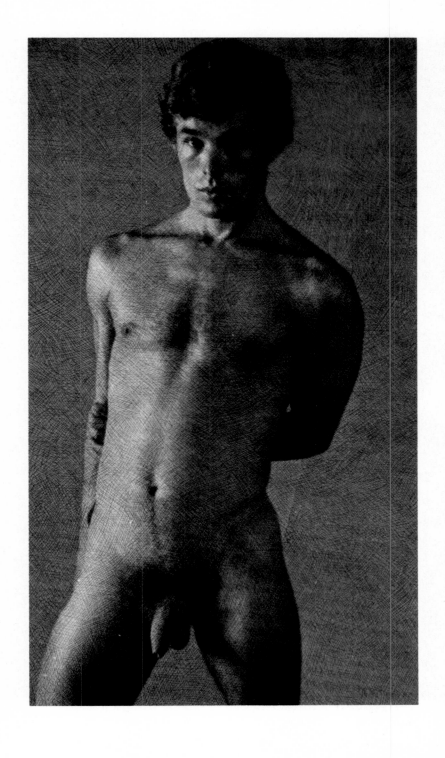
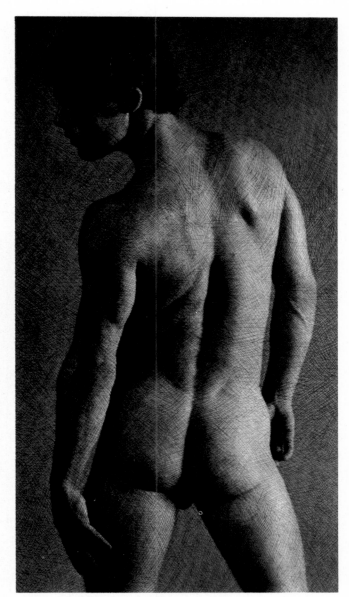
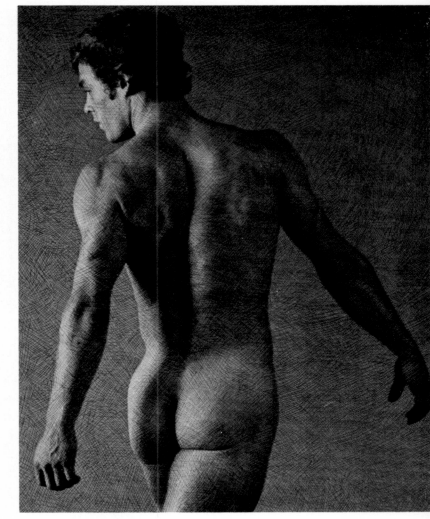

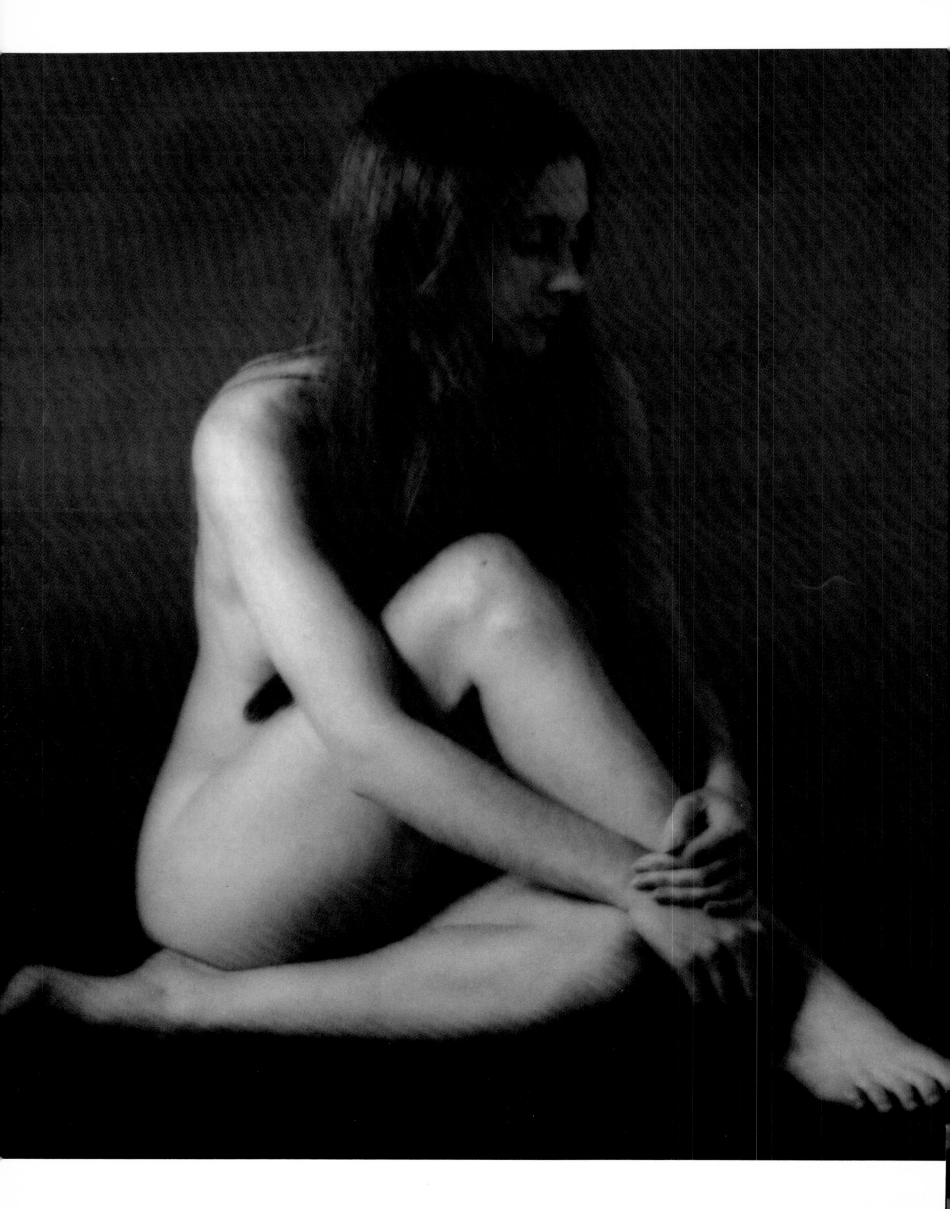

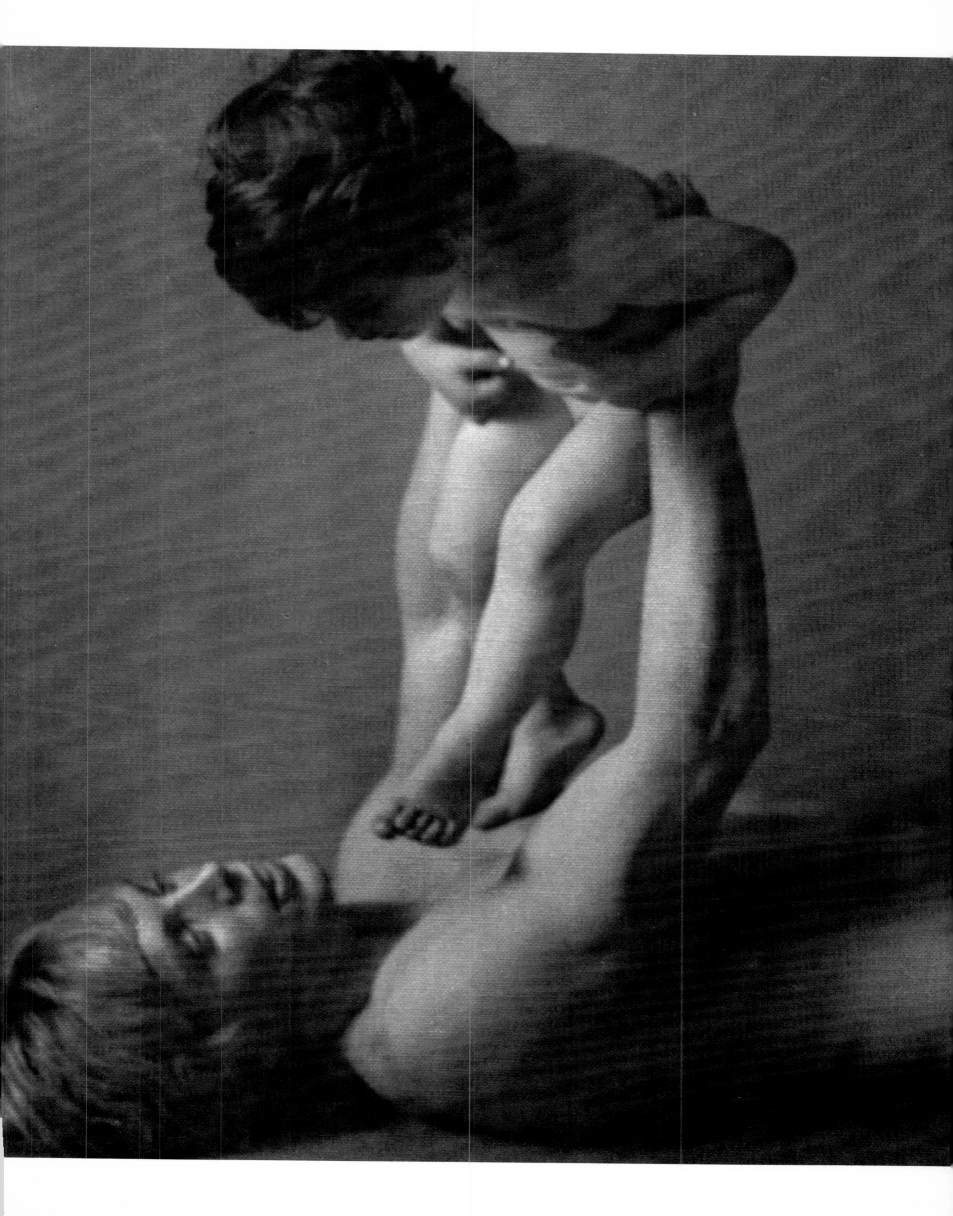

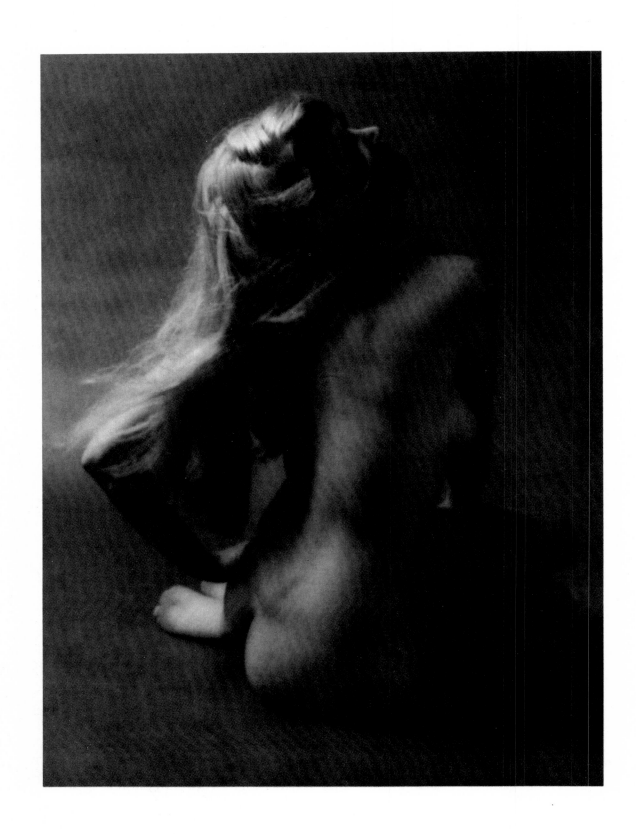

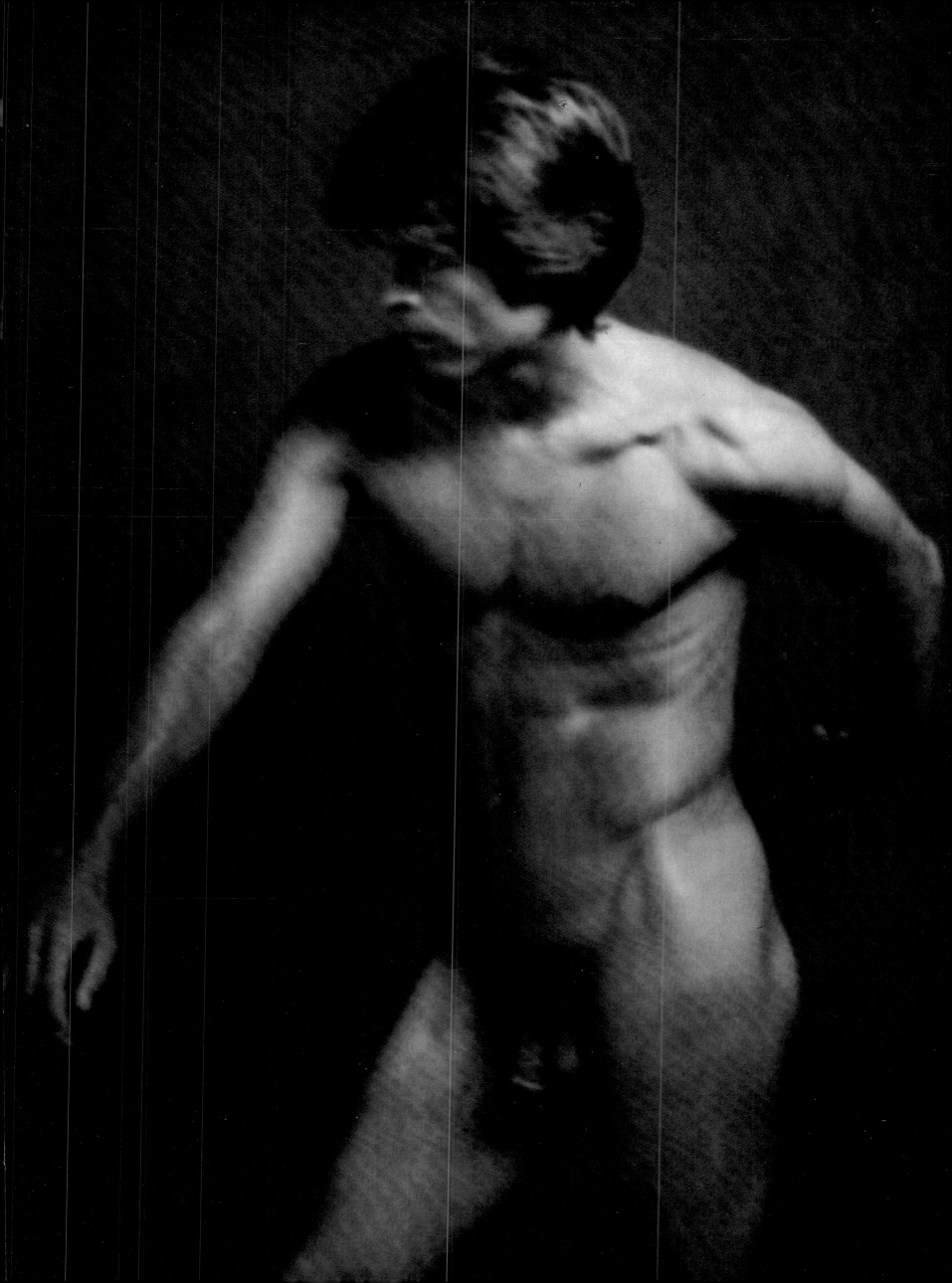

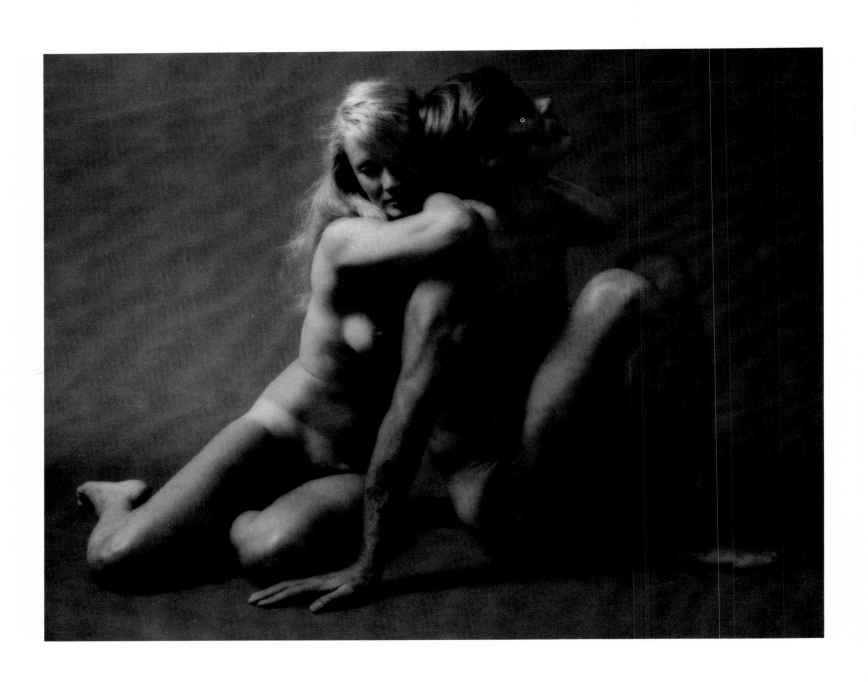

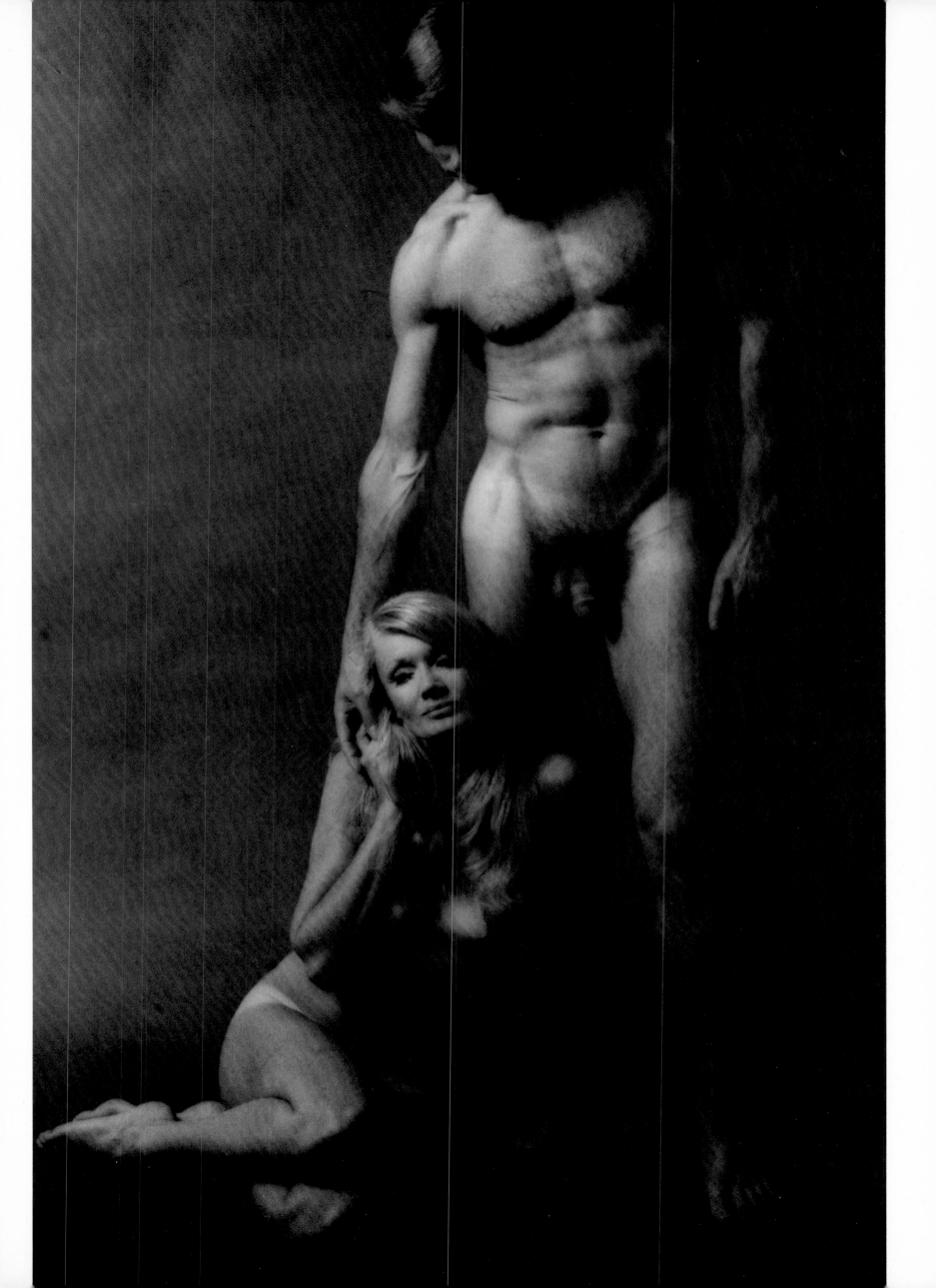

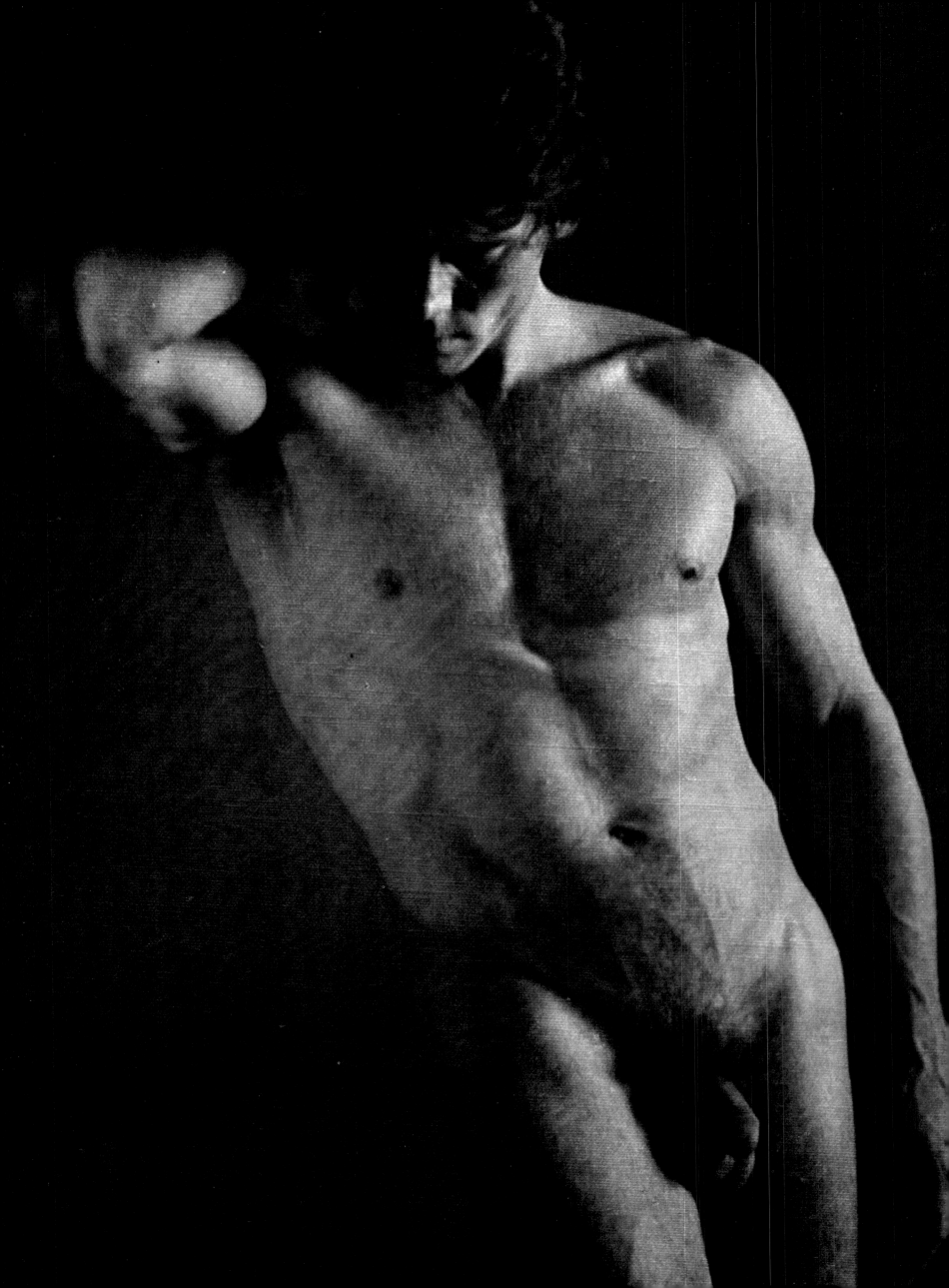

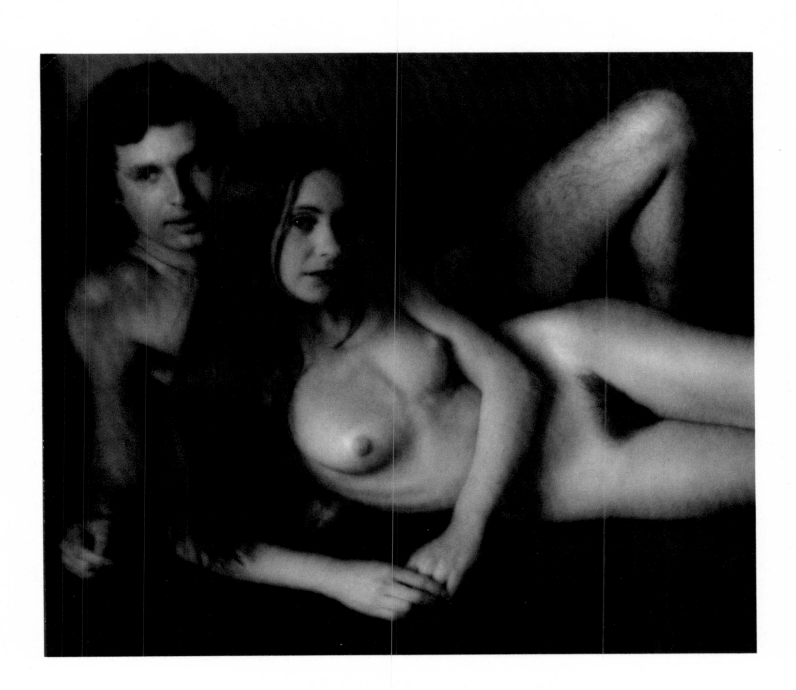

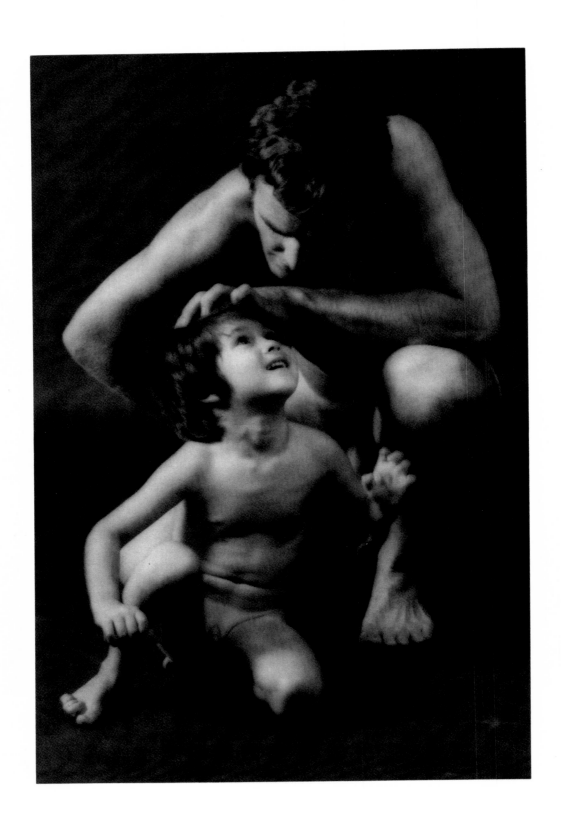

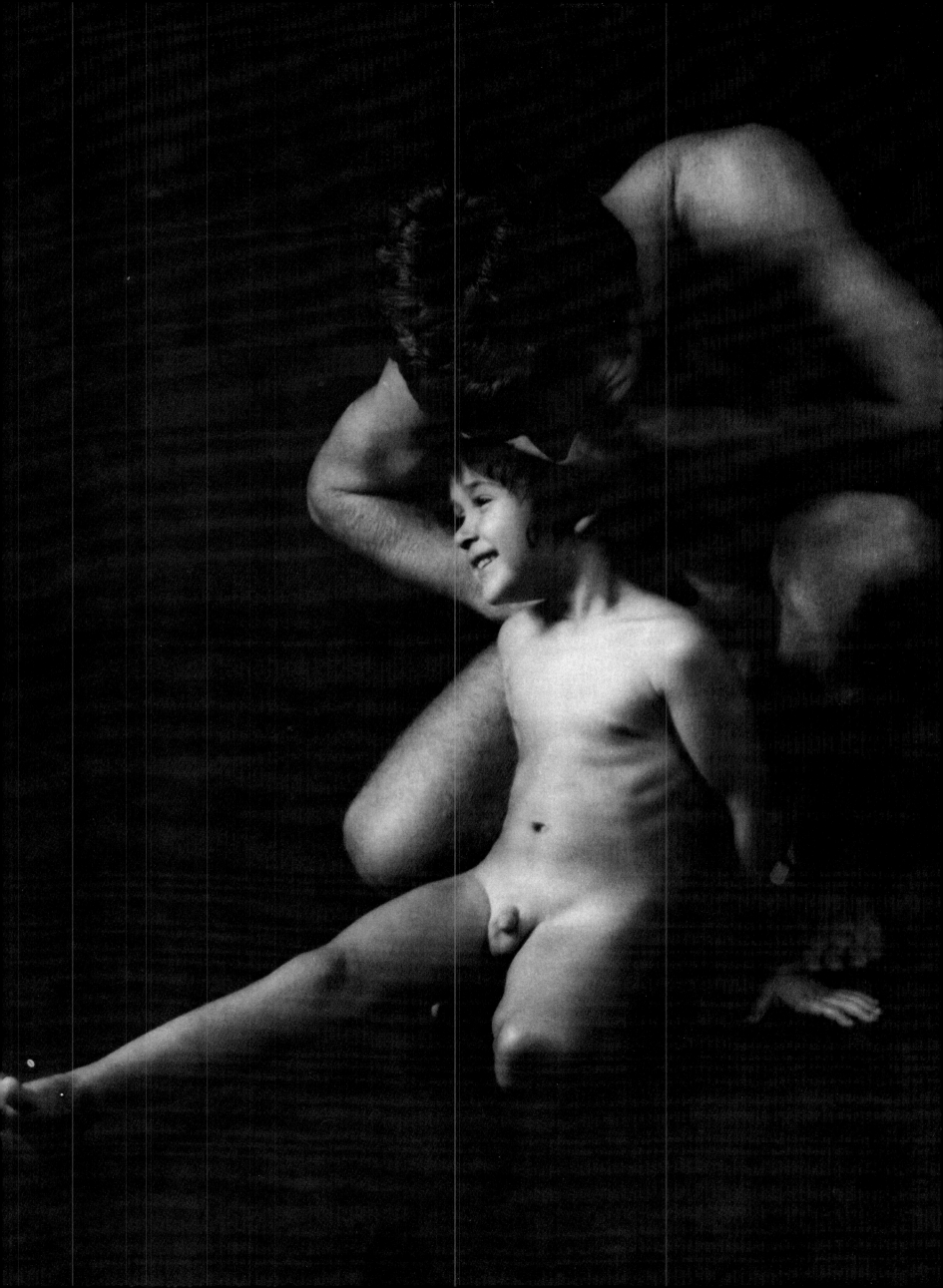

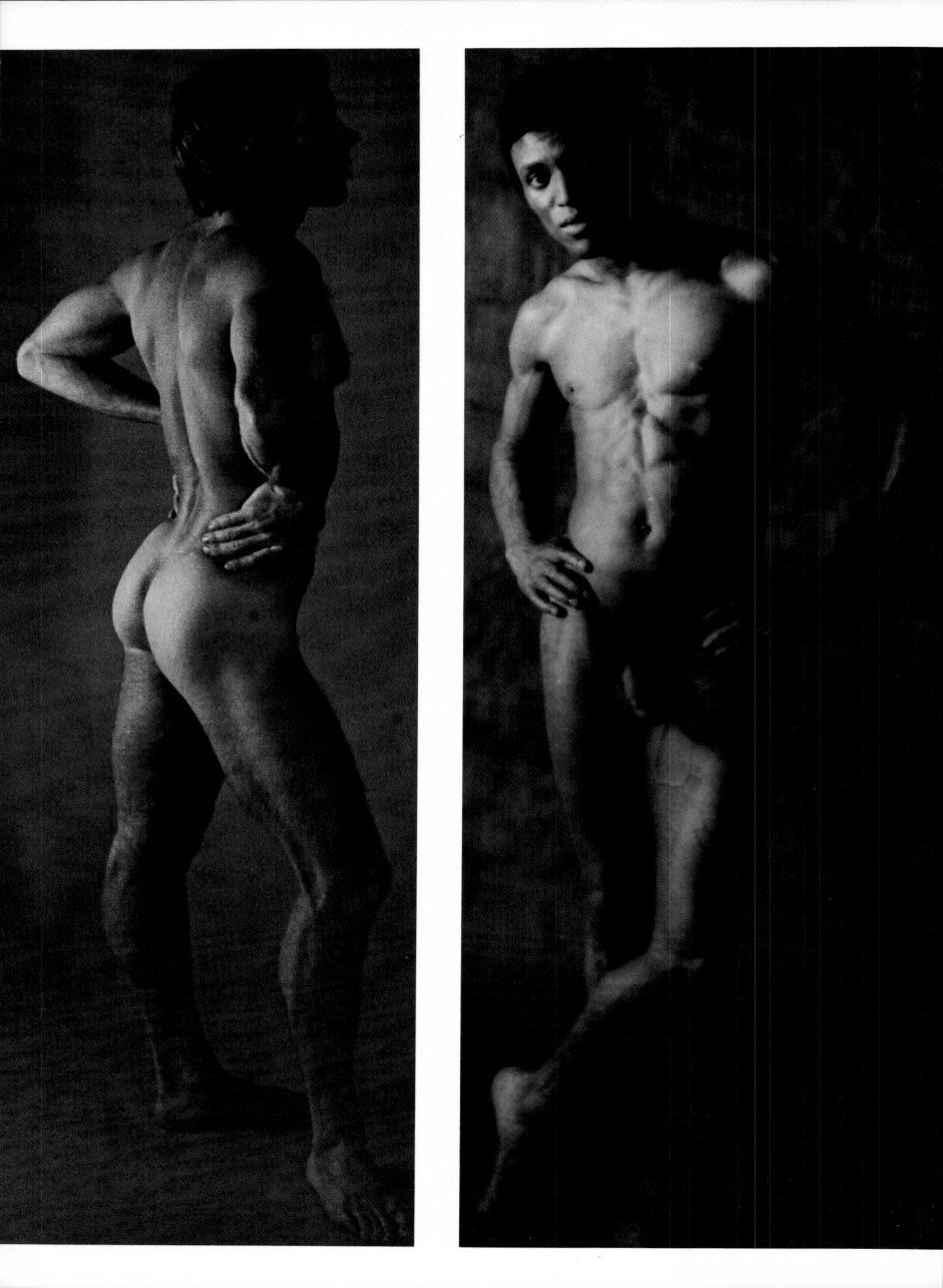

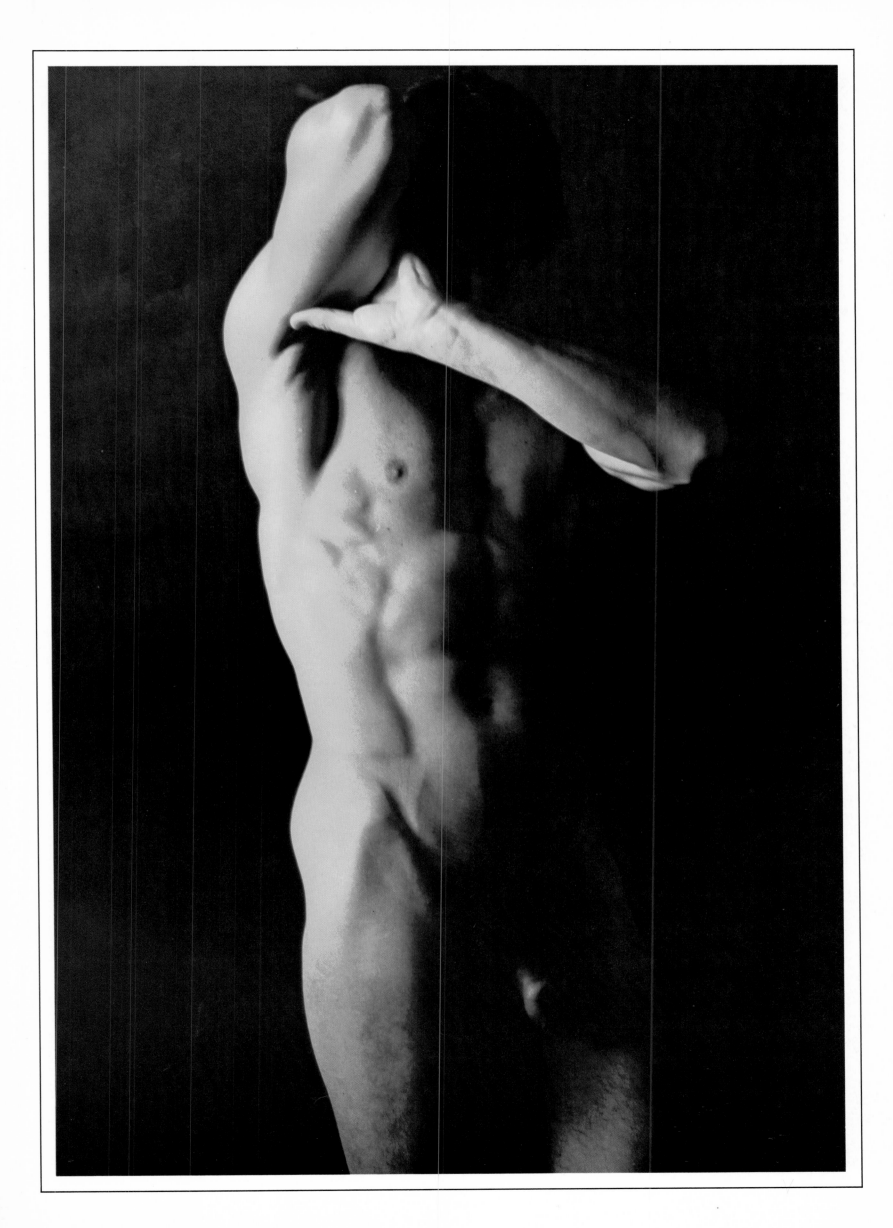

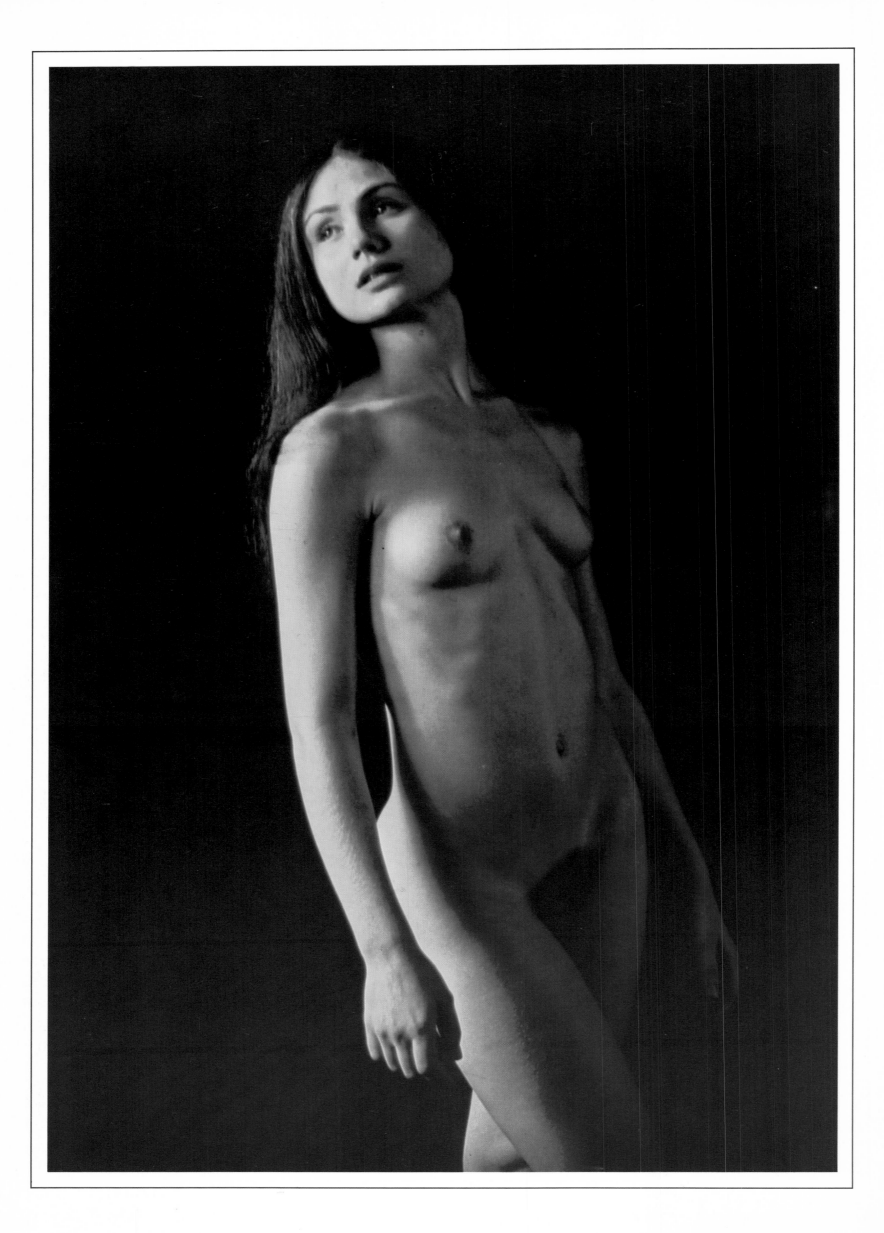

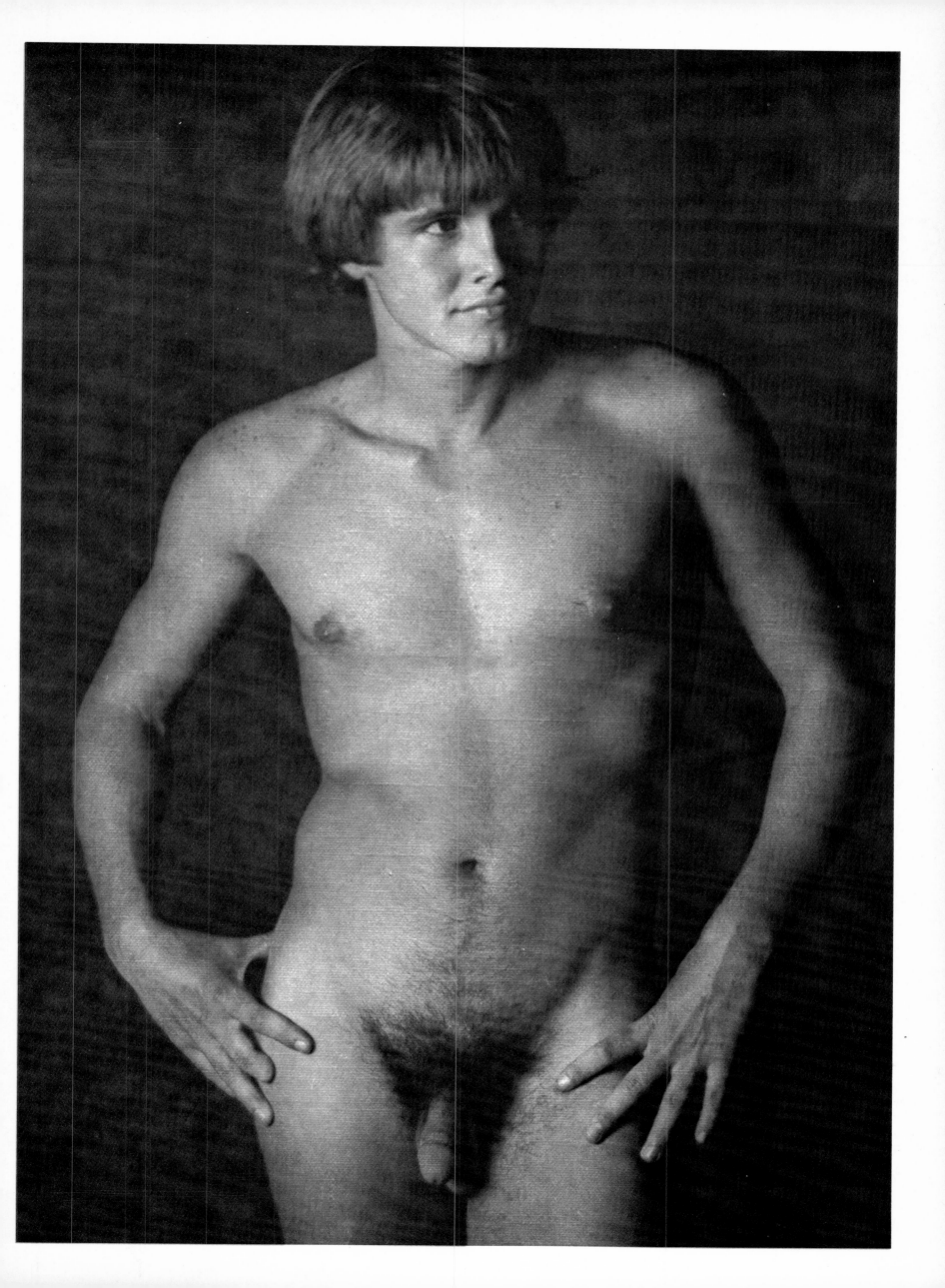

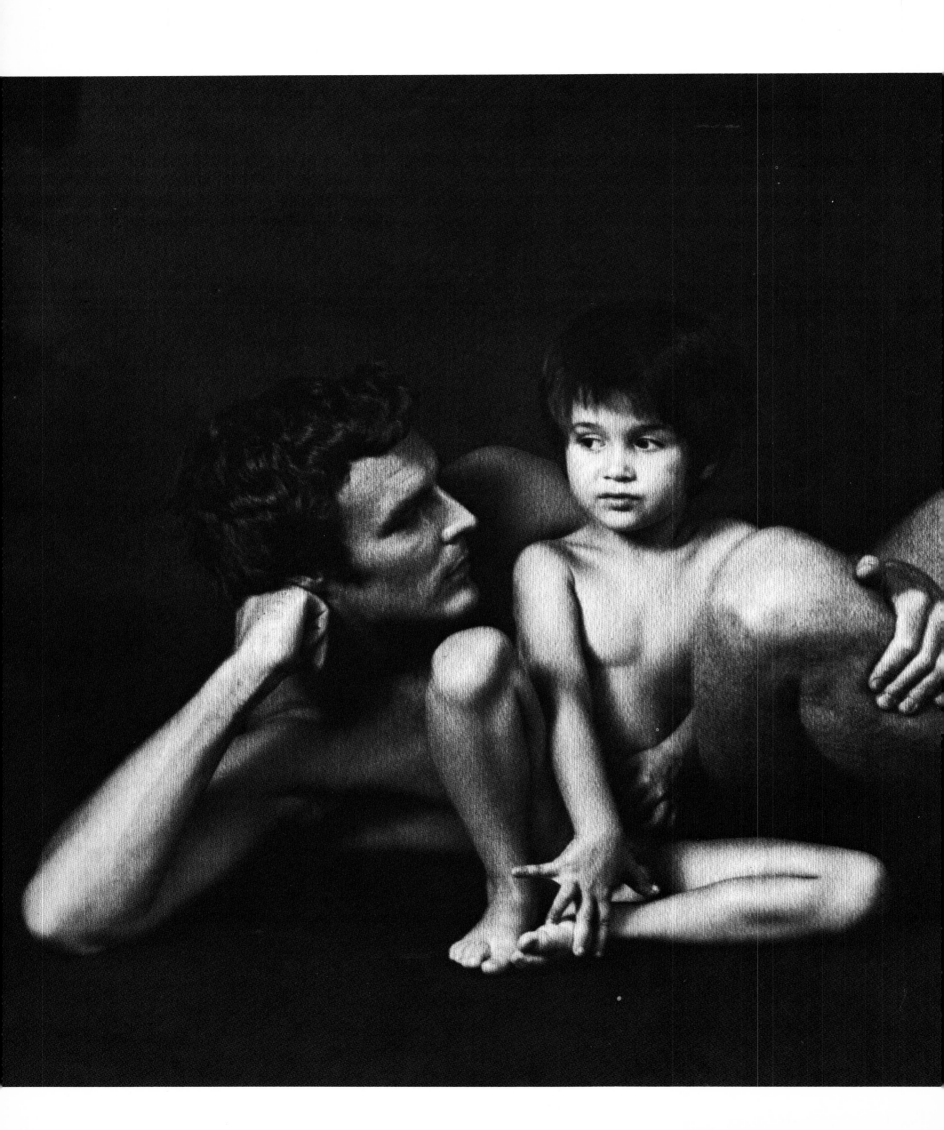

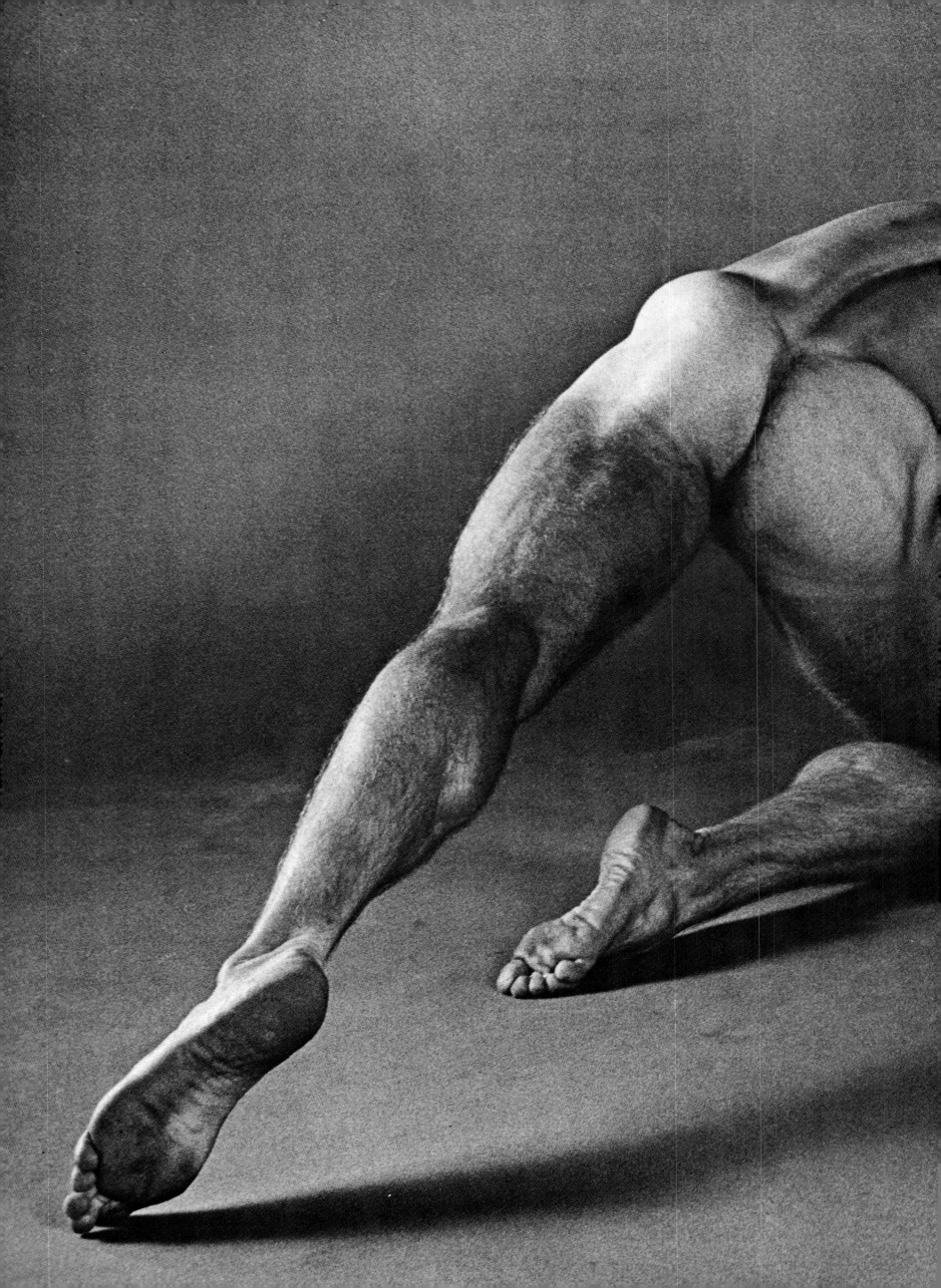

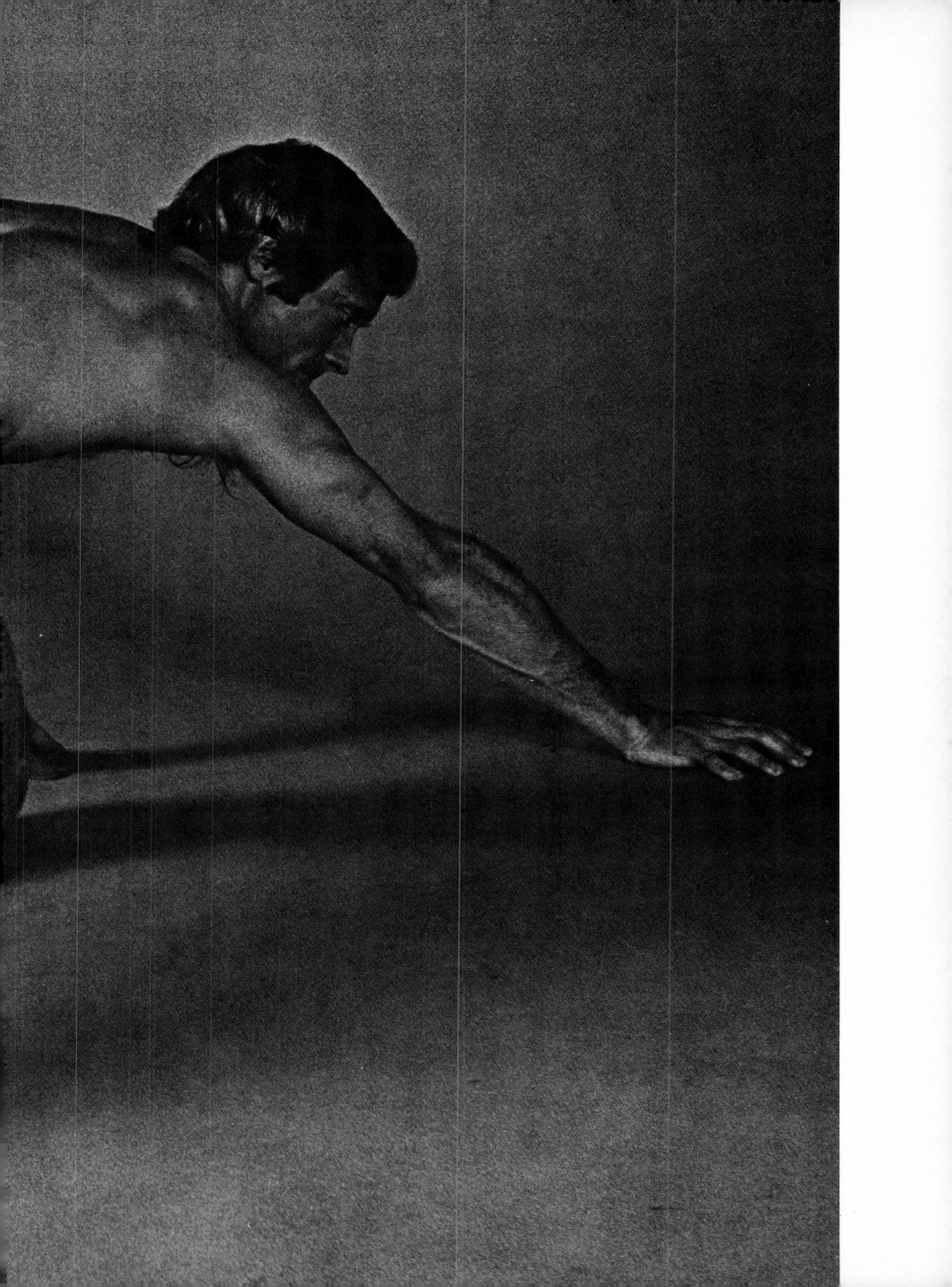

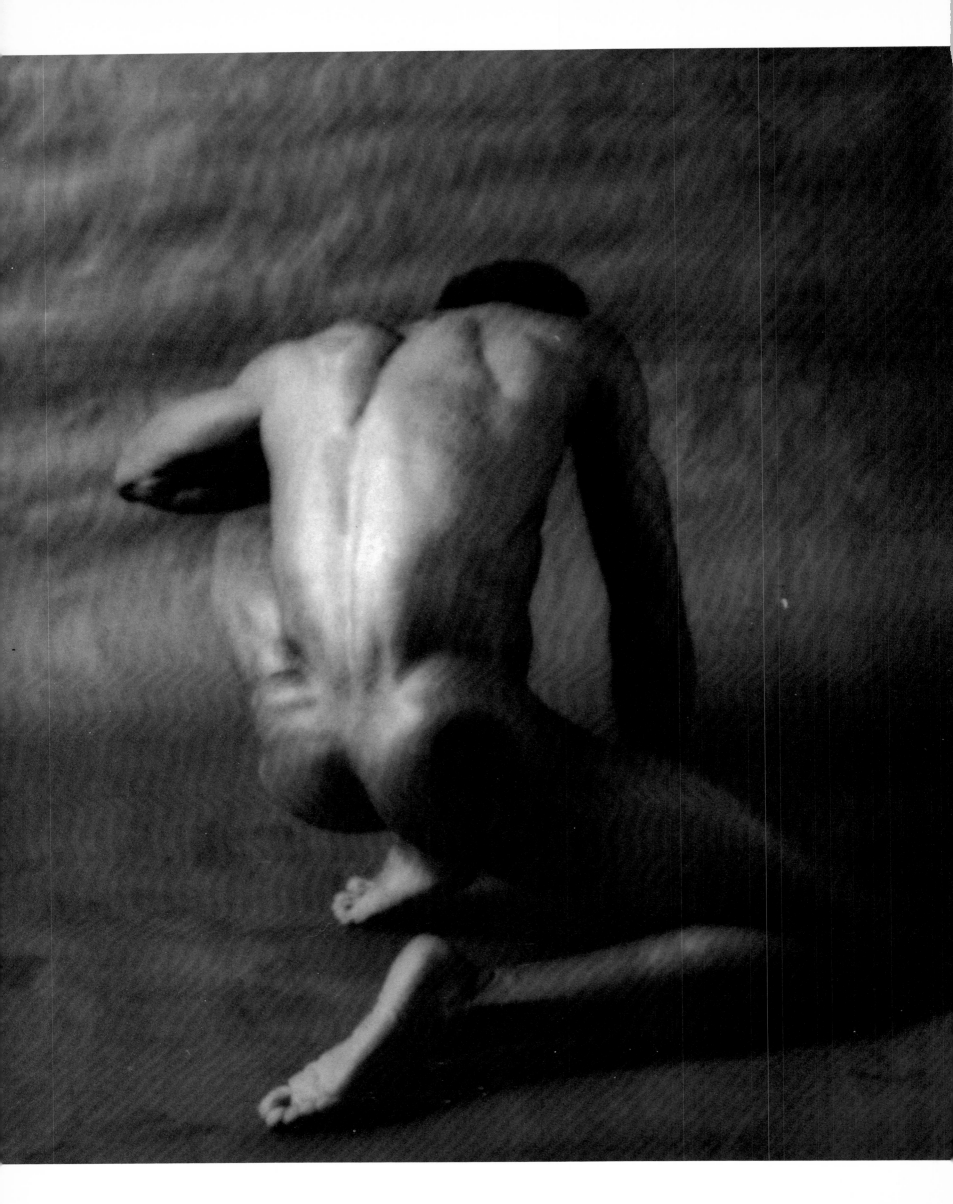

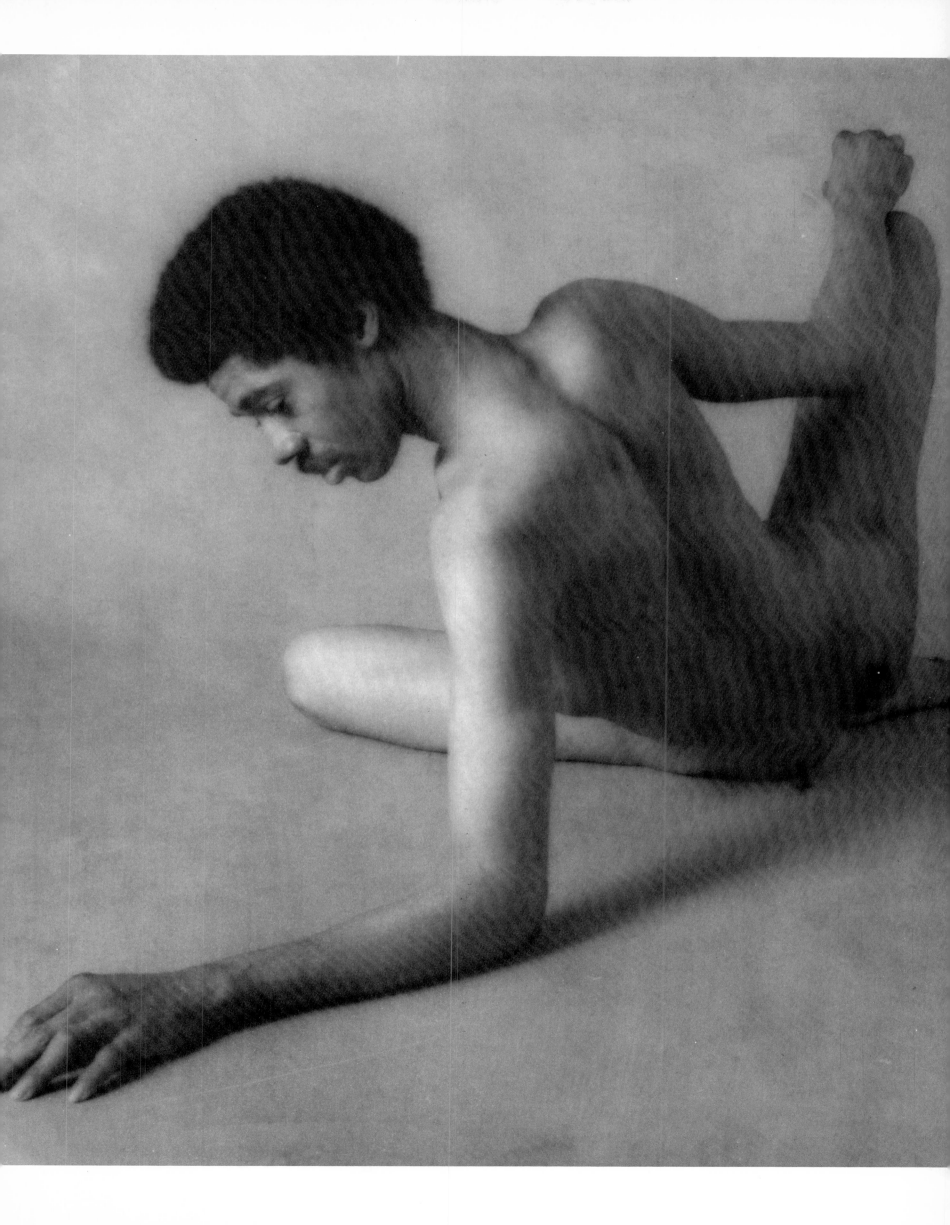

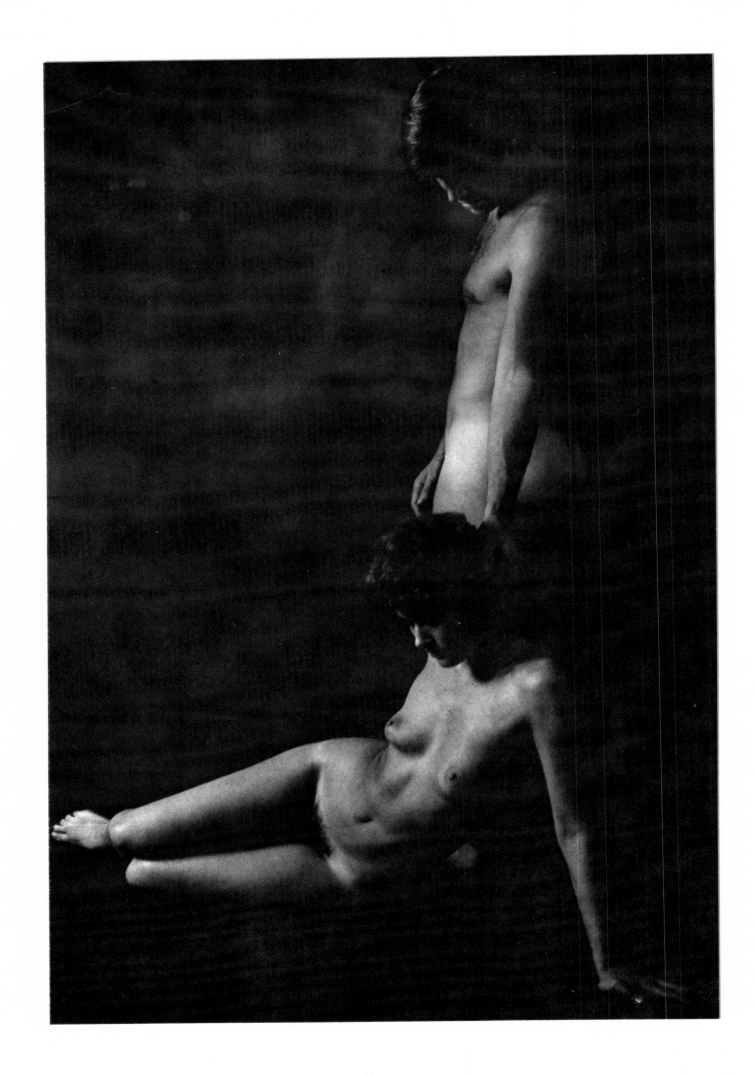

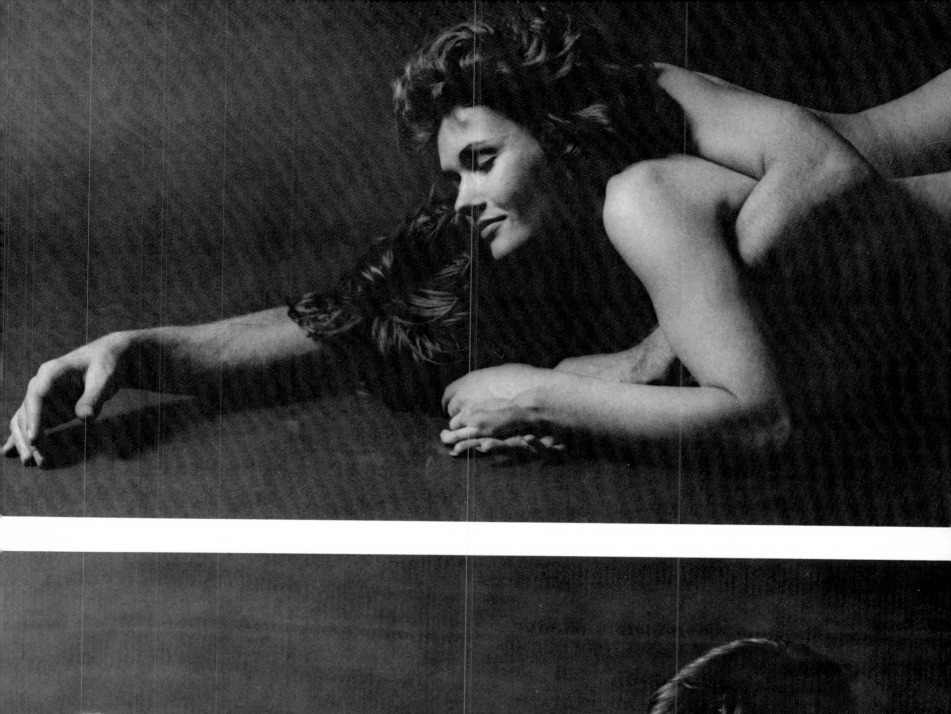
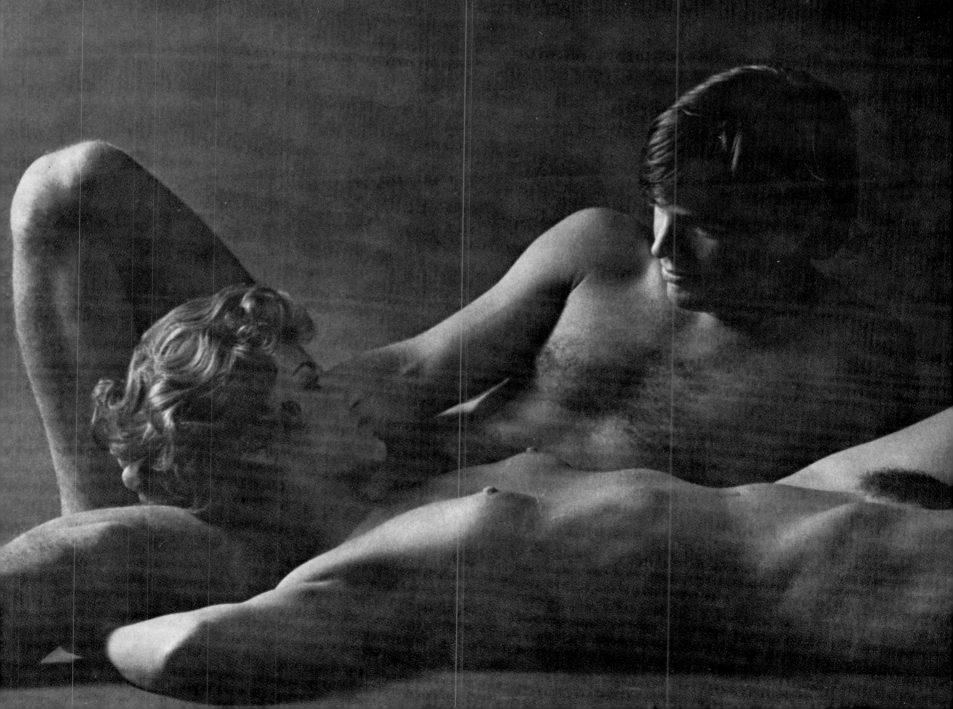

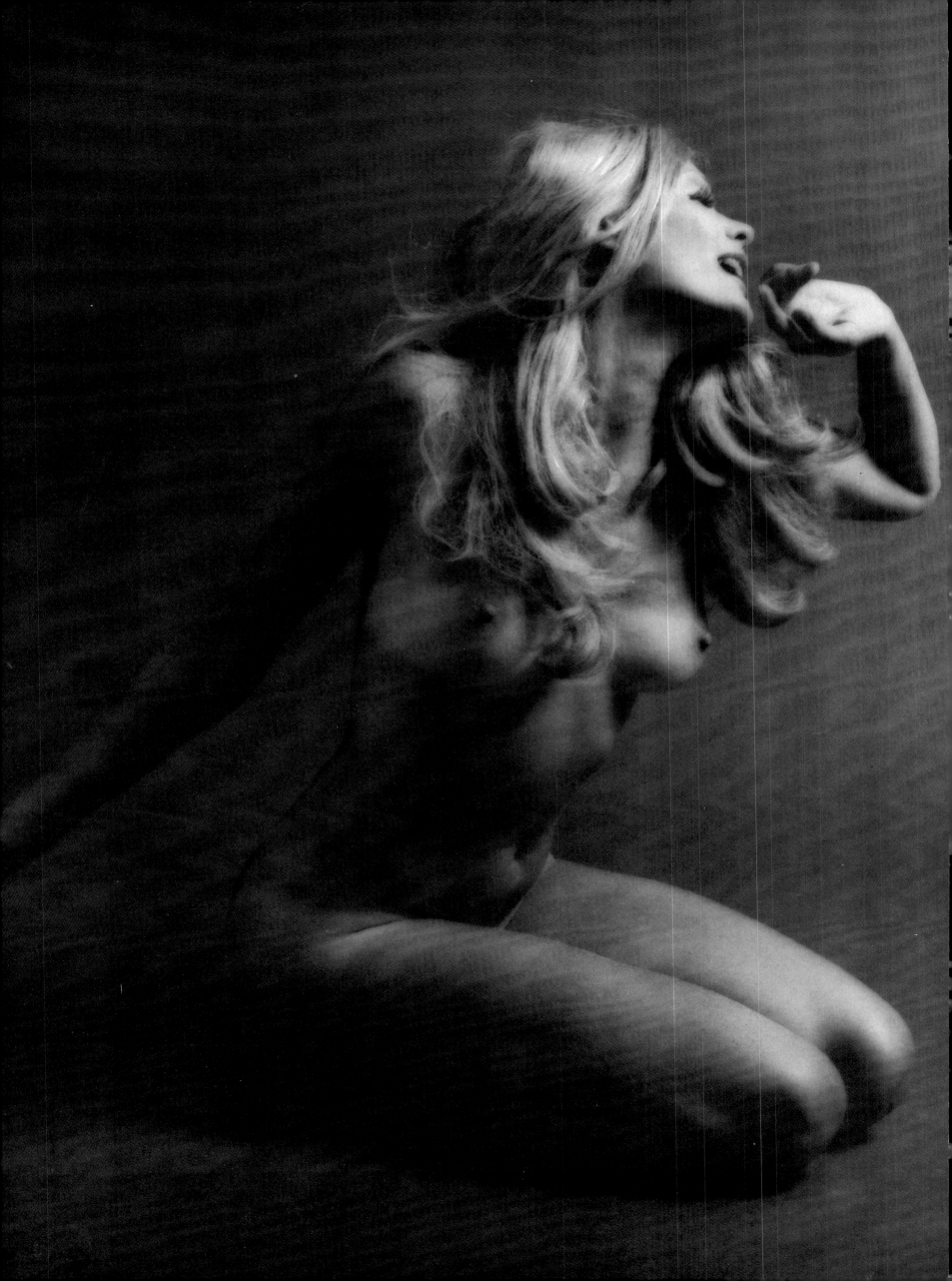

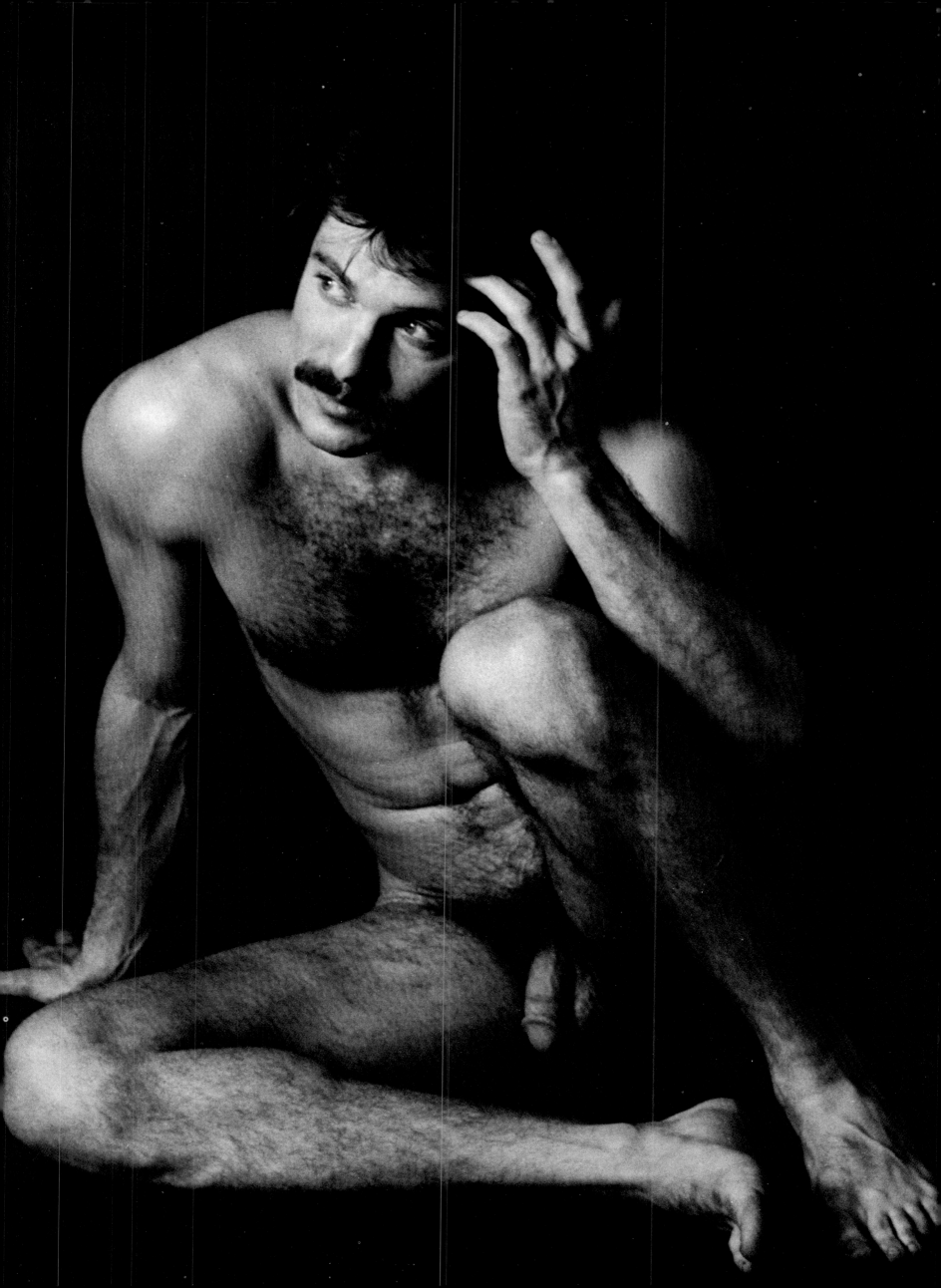

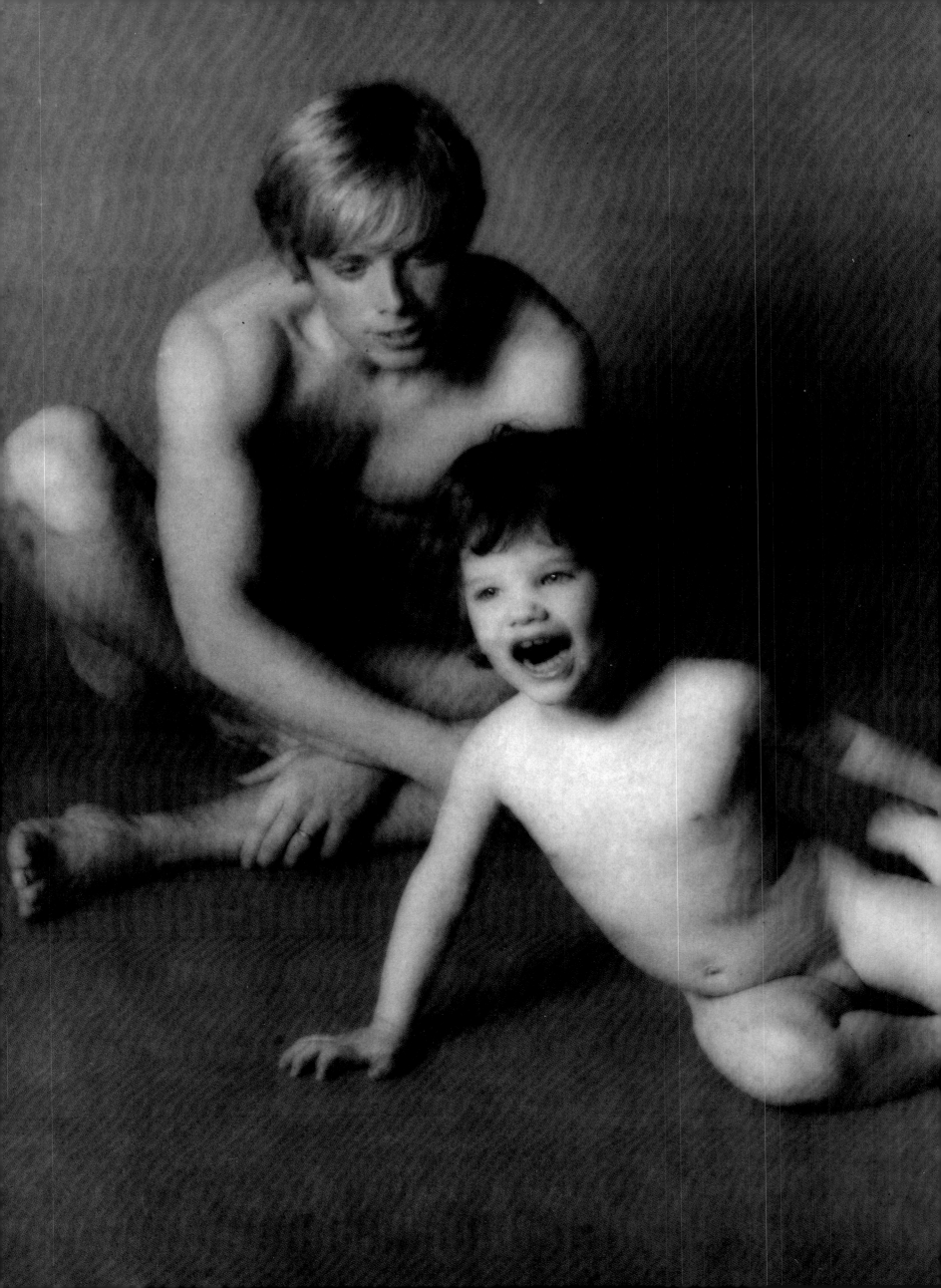

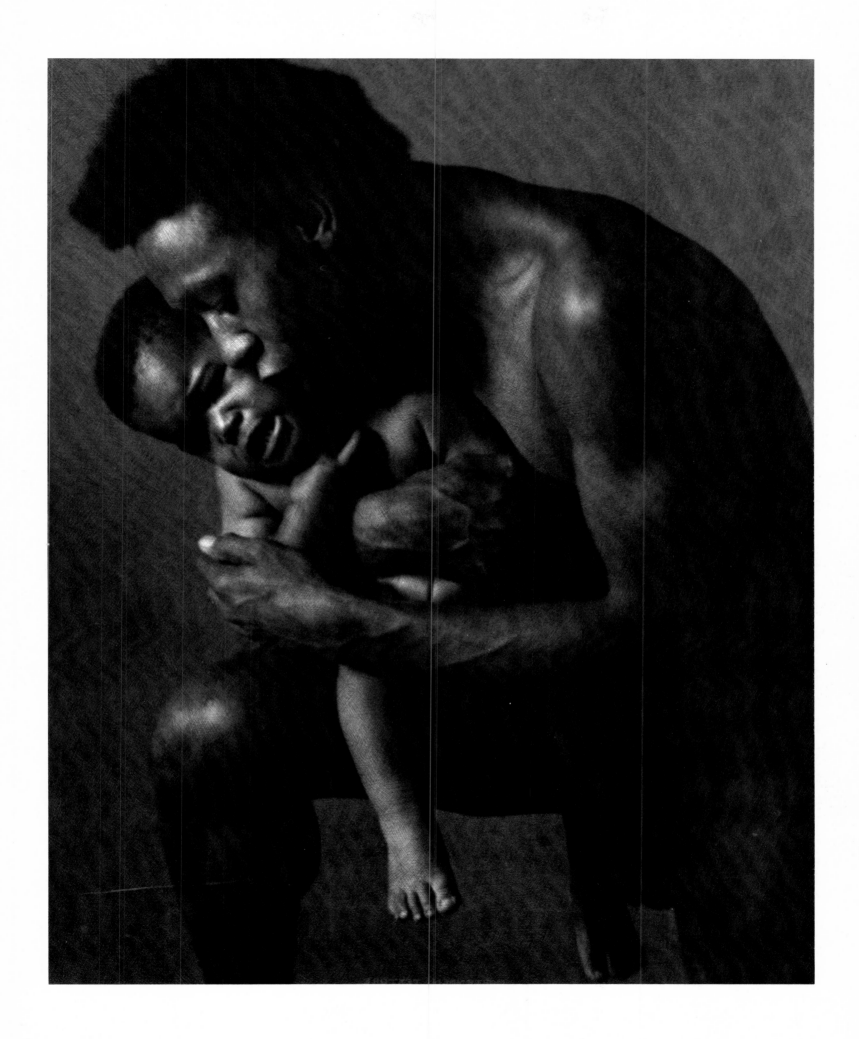

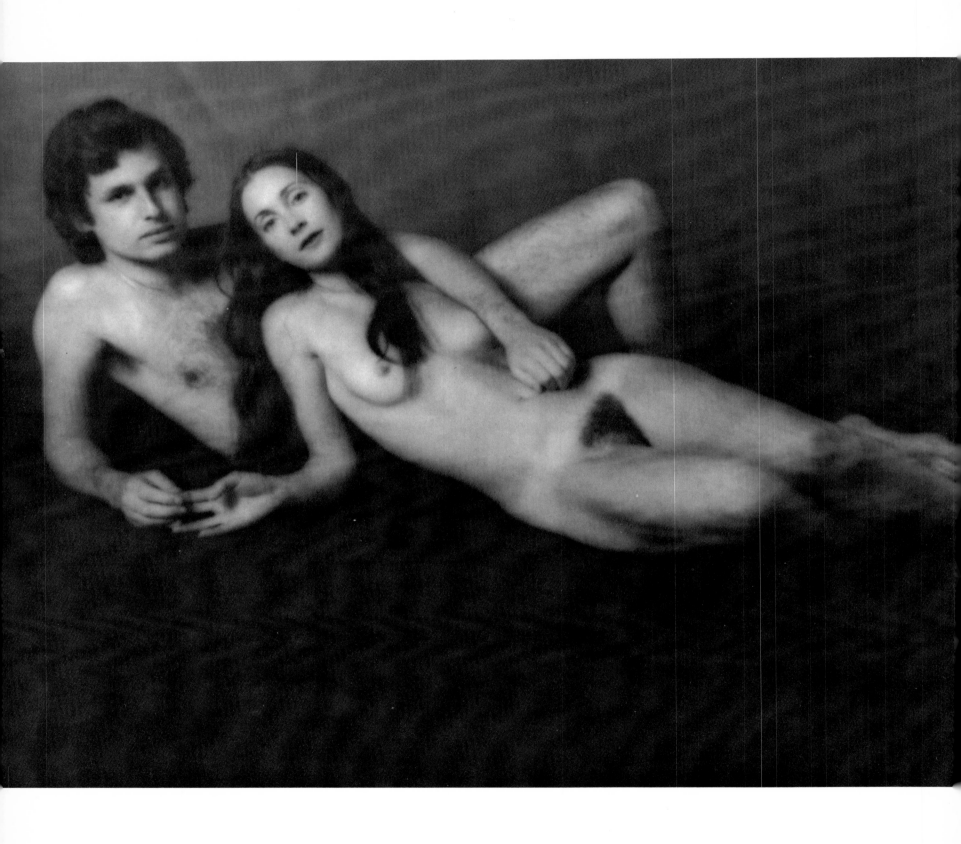

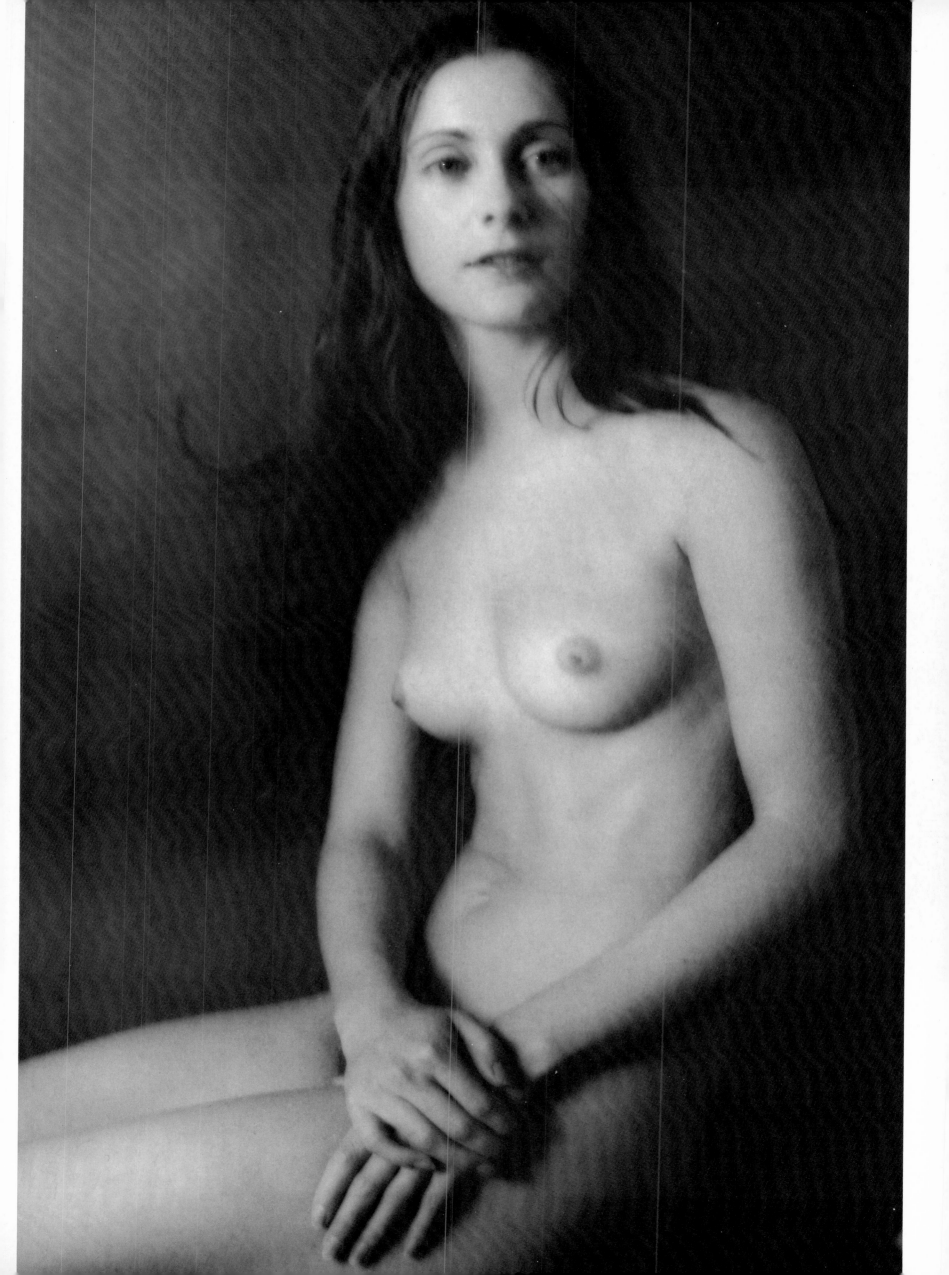

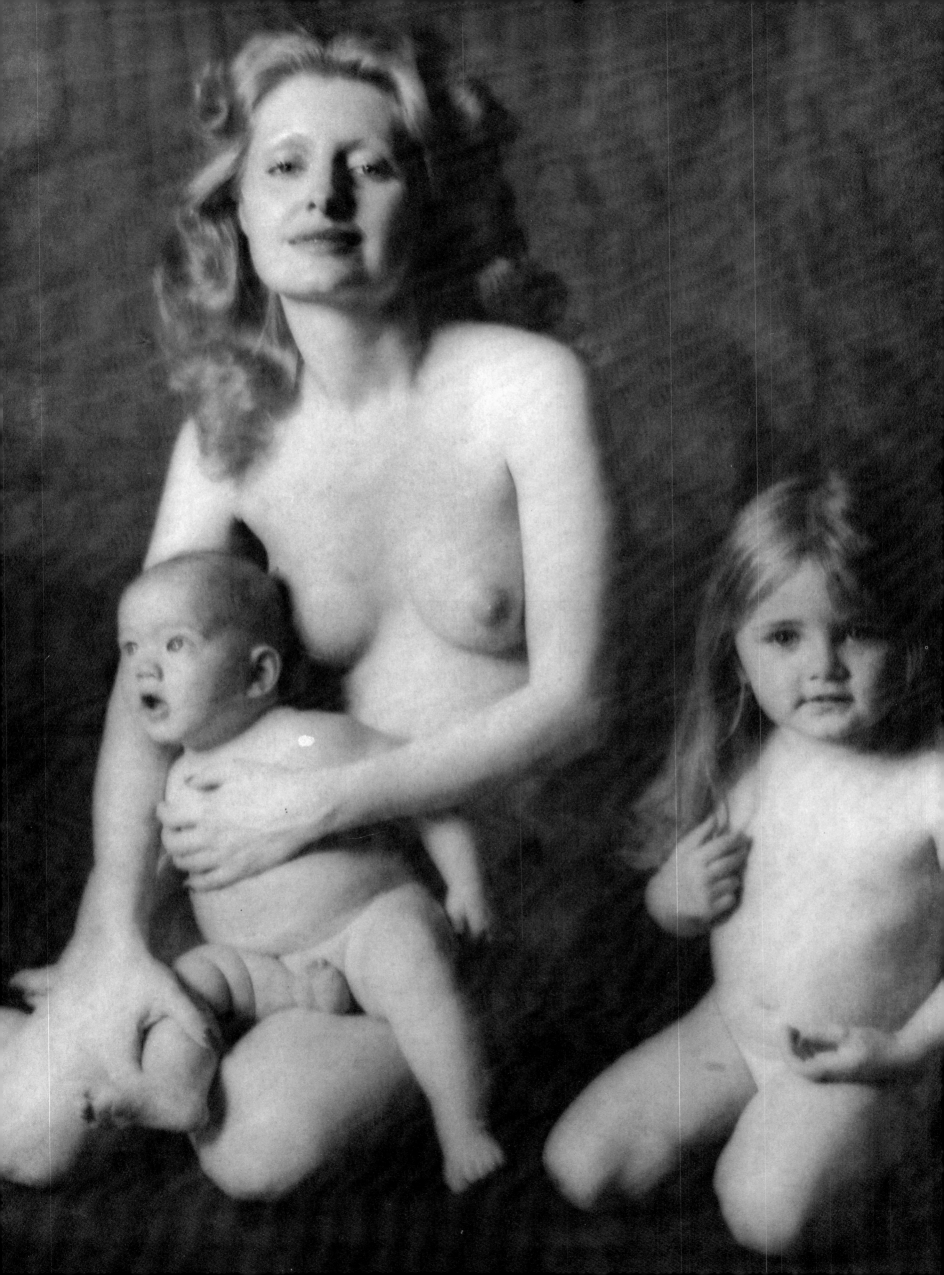

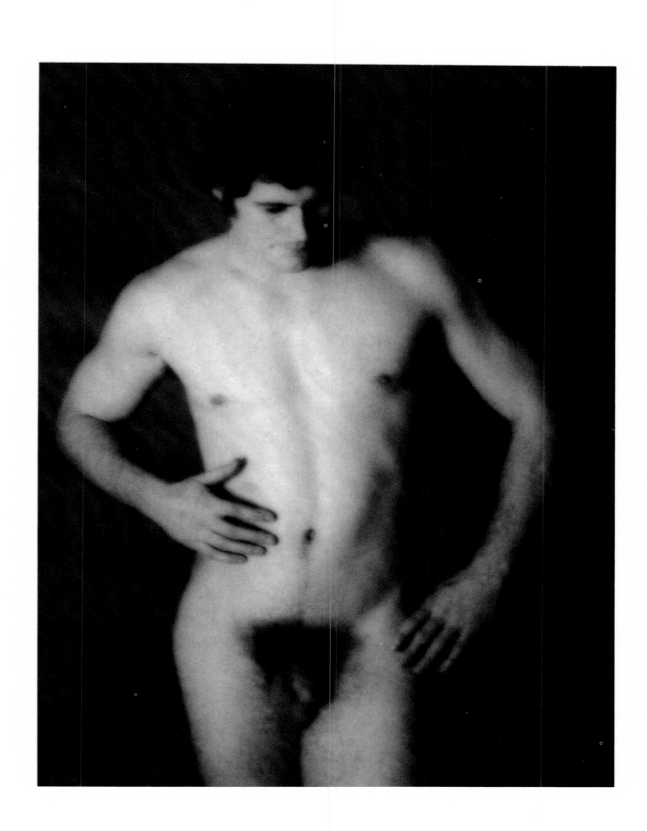

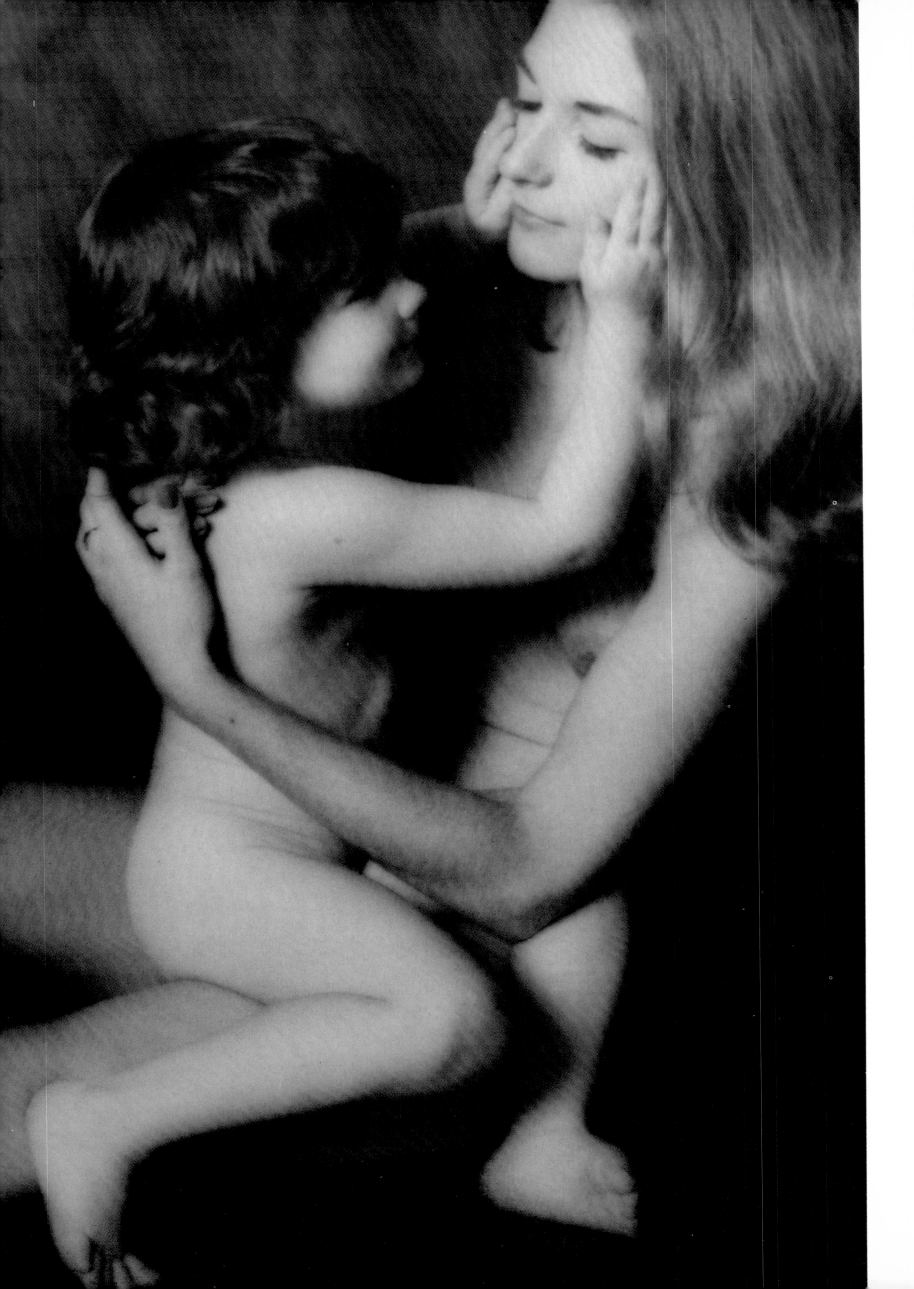

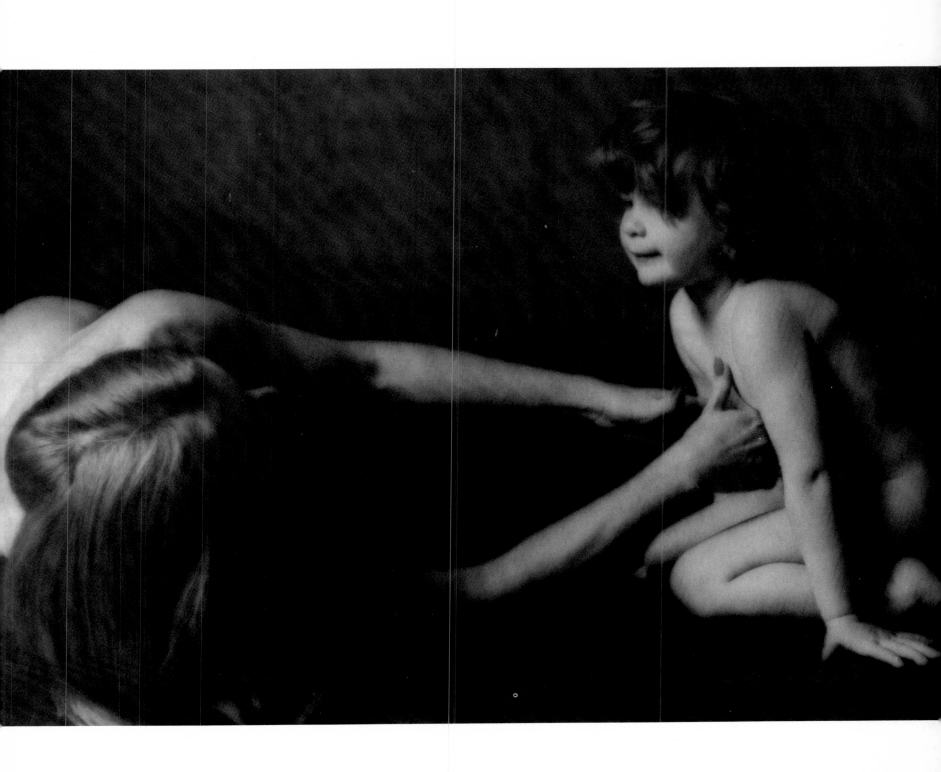

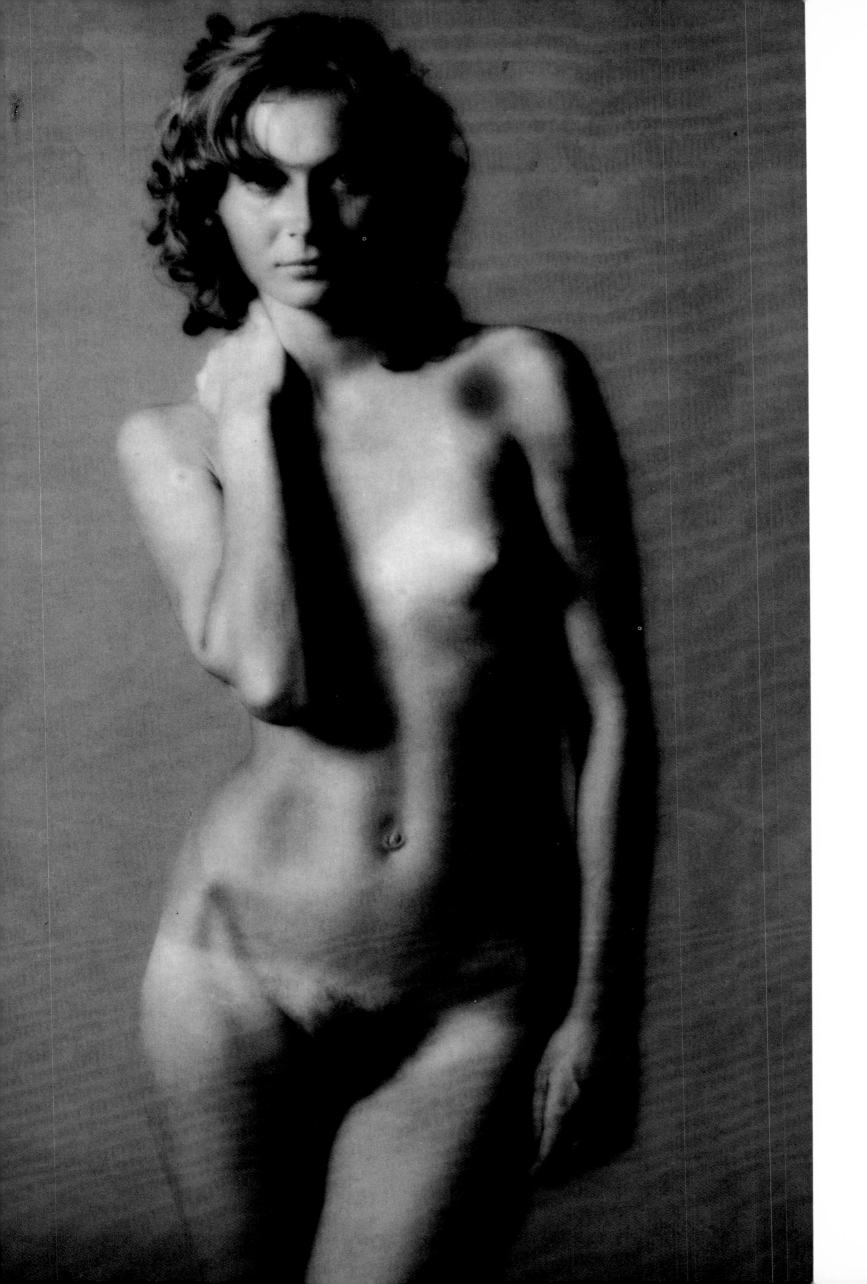

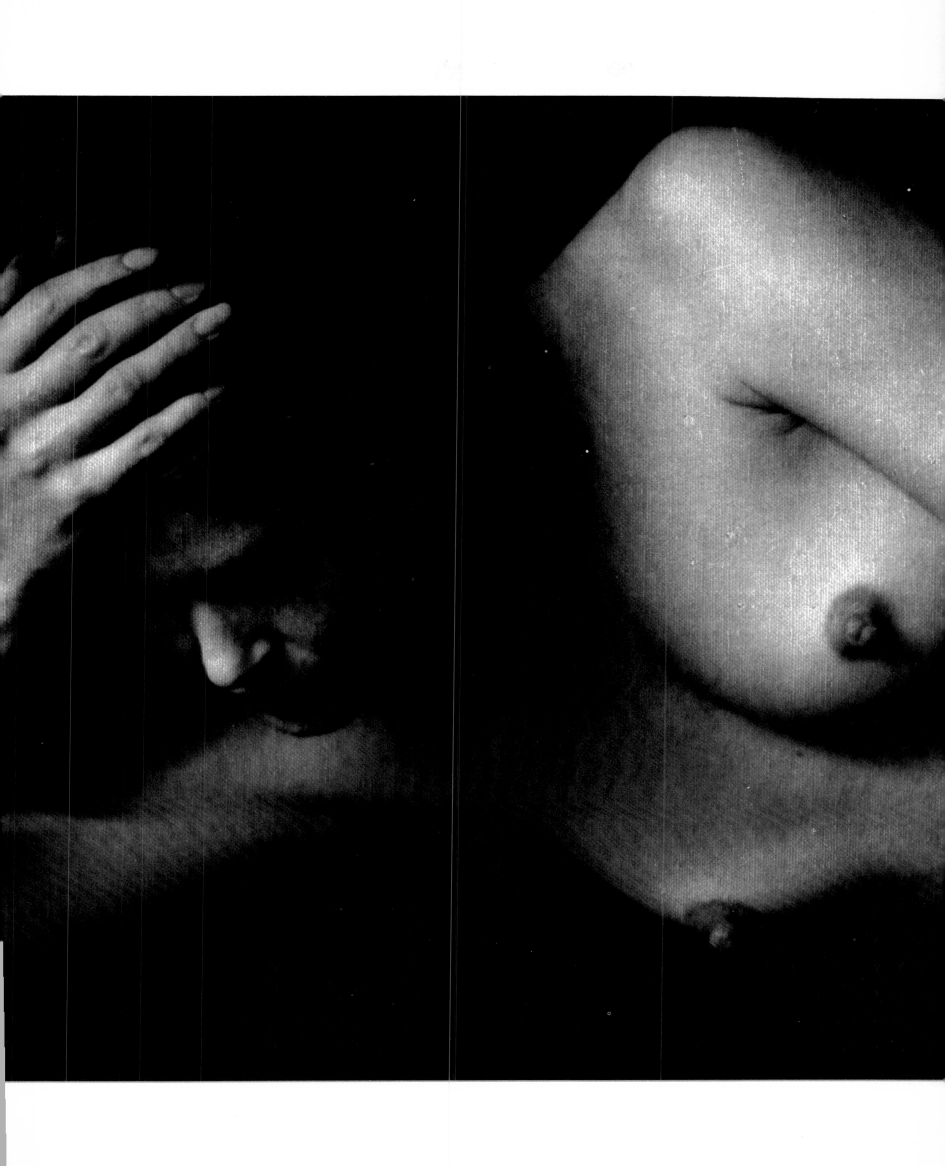

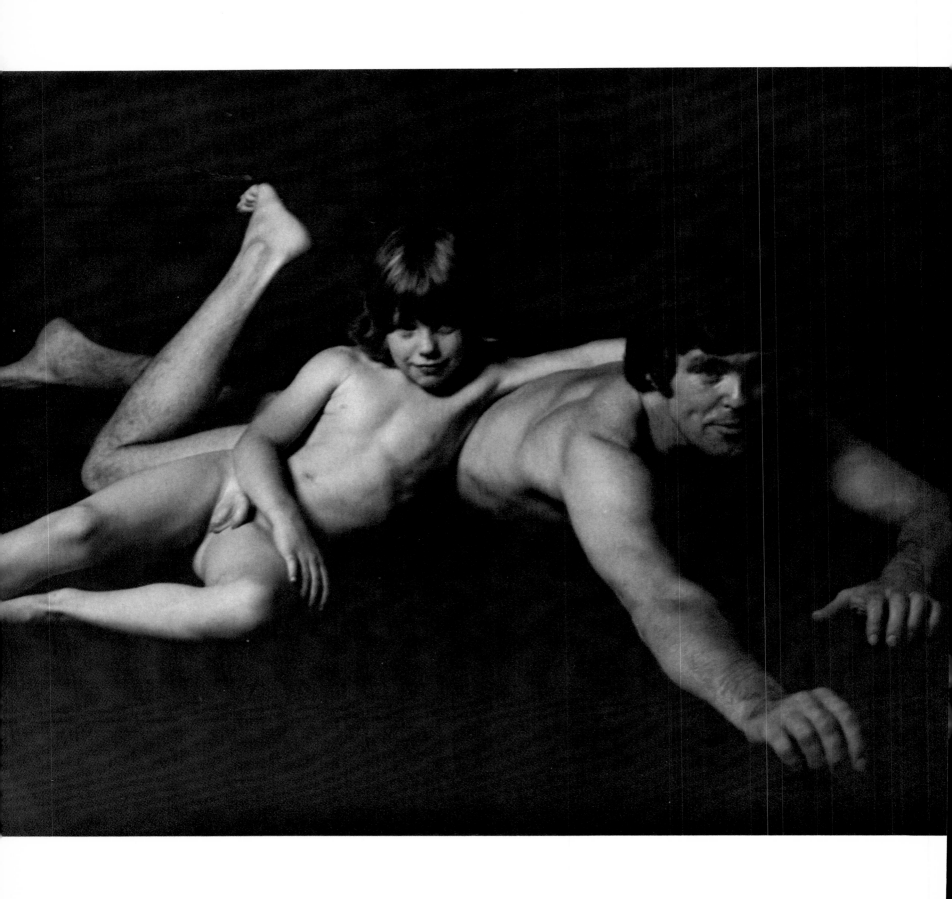

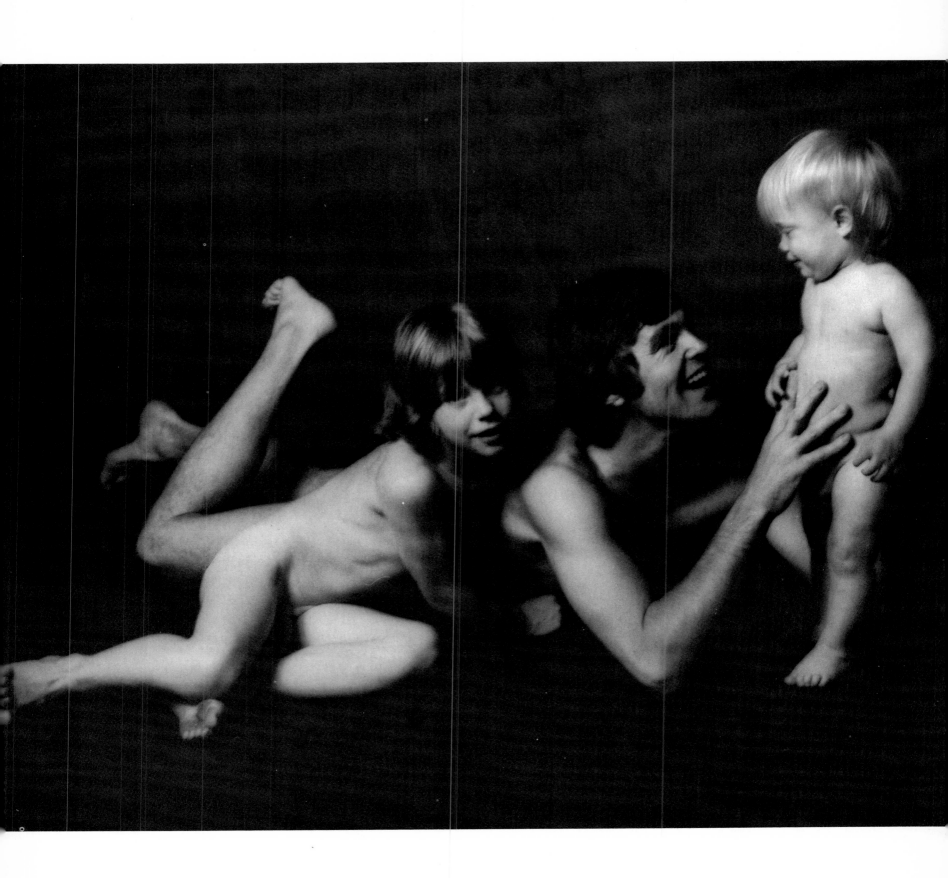

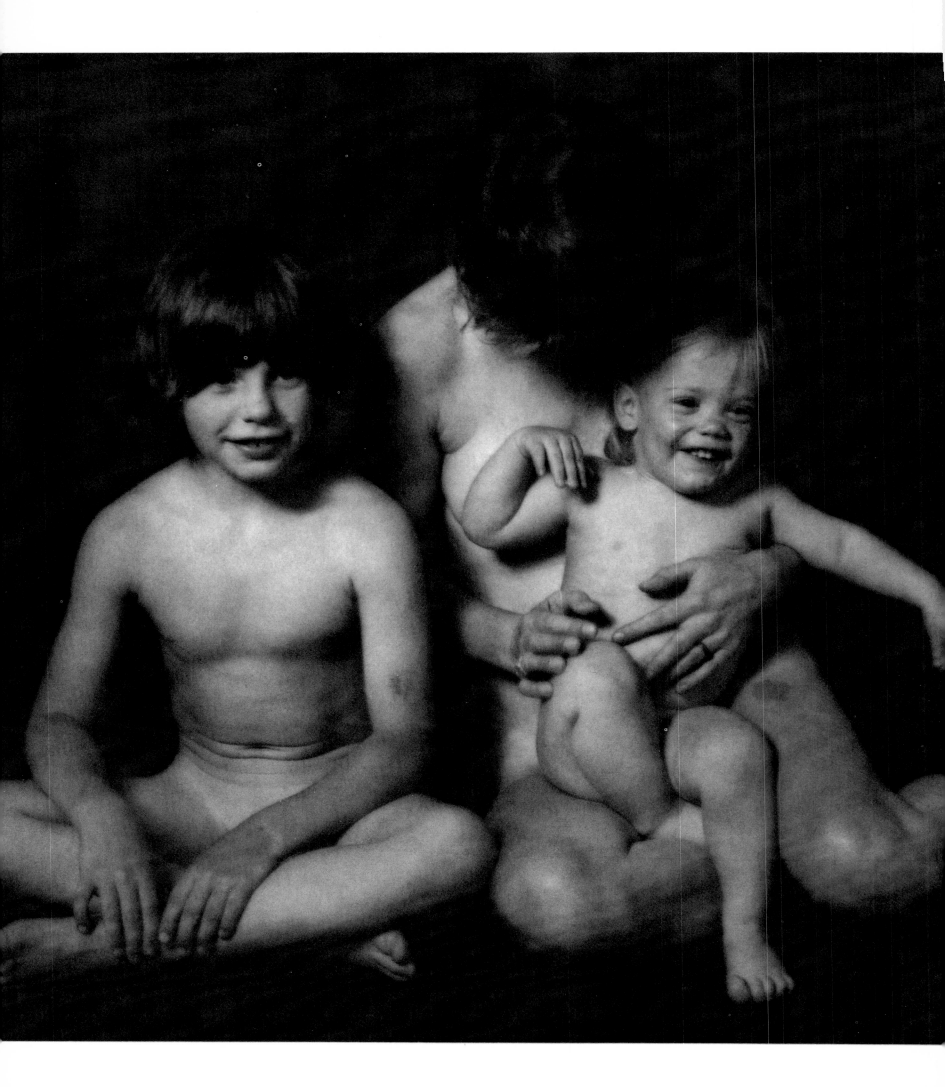

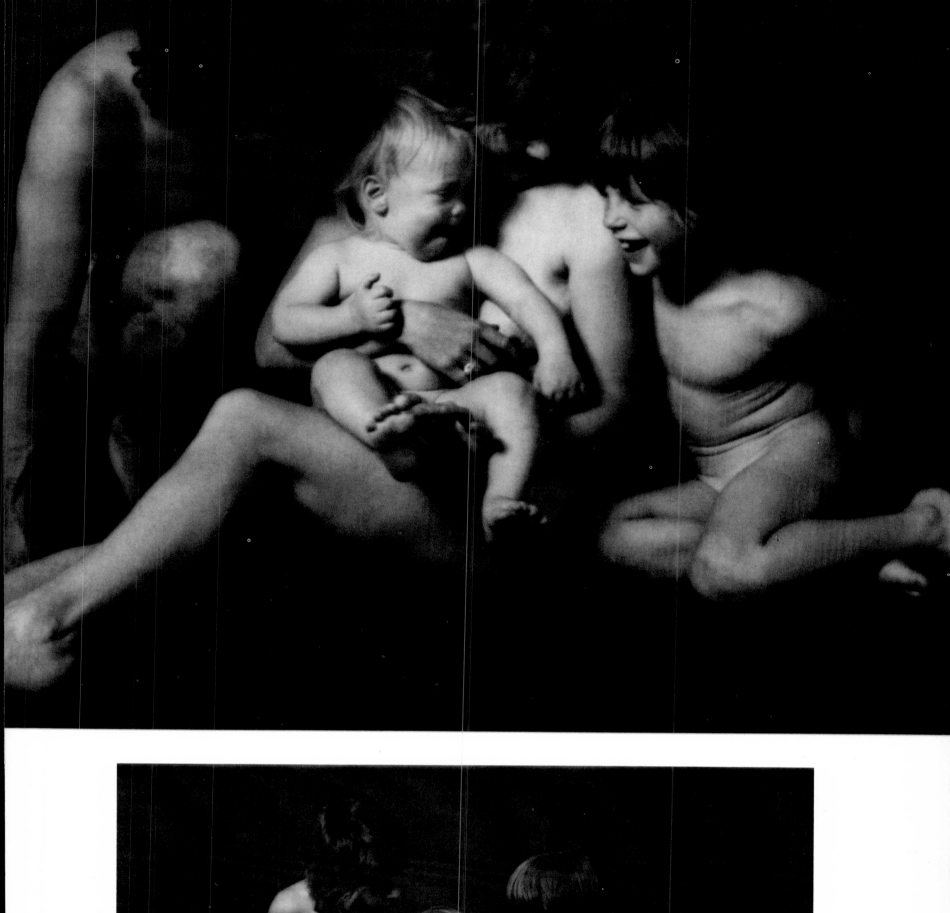
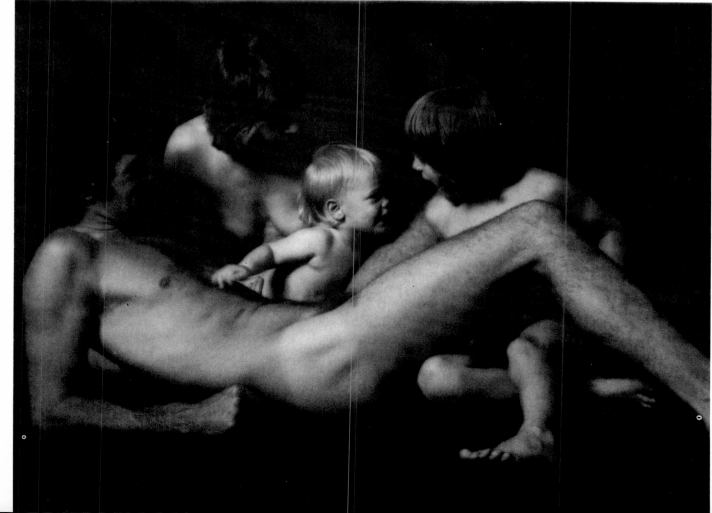

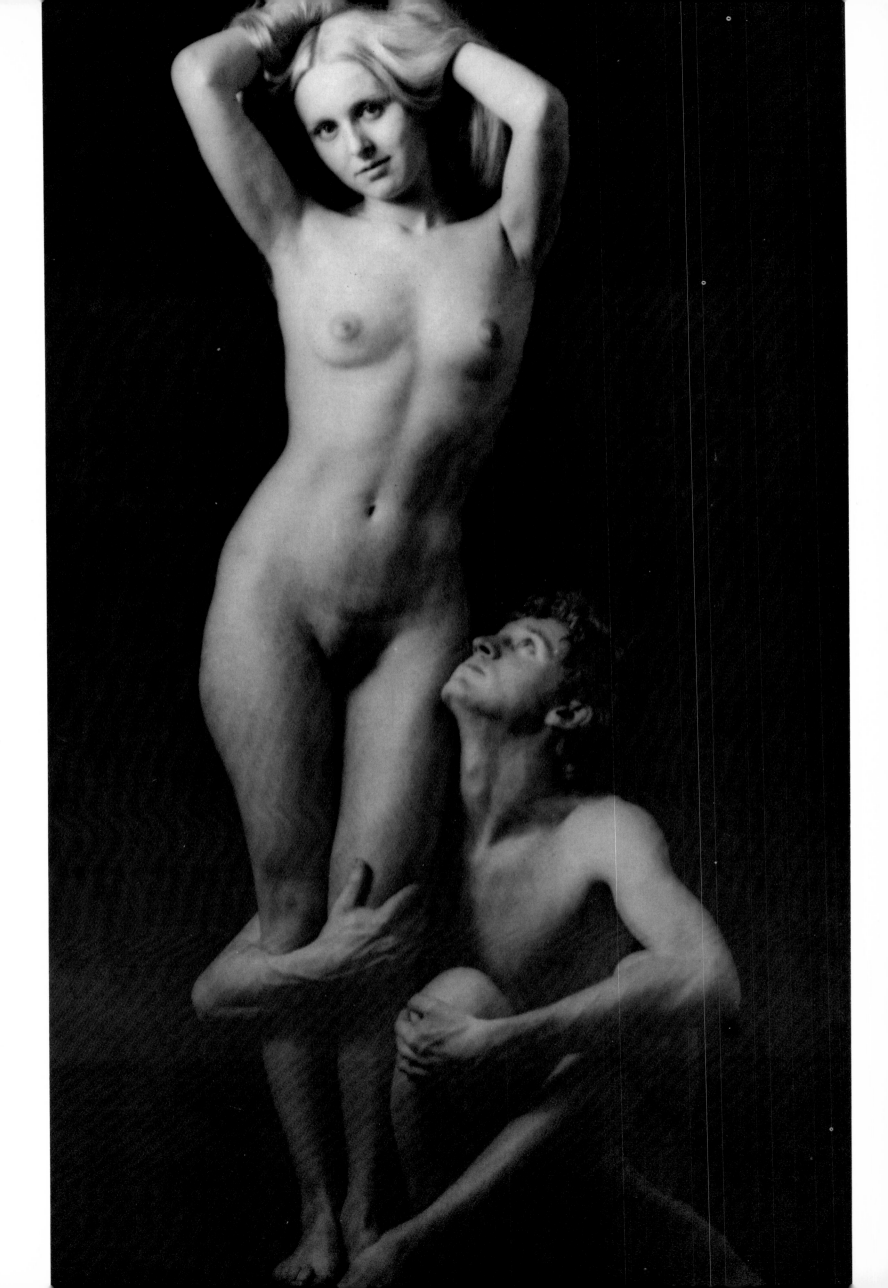

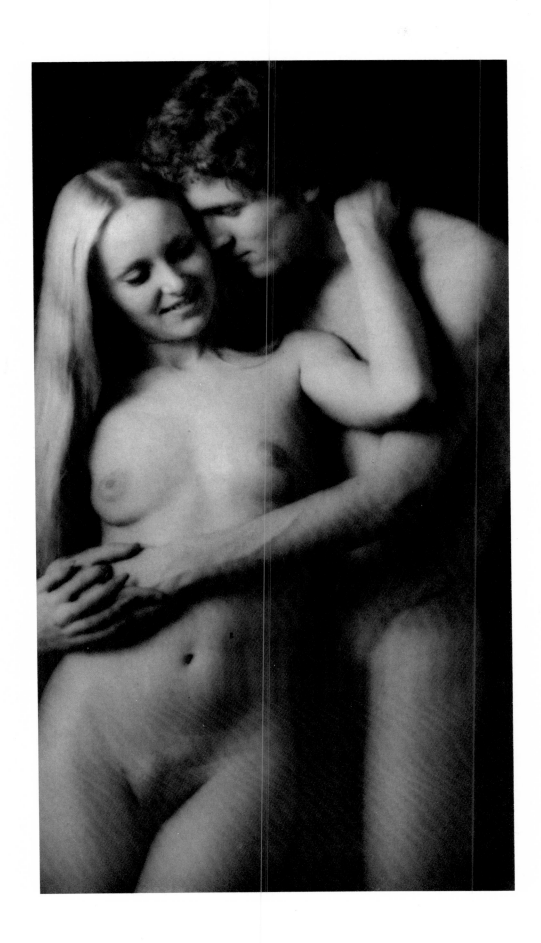

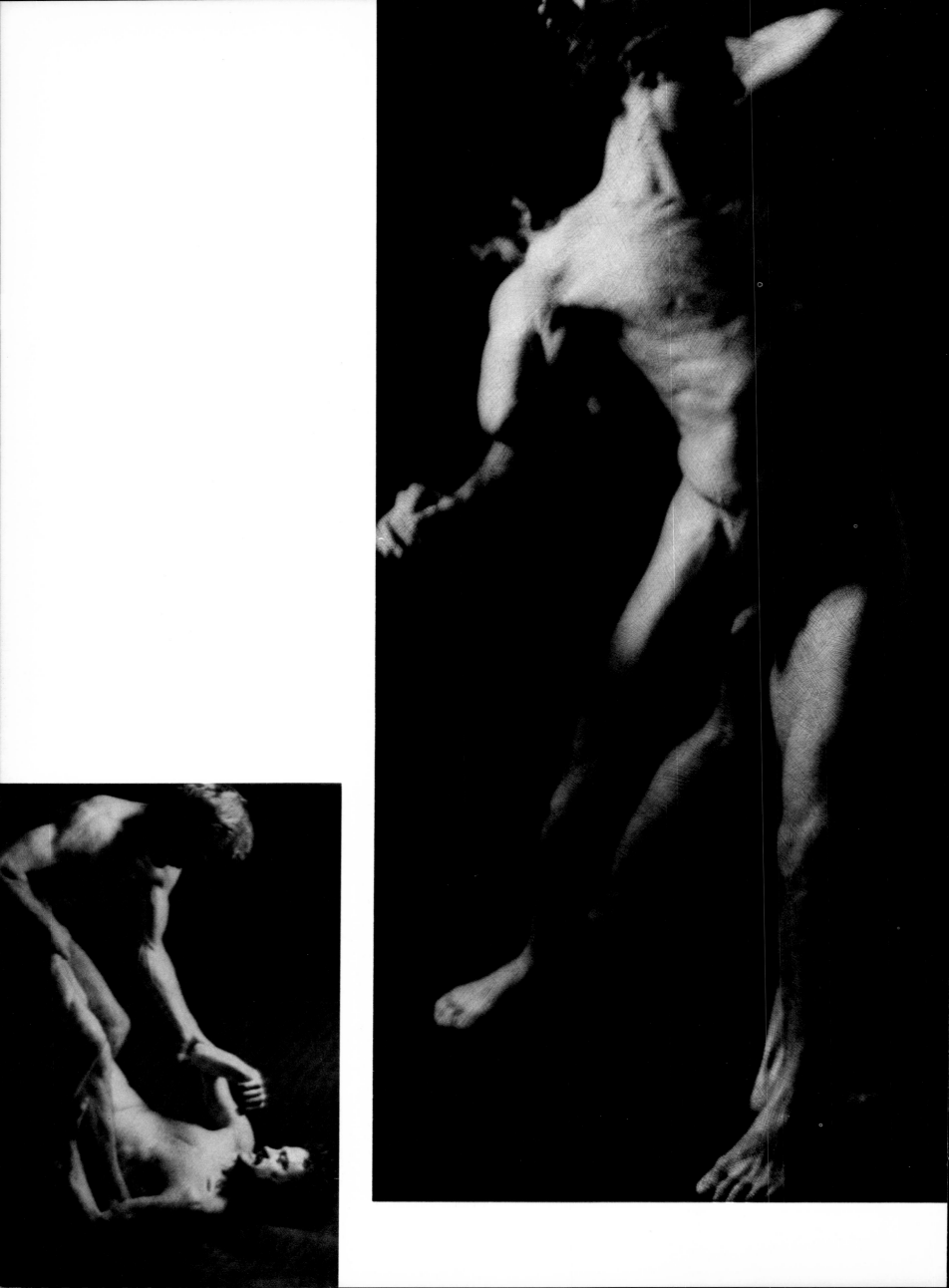

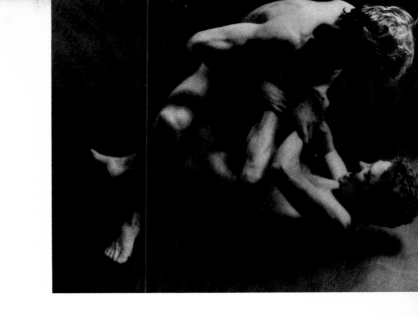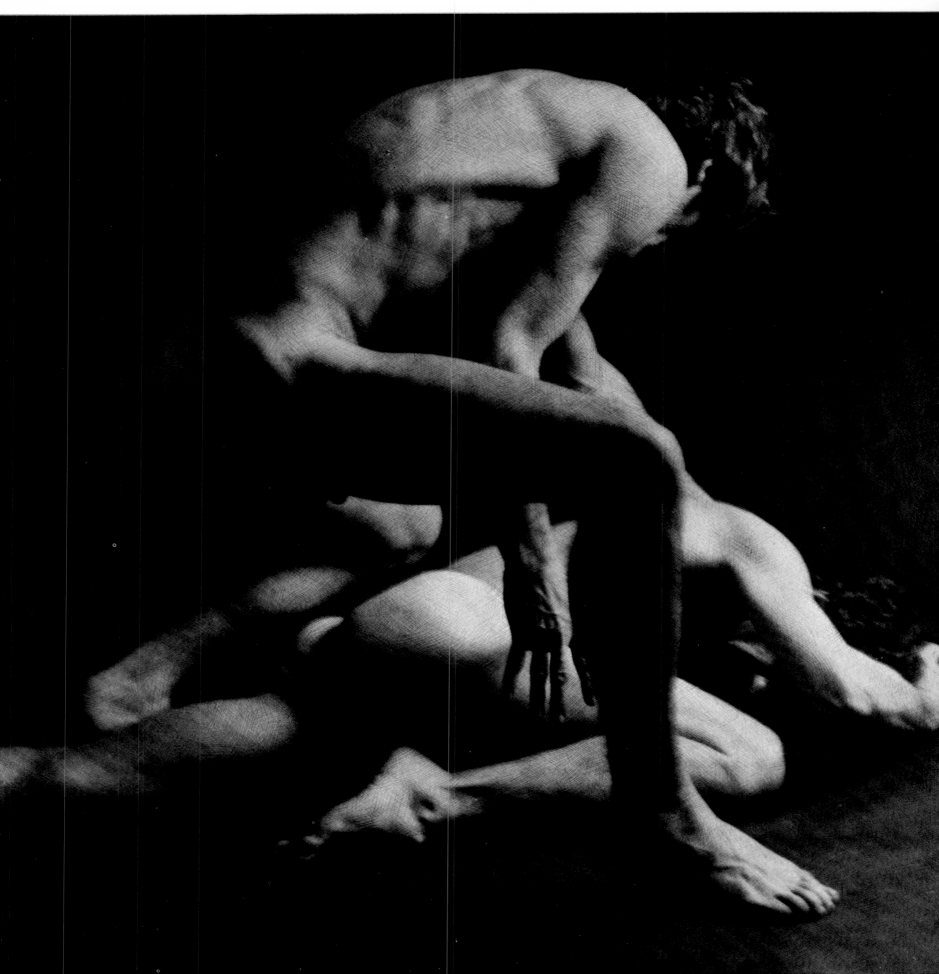

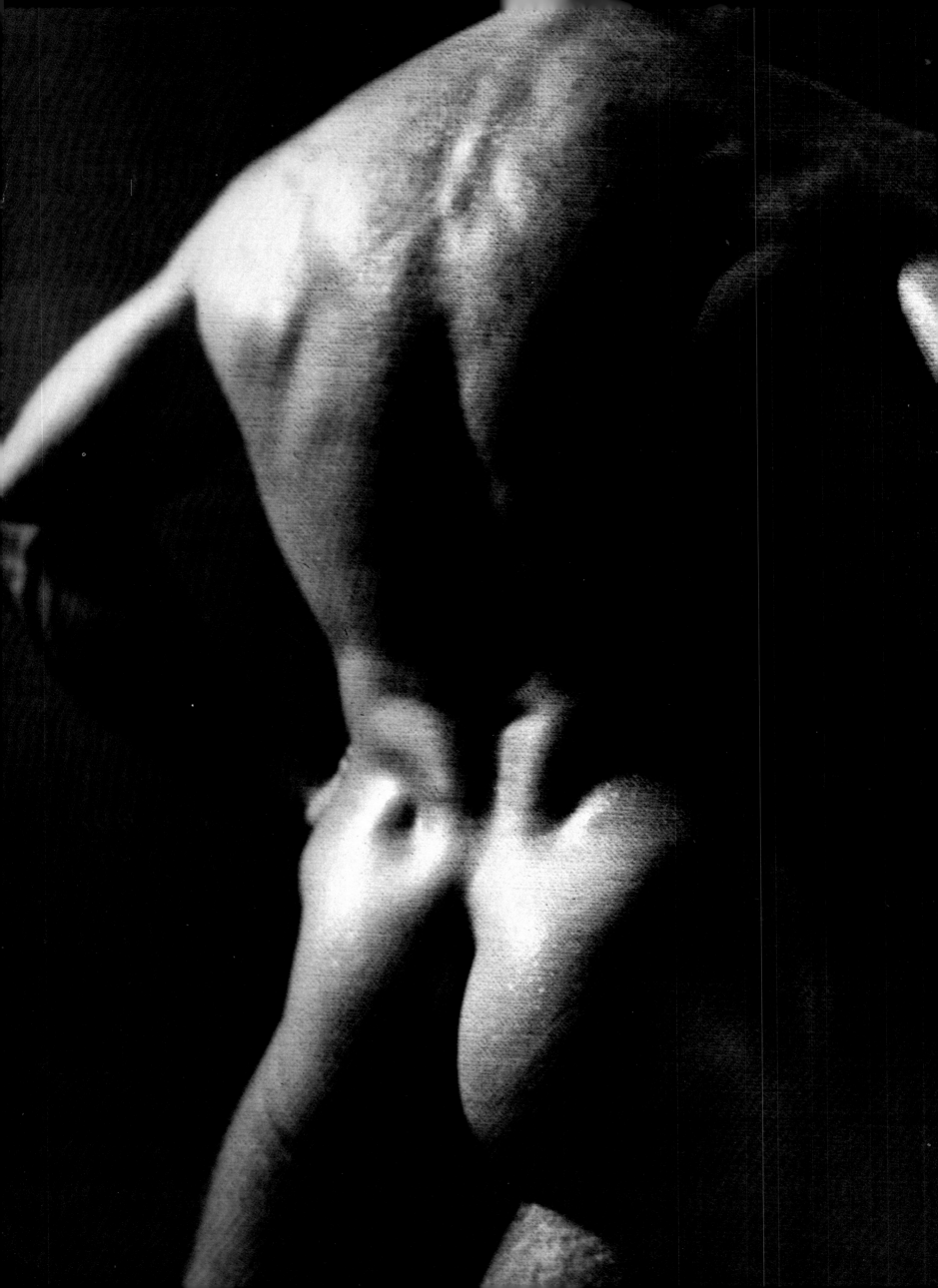

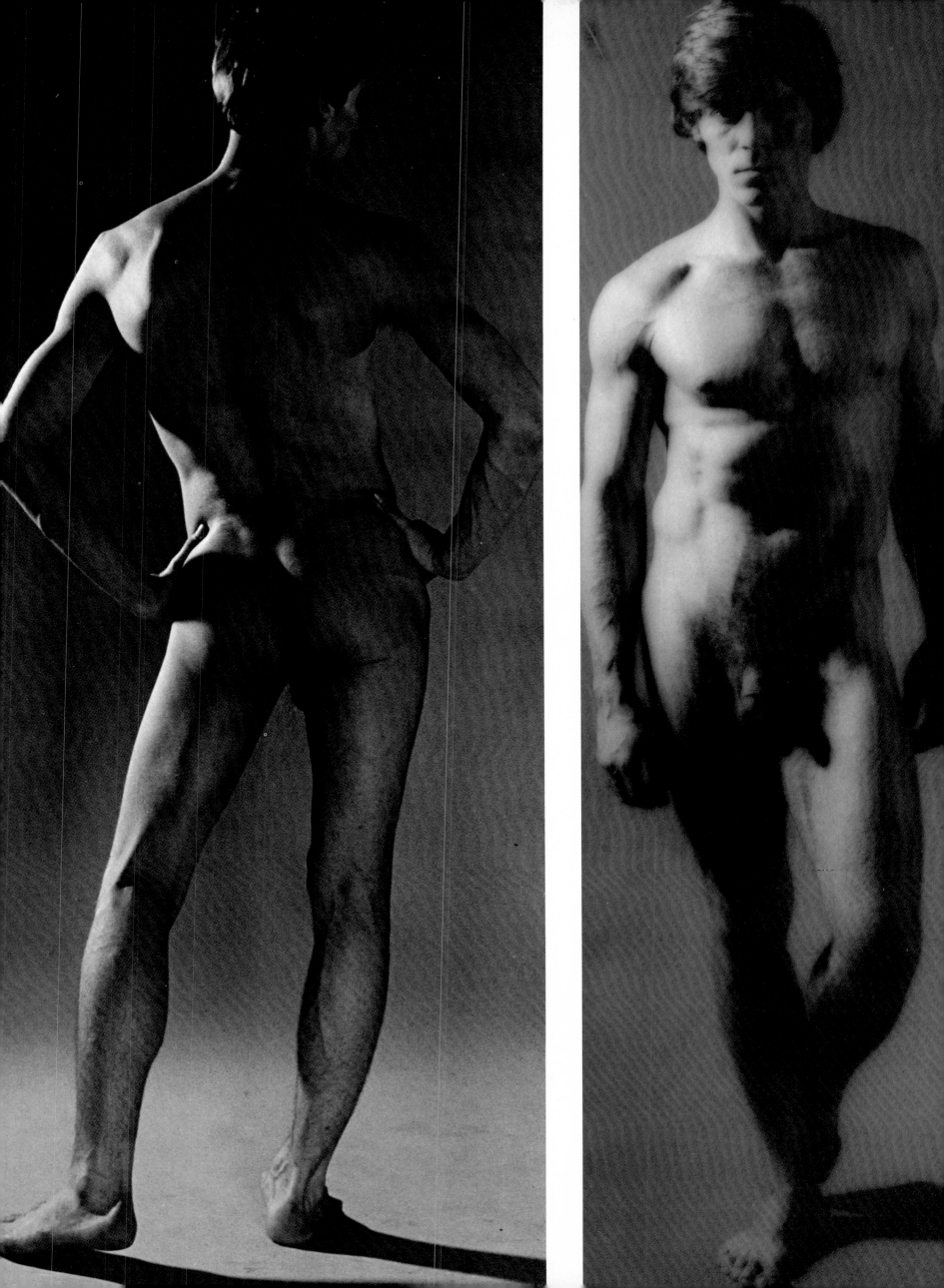

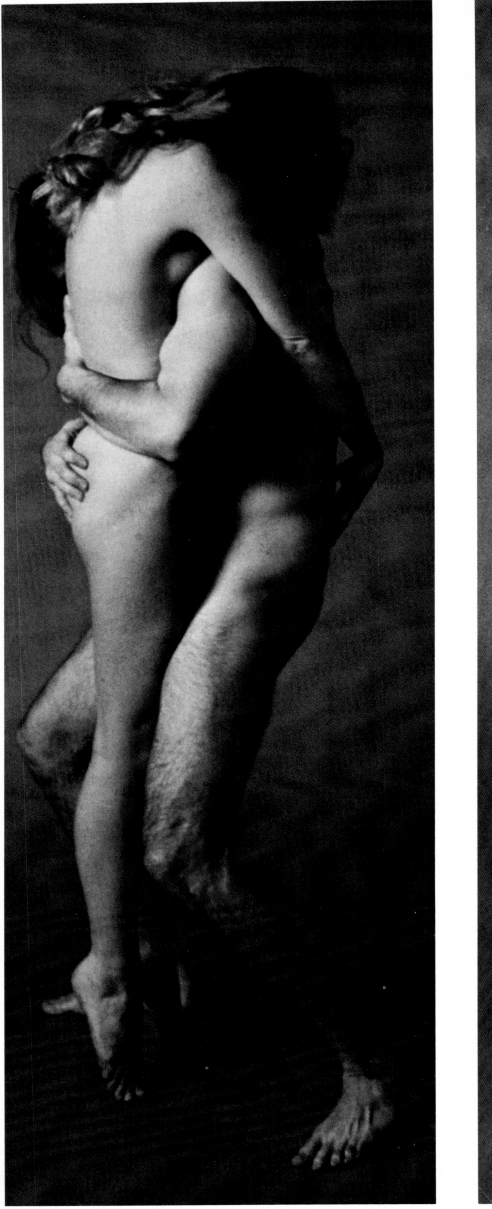
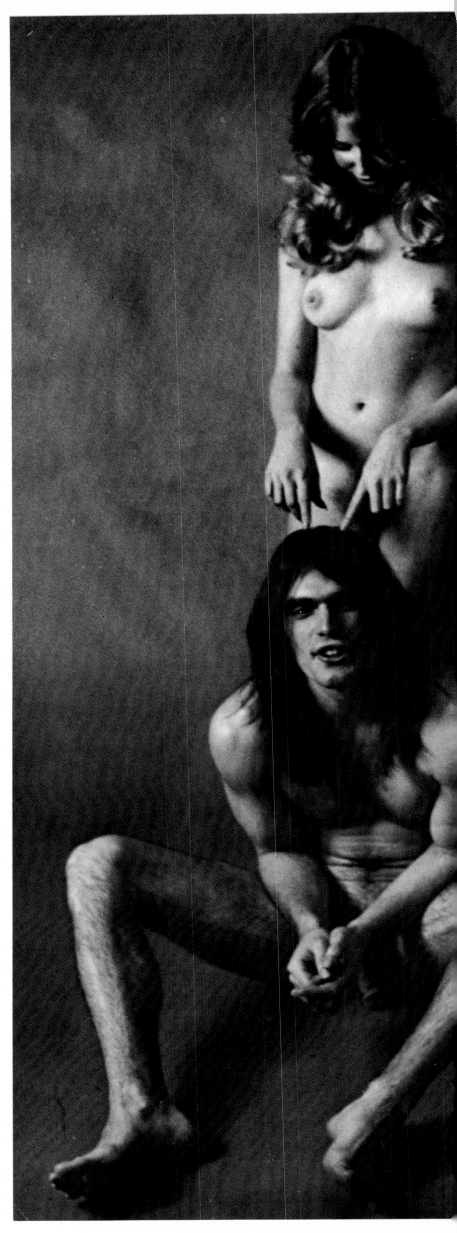

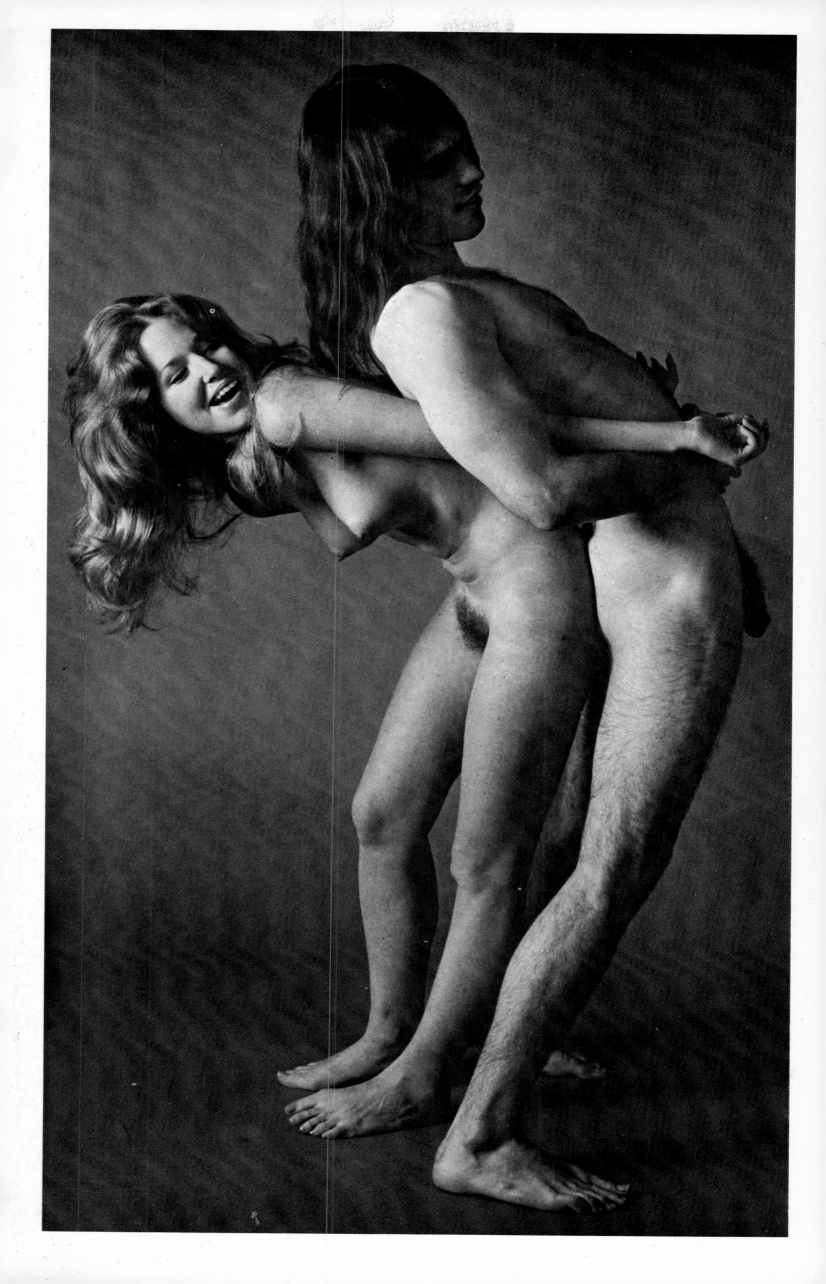

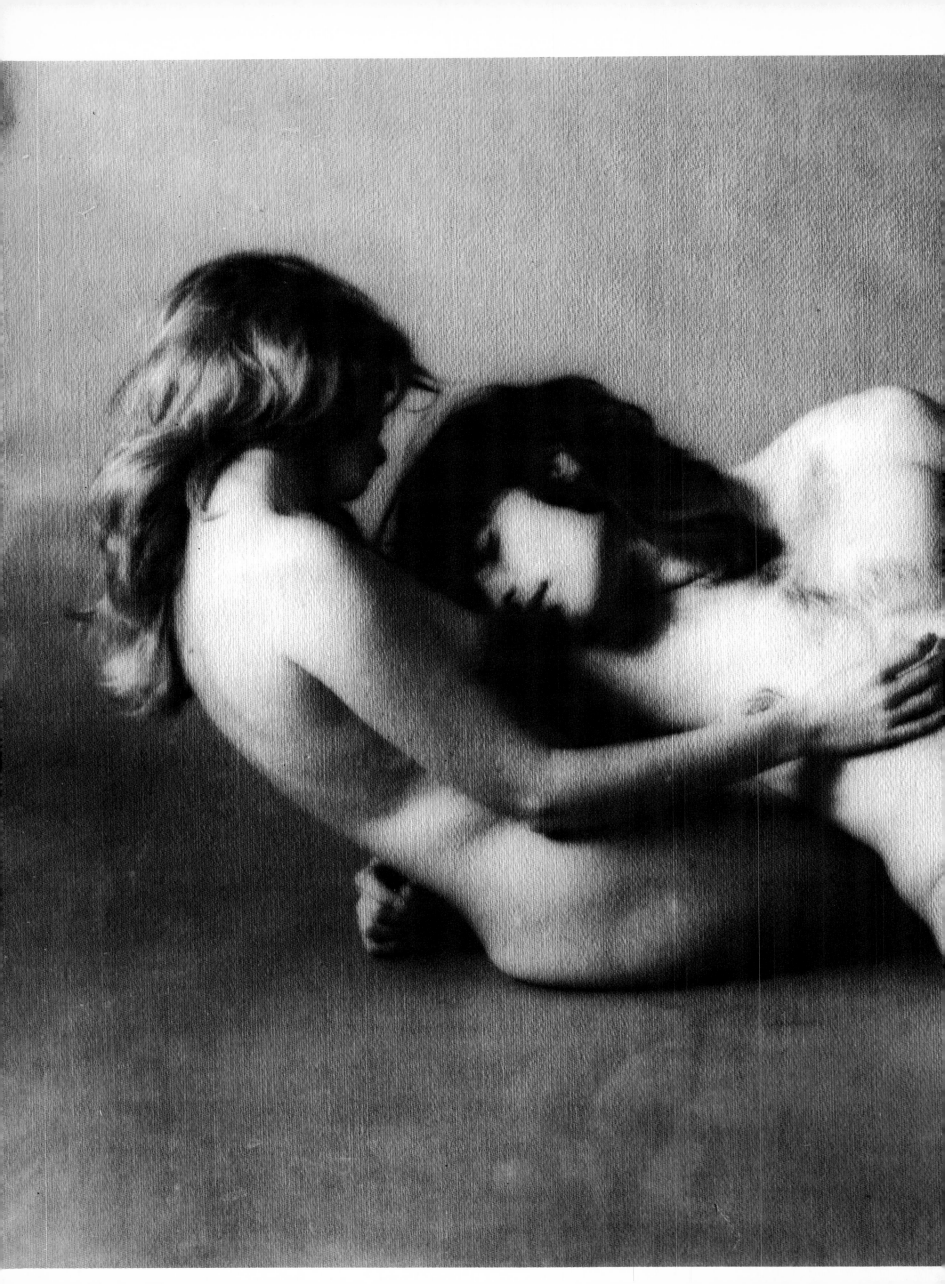

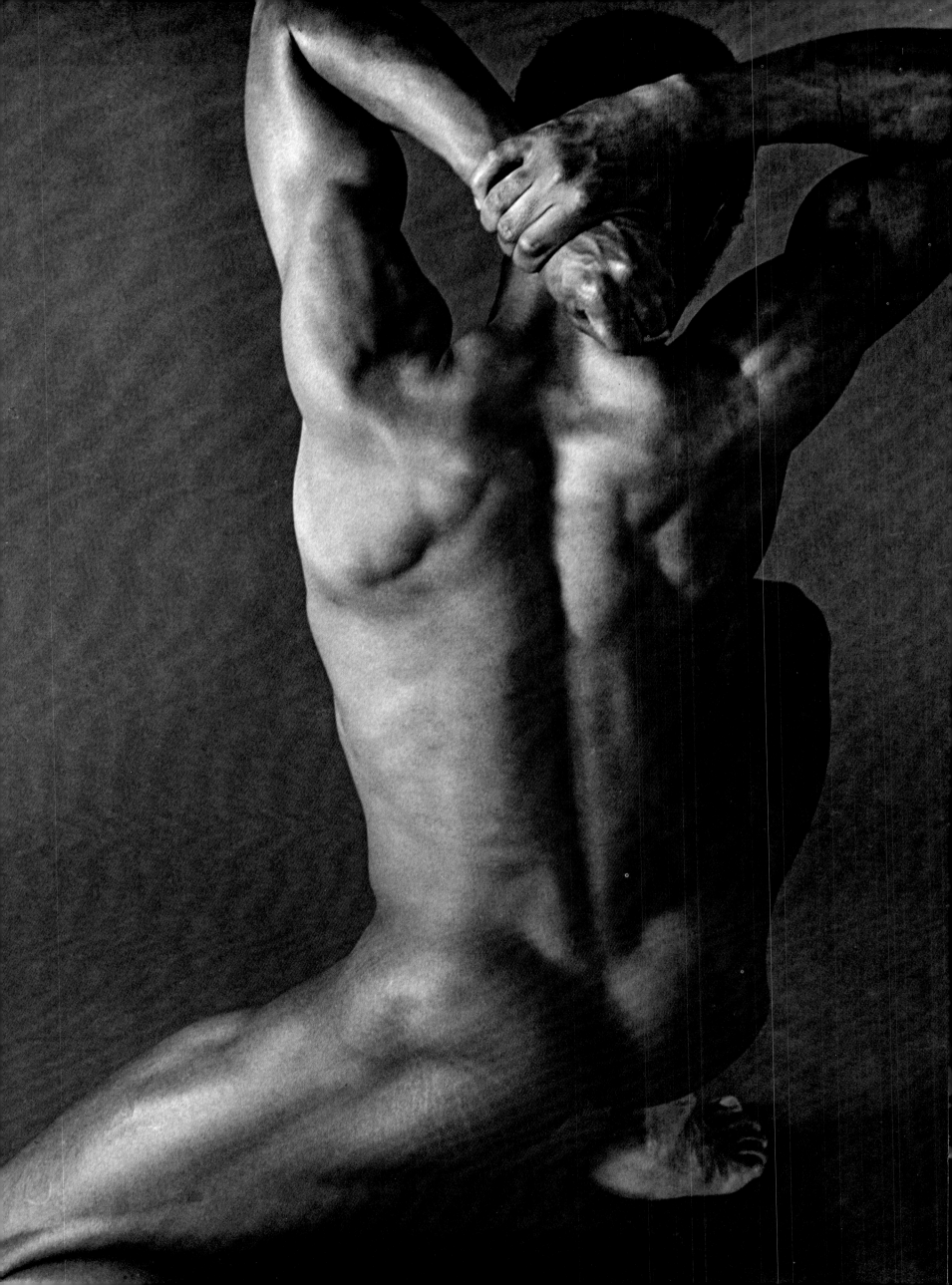

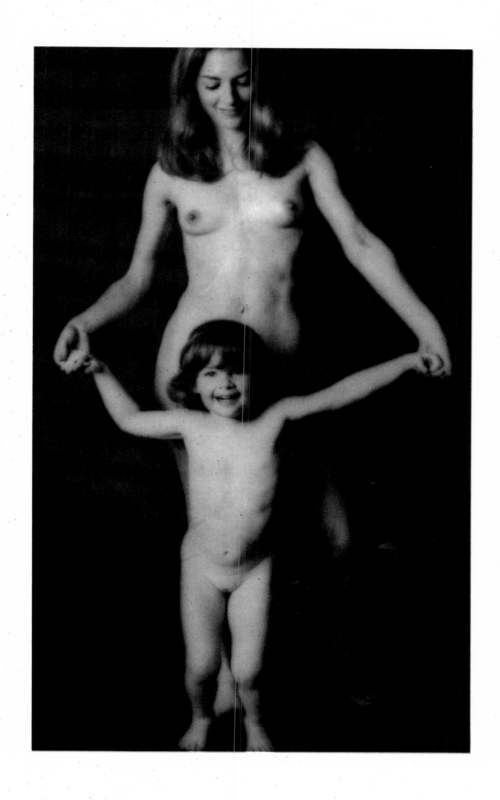

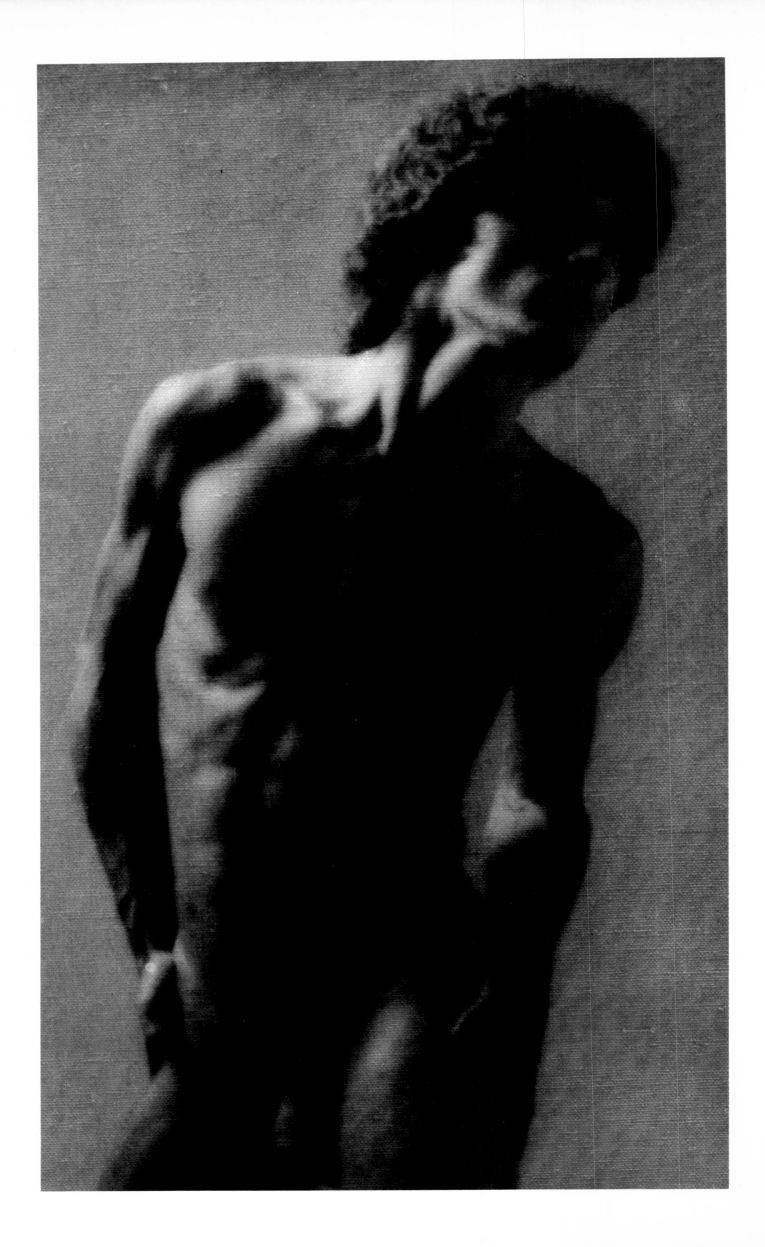

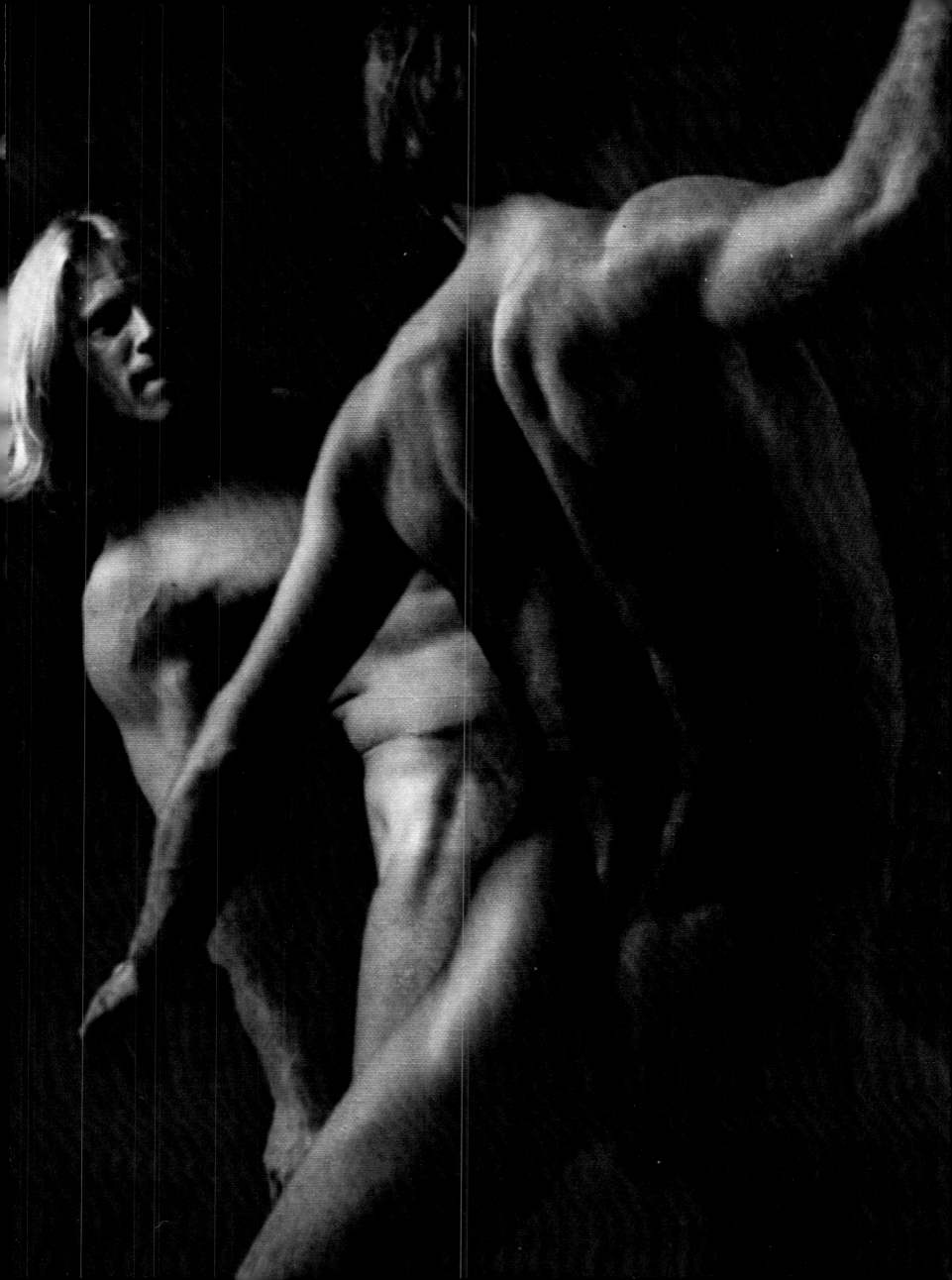

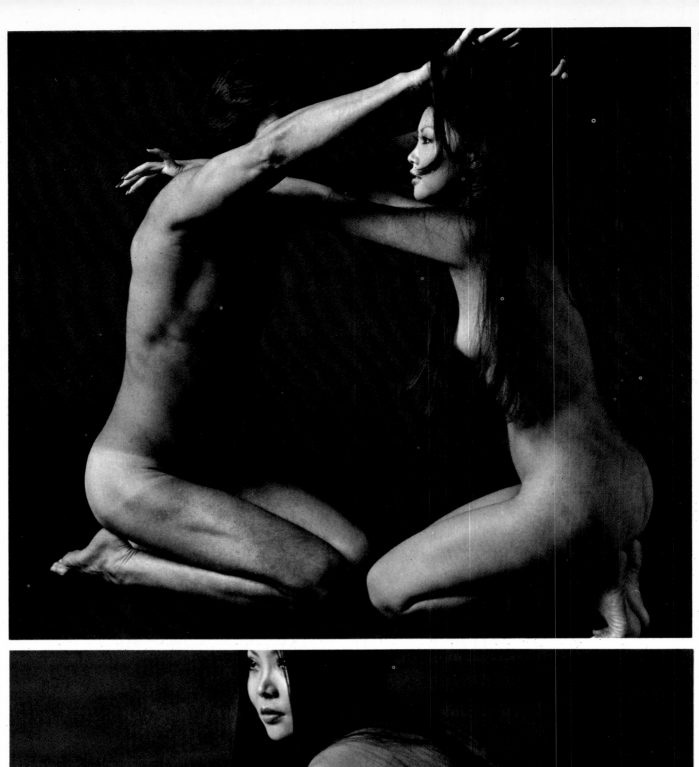

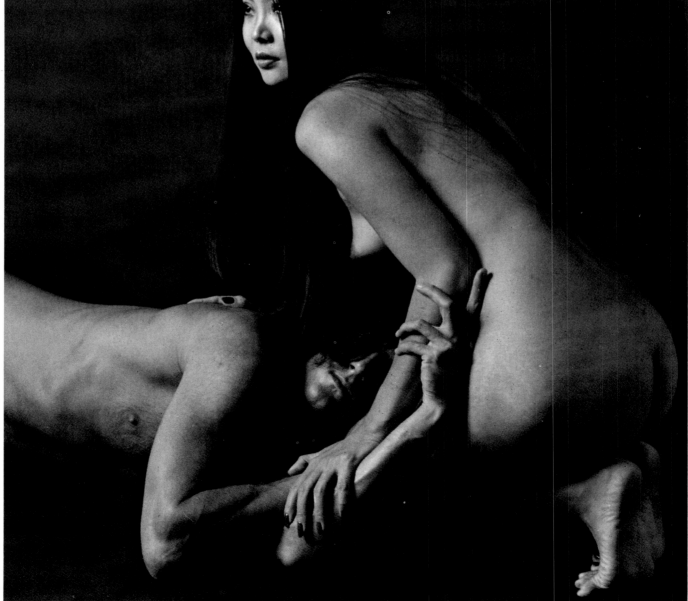

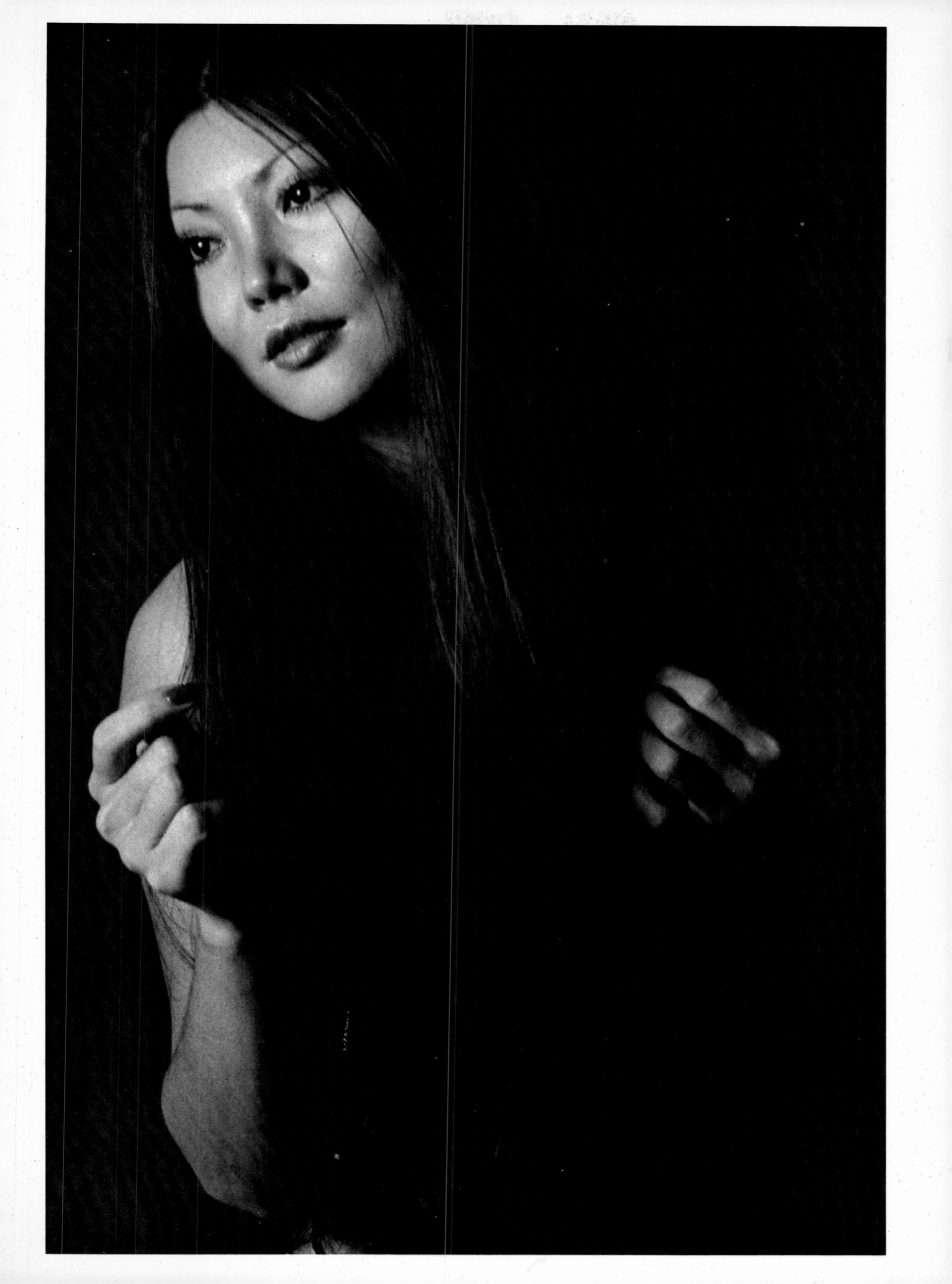

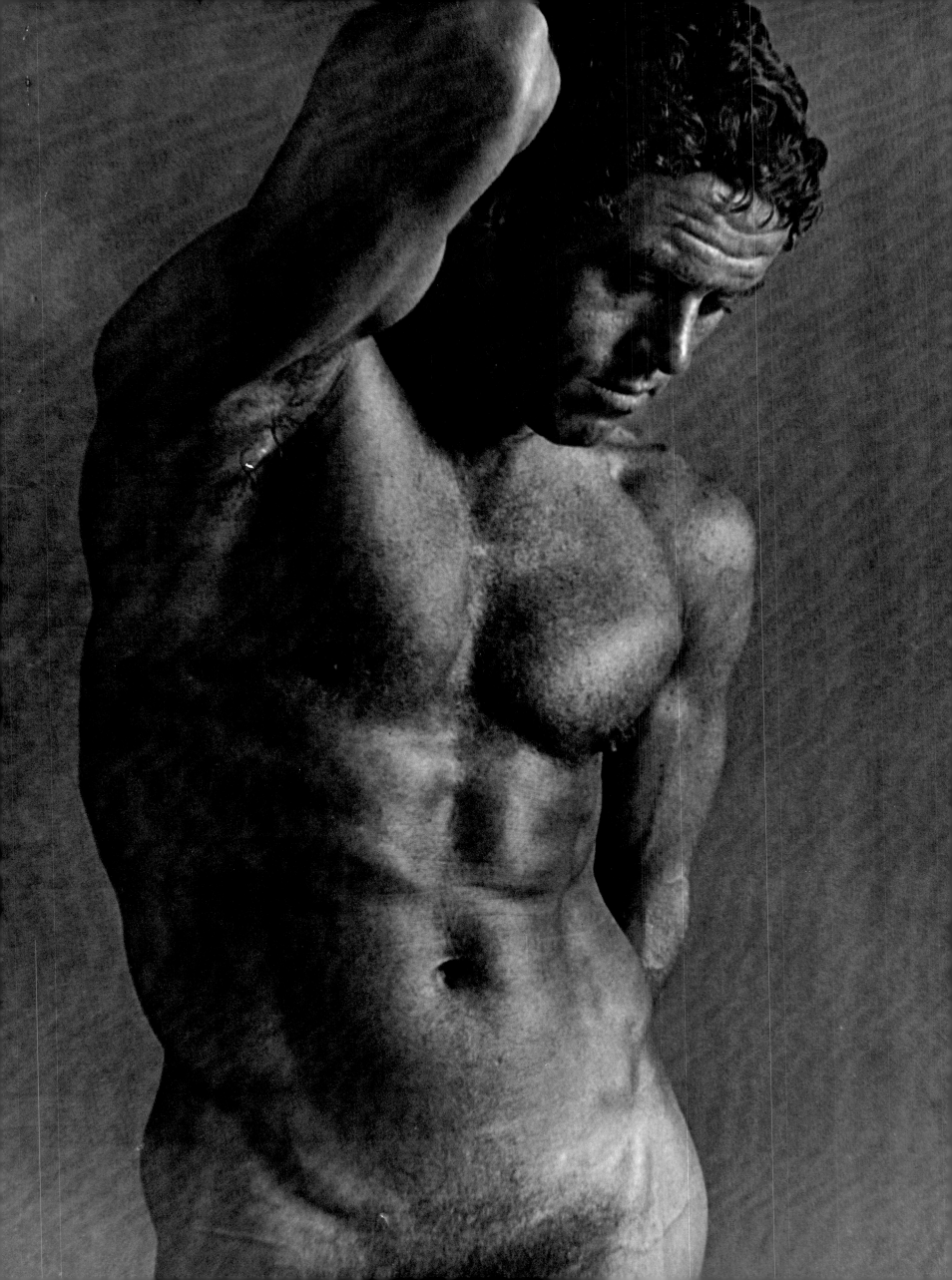

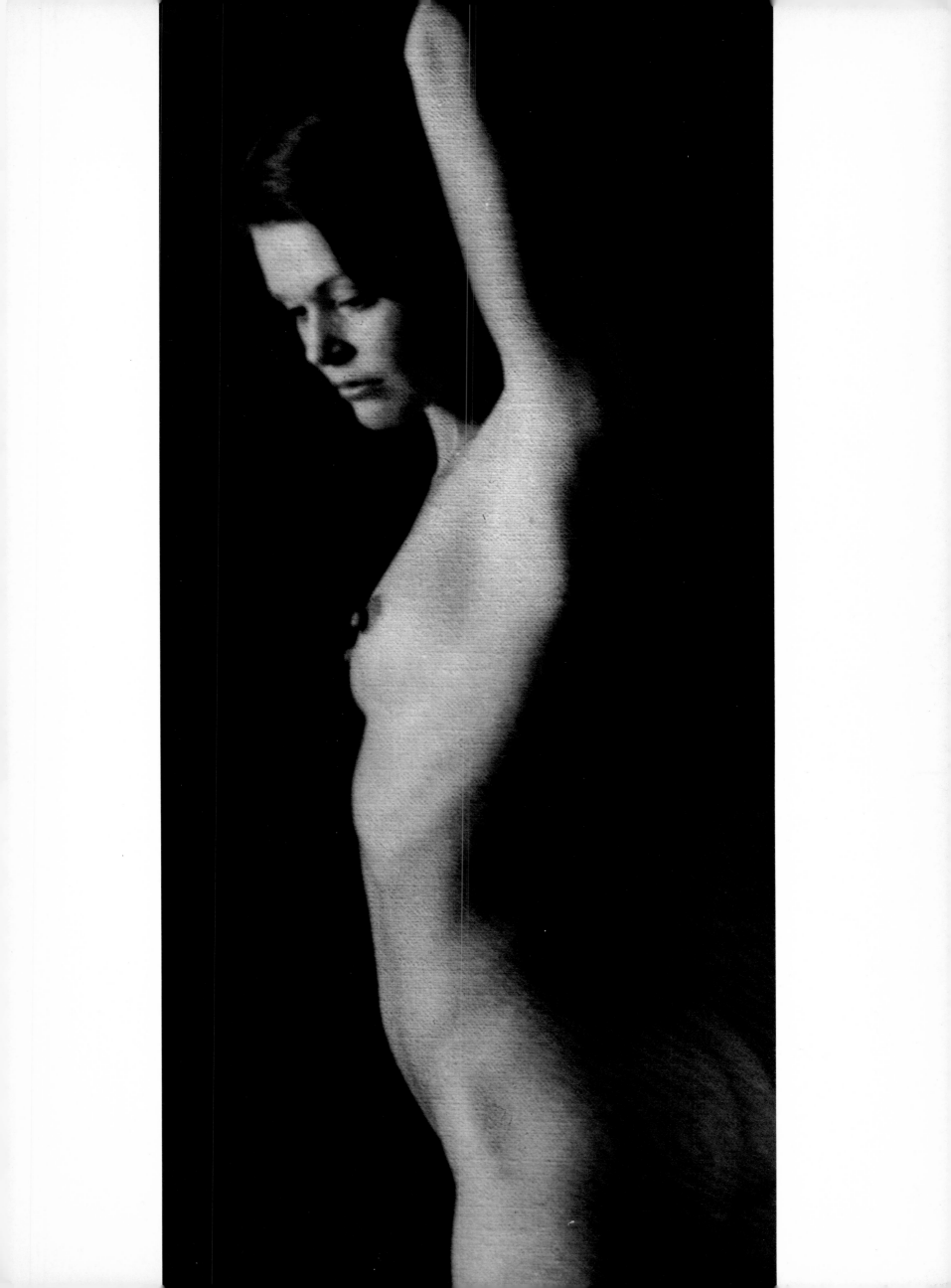

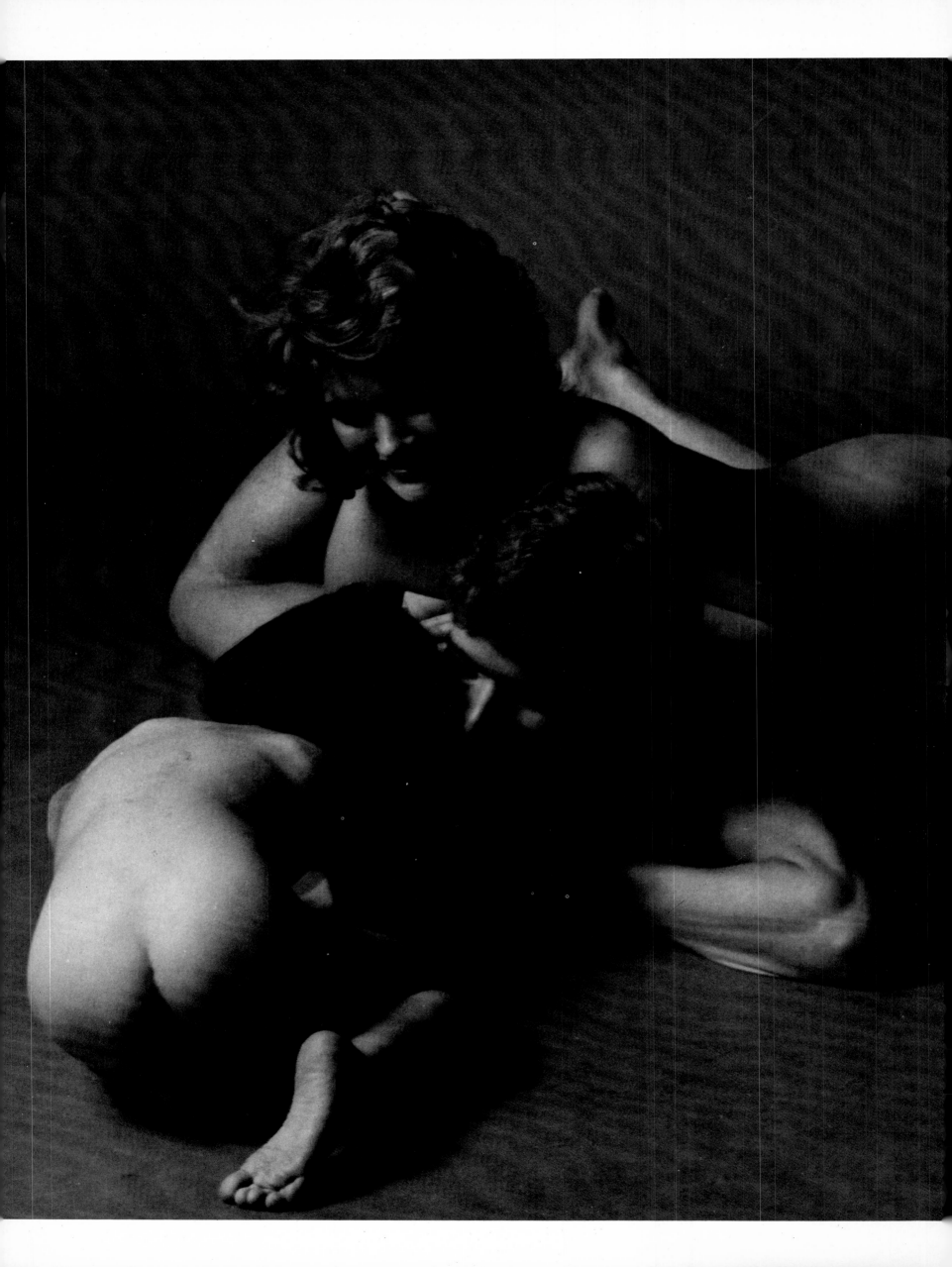

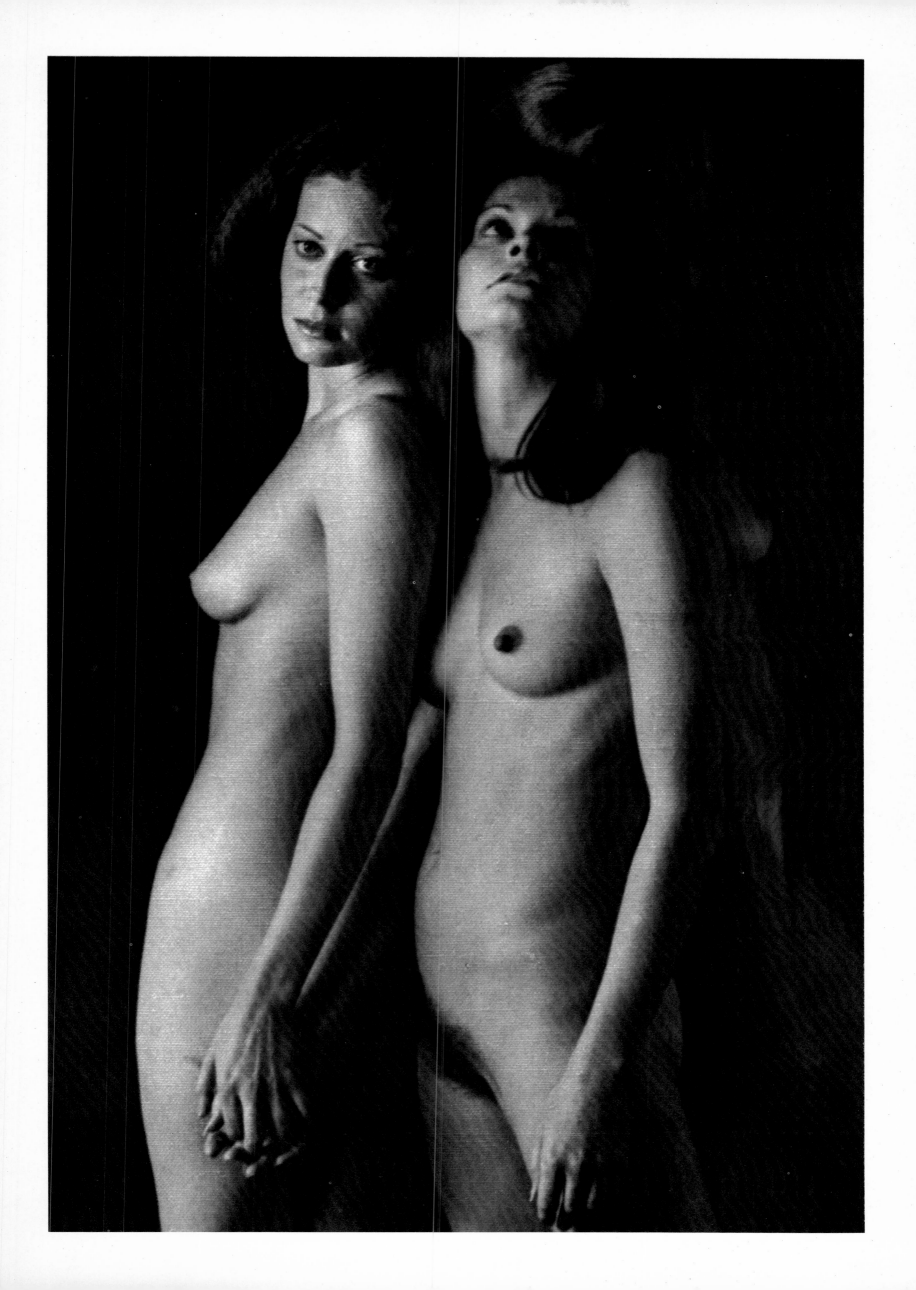

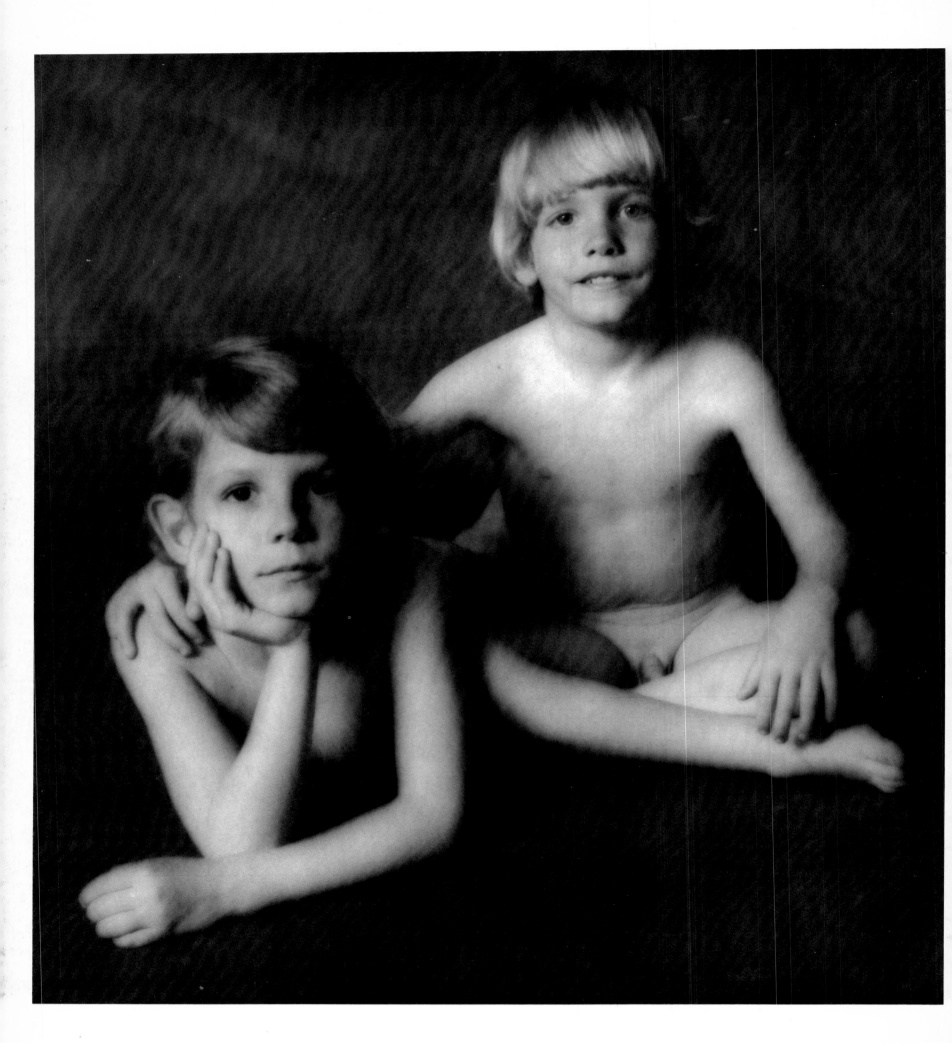

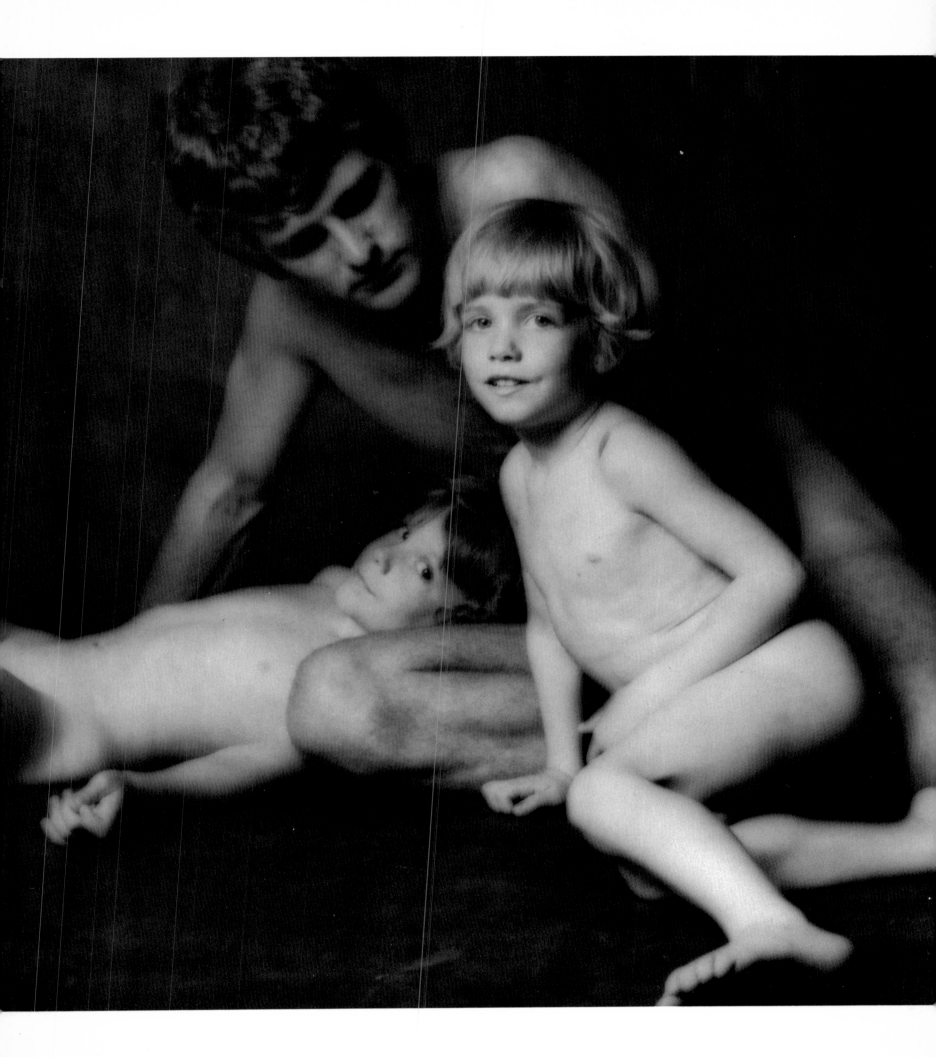

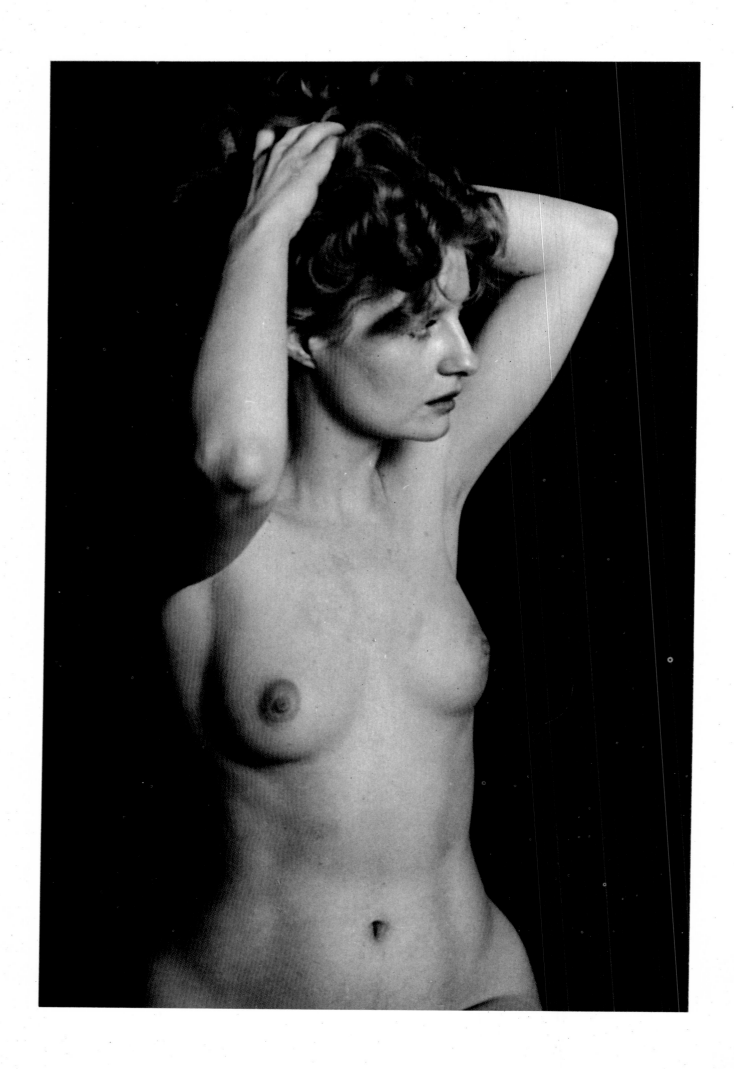